LIGHTING for DIGITAL VIDEO and TELEVISION

John Jackman

CMP **Books**

San Francisco, CA • New York, NY • Lawrence, KS

Published by CMP Books
an imprint of CMP Media LLC
Main office: 600 Harrison Street, San Francisco, CA 94107 USA
Tel: 415-947-6615; fax: 415-947-6015
Editorial office: 1601 West 23rd Street, Suite 200, Lawrence, KS 66046 USA
www.cmpbooks.com
email: books@cmp.com

The programs in this book are presented for instructional value. The programs have been carefully tested, but are not guaranteed for any particular purpose. The publisher does not offer any warranties and does not guarantee the accuracy, adequacy, or completeness of any information herein and is not responsible for any errors or omissions. The publisher assumes no liability for damages resulting from the use of the information in this book or for any infringement of the intellectual property rights of third parties that would result from the use of this information.

Acquisitions editor:	Dorothy Cox
Technical editor:	Arledge Armenaki
Copyeditor:	Rita Sooby
Layout design:	Justin Fulmer
Managing editor:	Michelle O'Neal
Cover layout design:	Damien Castaneda

Distributed to the book trade in the U.S. by:
Publishers Group West
1700 Fourth Street
Berkeley, California 94710
1-800-788-3123
www.pgw.com

Distributed in Canada by:
Jaguar Book Group
100 Armstrong Avenue
Georgetown, Ontario M6K 3E7 Canada
905-877-4483

For individual orders and for information on special discounts for quantity orders, please contact:
CMP Books Distribution Center, 6600 Silacci Way, Gilroy, CA 95020
Tel: 1-800-500-6875 or 408-848-3854; fax: 408-848-5784
email: cmp@rushorder.com; Web: www.cmpbooks.com

Printed in the United States of America
03 04 05 06 07 5 4 3 2

ISBN: 1-57820-115-2

CMP**Books**

Table of Contents

Preface

I participate in a number of Internet forums related to video production and often field questions about lighting issues. After a thread in which several of us explained to a beginner why he needed to light his videos, one wag posted:

"Remember, without lighting all you have is a black picture."

Facetious, tongue-in-cheek, but true! The most common mistake beginning video shooters make is to overlook the importance of good lighting.

I've always been interested in lighting. In my earlier days it was theatrical lighting; I just loved playing with the light boards (I built one myself) and figuring out dramatic lighting effects. Then I became interested in video production. That was back in the days of the Sony PortaPak® — the genesis of gucrilla video — and you "didn't do no stinkin' lighting." Point-and-shoot was pretty much all you did outside of the studio. The PortaPaks ran $^1/_2$-inch reel-to-reel tape, black and white only, and about 150 lines of resolution on a good day. The tape deck was about the size of a mini-tower computer today, with a shoulder strap and batteries that seemed to last about 10 minutes. Next came $^3/_4$-inch U-Matic® and $^3/_4$-inch SP. And then came the day when a great program I had taped was rejected for broadcast because of poor lighting in some critical interview scenes.

I got back into lighting with a vengeance. My earlier fascination with theatrical lighting effects was reawakened, and I started to experiment. When the first 3D programs came out (anyone remember DKBTrace, the original Caligari, and Turbo Silver?) and everyone else was playing with reflective surfaces, I was playing with the lights. I've been playing with lights ever since.

Once you discover the difference great lighting can make, you'll be playing along with me!

John Jackman
Lewisville, NC
Summer 2001

Acknowledgments

This book is dedicated to my wife, Debbie, who has had to listen to me criticize the lighting of movies and television for donkey's years, and without whose help and support my production work — and this book — would not have been possible. Special thanks also to my technical editor, DP Arledge Armenaki, who helped make sure that even the most technical stuff was understandable. And a special tip of the hat to Bob Collins, SOC, who was going to be technical editor but had his daily life interrupted by major surgery. Best wishes for a rapid recovery, Bob!

Why is Lighting Important for Television and Video?

If you're fairly new to television and video production, you might not have a sense of why lighting is so important. The cameras you've used are so sensitive, you can often get away with no additional lighting. The only thing you don't understand is why your shots are overexposed or contrasty sometimes, and you might not be able to figure out why one shot will look like a Hollywood film and the next like a cheap home movie.

If, on the other hand, you're a more experienced television production person with lots of years in news and studio work, you might understand a lot about the basic issues of controlling contrast and exposure but still not have much experience with anything more than flat studio lighting and a three-point interview setup. If you're called on to light a realistic night scene or simulate natural lighting in a living room, you could be baffled.

The real key to fine lighting is not only to simulate reality, but to communicate the proper mood and feeling to the viewer. You need to know more than just basic techniques; you need to have an understanding of how certain looks communicate to viewers. You need to develop an artist's eye for light and shadow and color and the techniques for reproducing them.

In this book, I will travel through the world of television and video lighting in a fairly methodical way so that you build an

understanding of the "whys" behind the "how-tos." If you come along for the journey (rather than cheat and just flip through to find a setup diagram or two), by the time I'm finished, you'll understand the principles behind the techniques. That means you'll be able to improvise and create new techniques for unique situations, rather than having to fall back on some textbook diagrams, and it means you'll be able to do a better job at any lighting scenario.

Why is lighting so important to great video? There are a number of different reasons, some of which have to do with the camera and the way a CCD translates light into an electrical signal and some of which have to do with human perception. But just as important is that you're creating an illusion. Like a magician, you're trying to convince the viewer of something that isn't quite true. You're trying to make it seem as if colored electron beams flickering across a flat glass screen are actually lions and tigers and bears and people, the great outdoors, the grandeur of space, and the depths of the sea. You're trying to create the illusion of depth and size in a tiny flat plane, and even more difficult, you're not really trying to capture what the eye sees. You're trying to capture the mind's *interpretation* of what the eye sees, which can be a wholly different thing. But more on that later!

1.1 Owen Stephens, SOC, lights an intimate lunch in Naples, Florida, with his Pampa portable fluorescent instruments.

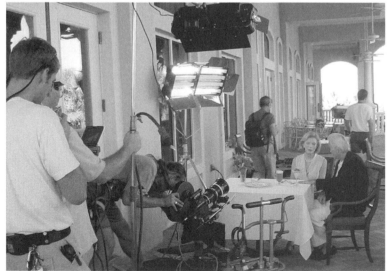

Good lighting is important for good-quality video four ways.

- First, you have to have proper exposure—enough light to generate a signal from the CCDs and raise the signal to a proper level but not exceed the limits.

- Second, you have to create the illusion of depth through the use of highlights and shadows so that the viewer forgets he is watching a 22×17-inch rectangle of glass with flickering lights behind it.

- Third, you have to use tricks and illusions to create mood and feeling with the lighting, just as the music director creates mood and feeling with the music.

Exposure and Contrast

The most obvious way in which lighting is important for video is in basic exposure. As the wag said, "without lighting, all you have is a black picture!" You have to have enough light on your subject to excite the electrons in the camera's imaging chips to a certain level. It doesn't matter that *you* can see it—if the camera can't see it, your video is toast. You'd think this observation would be obvious, but it's amazing how many people try to create a night scene by just shooting in the dark.

1.2 The Sony VX1000 revolutionized digital filmmaking but had very poor low-light characteristics.

Inadequate exposure is probably my most common postmortem diagnosis when folks bring me their videos and ask what went wrong. One producer of an independent short brought me raw camera footage to review of a scene that was shot in a field at night with a Sony VX1000. He had (almost) all the right equipment but really had no idea how to use it, and the result was dreadful. The crew had shot in a field with no easily available power, so they used a small generator and several lights. Unfortunately, they didn't bring enough stingers (extension cords), so when the generator was far enough away that it did not interfere with the audio, they couldn't get the lights very close to the subjects. Rather than concentrating all the lights on one side (which might have just barely worked), they distributed them around to create a flood of weak, flat lighting. Then they turned on the *autoexposure* control on the VX1000. I can hear the groans out there already from those of you who know that the VX1000 is

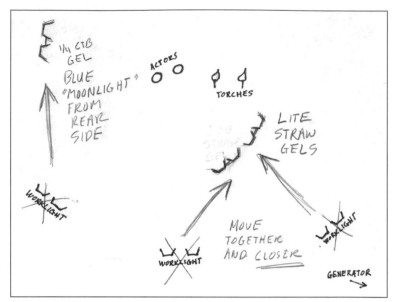

1.3 Lighting diagram for the VX1000 night shoot.

pretty poor at handling low light. As a result, the camera tried to make the scene look like a fully lit room and cranked the gain all the way up to +18dB, creating a flat, grainy picture that looked like surveillance video. The one thing it didn't look like was a night scene. "What can we *do*?" wailed the producer, who had now wasted a whole day on this scene.

I drew a diagram, using the same lights they had used but with lots more stingers to bring the lights closer to the subjects. I put most of the lights in a group on one side with straw gels. I used one light with a blue gel as a kicker (a light behind the subject and to the side opposite the key, or the main source of light) from the rear on the other side, leaving the camera side unlit. Then I showed their young shooter how to expose manually. The results were pretty good, giving the feeling of a moonlit night. I think they even gave me a credit in the roll!

But just as you must have *enough* light, *too much* light or *too much contrast* can be a problem as well. If a backlight is too intense compared to the key, the highlights will be "hot"—over the 100-unit definition for full white—and might clip so that there is no detail in that area of the picture. If the camera operator stops down to expose for the backlight, then the rest of the subject will be underexposed and the picture will seem too contrasty.

1.4 Sam Waterston, Steven Hill, and Angie Harmon in "Law and Order," one of the best-lit dramas on television. Photo courtesy of Jessica Burstein.

Overexposing causes worse problems than underexposing because sometimes the result can't be repaired. A local station where I live (whose call letters shall remain anonymous) uses location news footage that is nearly always overexposed. I don't mean a little bit, I mean *grossly*. Large portions of the picture are clipped white and the dark areas are medium gray. When they interview people of color, it's not uncommon for them to look almost Caucasian. When they interview a Caucasian, the face is a white blob with little detail. The studio (though I don't like the lighting esthetically) is at least properly exposed, accentuating the difference in the location footage.

Once you have a basic level of exposure, what do you do with it? It's fairly easy to avoid overexposure by blasting several thousand watts on a scene so that it gets the electrons in the camera hopping and then stopping down until the zebras go away. However, it's much harder to find the nuances that really convince the viewer's eye and mind of texture, of feeling, of mood. This is where the acceptable is separated from the great.

Beyond Basic Exposure

Great lighting begins with the creation of an illusion of depth. Keep in mind that no matter how much television is a part of our lives, the TV screen is still just a flat piece of glass with flickering colored lights. Although it has height and width, a television screen is fundamentally two-dimensional: it has no *depth*. No amount of great acting or wonderful music will create that

illusion of the third dimension; it's entirely up to the lighting designer to create the feeling of depth through careful crafting of highlights and shadows—the visual cues that the brain uses to interpret depth. In fine art, the use of light and shadow to create a sense of depth is known as *chiaroscuro*. Together with the refinement of perspective, it is an essential element of the great Renaissance art.

Most local news studios, talk show sets, and soap opera sets are *flat lit* with loads of light and almost complete elimination of shadows. This technique is used for convenience and economy. The result is a very flat, two-dimensional feeling. The eye doesn't find the cues that help the brain interpret depth, so it's hard to figure out how deep the set is and how far the anchors (or actors) are from one another. You're used to that look from seeing the evening news regularly, so it doesn't bother you, but boy does it telegraph "LOCAL NEWS" to the viewer. Use that lighting scheme for a drama, and it just won't work.

Contrast this to the realistic lighting used in many of today's TV dramas, such as Steven Bochco's *NYPD Blue,* Dick Wolf's *Law and Order*, or Aaron Sorkin's *West Wing*. These shows make very heavy use of light and shadow, often lighting the subject heavily from one side with a softbox or very close Chinese lantern as key and leaving the other side in near darkness. The crew work hard on their lighting to convey the feeling of depth and dimension. Light patterns on walls, mixed color temperatures, shadows—all create a feeling of the depth of the scene but also clearly cue the viewer as to an off-screen light source that is appropriate to the set.

Although some of these shows write new rules for lighting, most films and dramatic programs borrow heavily from what I call Hollywood visual vernacular: the peculiar set of visual cheats and shortcuts that have developed over the last 100 years of filmmaking. Vernacular refers to the "common language," or tricks, that are part and parcel of the common visual language of film. Many of these tricks aren't very realistic, but they are a type of visual shorthand that we have been indoctrinated to by years of watching Hollywood films. It's important to have a sense of these cheats and what they are associated with in the minds of viewers. Why? Because they work. They are much like the tried-and-true cheats of the theatre: techniques that work and that the audiences are used to and accept without question.

In the live theatre, there's an expression that's quite important: suspension of disbelief. The phrase, which originates with Coleridge[1] (he was talking about poetry), has come to mean a state in which the audience is fully engaged in the illusion of the drama. In practice, it is a balance of techniques and conventions used by the actors, director, and crew to create a certain semblance of reality; then the audience meets them halfway by "suspending disbelief" in the patent fakery. It's a delicate balance, easily broken; the audience will only go so far. If an actor drops out of character or does something utterly incongruent, the spell will be broken. The audience's attention will be focused on the knowledge that it is an actor pretending to be Romeo, not Romeo himself. If the tech crew makes a gross mistake (the phone rings long after it has been answered or the gunshot sounds before the policeman has gotten the pistol out of his holster), so too the spell will be broken. The audience will go so far, but no further.

But those tried-and-true cheats that I mentioned above are, in a way, a part of the unconscious contract between audience and play actors. They are a set of conventions everyone accepts more or less willingly: cheats that the audience will accept and obvious artifices that still will not break the suspension of disbelief. That's what the Hollywood visual vernacular is about—artificial devices that work without interrupting or unduly jostling the audience's suspension of disbelief.

A great example of stock Hollywood vernacular lighting occurs in one of Elvis' films, *G.I. Blues*. It's a bedroom scene, where he sings a lullaby to a baby. This room was lit pretty much in Hollywood formula fashion—effective, but certainly not breaking any new ground in lighting design. The bed and Elvis are fully lit, while the rest of the bedroom is broken into a pattern with several blue-gelled lights with cookies. I think I even recognize the pattern of the standard Mole–Richardson cookie! The light level in the room is quite excessive for what the scene portrays, and it really doesn't look like any dimly lit bedroom I've ever seen. But with the exception of directors of photography (DPs), lighting designers, and gaffers, no one notices! Most viewers accept the scene without question, their suspension of disbelief fully engaged.

1. *Biographia Literaria*, Chapter 14, Samuel Taylor Coleridge (1817).

As unrealistic as some of these tricks are, they are effective. The viewer will watch the scene and accept the effect and the mood without question. Although it might be exciting to rewrite the rule book and create new techniques that speak to the viewer, it's not always going to work. Sometimes it will. Other times it will flop or call such attention to itself that it disrupts the viewer's involvement in the story. But even more to the point, most of the time, you don't have the luxuries of time or budget to mess around and experiment. It's often more effective to simply use the old rule book to convey the right effect.

Because the real key here is to communicate the proper mood and feeling to the viewer, I'm always disturbed by the "artistes" who seem to feel that filmmaking is some kind of personal experience for them that they are letting the audience witness. As far as I'm concerned, the art is in creating an experience that *communicates* to the viewer. Lighting that calls attention to itself, that sets the wrong mood, or that focuses the eye on the wrong part of the picture is lighting that has failed. It's similar to a sound track that uses obviously artificial sound effects or an actor that makes the viewer turn to their neighbor and say, "What wonderful acting!" Truly wonderful acting immerses the viewer so much in the character and the story that the viewer would never think to make such a comment.

1.5 Filmmaker Elyse Couvillion and DP Allen Daviau, ASC, used light to help convey the story line to the viewer in the independent short *Sweet*. Photo courtesy of Bruce Coughran.

Whether you use a hackneyed Hollywood trick to create that mood or come up with a new and creative technique of your own, the important point is to create an illusion that will fool the eye and mind of the viewer. Great lighting, like great music, will reinforce the emotional or psychological effect of what is happening on-screen.

Suppose for a minute a scene of tension. The main character is hiding in a darkened room, when suddenly, the door slams open and a mysterious new player enters the scene. You don't know who he is or what his intentions are; he might be an ax murderer, or he might be the good guy. It might be effective to use a strong dramatic backlight, silhouetting the new player in the doorway. A bit of mist floating around makes the light beams visible, creating a sort of nimbus around the silhouetted figure. Tie this in with a dramatic chord in the background music, possibly a dolly forward, and you've got a great scene that will have the audience on edge.

Now imagine a very different scene: the first kiss of a teenage couple. Unsure of themselves, a spark crosses like an electric shock between them as their eyes meet; both move tentatively toward one another: hesitant, sensitive to any cue of withdrawal or rejection. Now apply the same lighting, the same music, the same dolly move. Yuck.

Although I suppose that I can stretch my imagination to find a spiky, edgy story line with tense characters where it might work, it's really not too likely. You want soft lighting; you want the rest of the scene to fade away a bit to convey the way that the young lovers' attention has collapsed in until only the two of them exist.

These extreme examples make the point that you need to decide what feeling you are trying to convey and that you must have an understanding of how certain looks will communicate to the viewers. You need to think out how to create that feeling—that sense of place, mood, or circumstance—before you even set up the first light. With a little practice, some tricks and techniques, and an understanding of how it all works, you'll be able to set up the proper mood quickly and with only a few instruments.

In the next chapters, I walk you through the basics, the tricks, and the techniques that will take you to the ultimate point of the book: the creative artistry of truly fine lighting.

Human Vision, the Camera, and Exposure

What You See

The human eye is a truly astounding piece of biological engineering. It is able to pick up images in near-darkness and in blazing sunlight. Overall, the human eye can perceive light in a light to darkness range of almost a billion to one. Unfortunately, when shooting video or film, the critical visual receptor is not your eye, it is the camera, and the camera perceives light differently from your eye and in a much more restricted range. The differences in this perception are critical to your understanding of how to light and expose video or film because the camera simply can't see the extended range of light the way the human eye can.

Bear with me for a moment while I take a look at the whole system of human vision and how it differs from the camera. Light in certain wavelengths is reflected off of objects. Some of this reflected light finds its way into the eye. There, the light beams are focussed on a multilayered receptor called the retina, where 125 million rods and 6 million cones translate the photons into neural impulses. The rods, spread all around the retina, are responsible for dim light and peripheral perception and really do not perceive color. The cones, which are concentrated in a central area called the macula, are responsible for color perception and see in the most detail. They require a higher light level to perceive color and detail.

But the eye is not the most amazing instrument of vision; that really is the human brain—the place where the neural impulses from rods and cones in the back of the eye are assembled and interpreted. What we glibly call "vision" is an incredibly complex event that involves the entire brain and is much more than sight. At least 32 centers for visual processing are distributed throughout the brain. The visual experience we normally have every waking minute is a multilayered integration of two different sets of peripheral vision and the detailed vision of the macula. The neural impulses from these two sets of rods and cones are transmitted to the brain, where they are integrated and interpreted so you can assemble an understanding of the objects around you. When you think this process through, this is the part that is truly amazing. The brain keeps track of position, motion, and orientation and integrates the signals from two separate receptors to perceive depth. With the merest glance and without conscious thought, you know that the variation in reflected light is a pencil on the table and that it is about two feet away from you. Again without conscious thought, you could reach over and pick it up—without even looking at it directly. It's really pretty amazing.

The brain uses a huge variety of very subtle details and cues to interpret and understand what the eyes register. Because of this detail, the brain is quite forgiving. It can use existing knowledge to fill in blanks that are poorly perceived. Through depth perception and slight motion, the brain can piece together what an object is, even when it is just on the edge of visibility. Slight motions of the head and eyes apparently play a huge role in supplying the brain with enough data to accurately interpret the world "out there," outside of ourselves.

This ability is quite important in the study of lighting because when you translate that complex, three-dimensional world of trees and rocks and dust bunnies under beds into a two-dimensional representation, the brain suddenly loses several of the subtle cues that it uses to interpret the world. In particular, it does not fill in blanks or vague areas the same way. Whether the two-dimensional representation is a television screen, a photographic print, or a line drawing, the creator of the representation must compensate for what is missing. In short, the representation needs to be better drawn and more carefully created than the reality

would have to be. The important elements must be clear and well defined. Sometimes it is even effective to blur out nonessential elements to help the eye (and the mind) focus on what is essential.

Let me give an example of what I'm talking about here. Suppose you're sitting in a dimly lit room you are unfamiliar with. Something in the corner catches your eye. You can't quite tell what it is, so you move your head a little bit, giving the brain extra data about the dimly perceived object. You might squint or shield your eyes from the light source to allow you a little better dim light perception. The little bit of extra information gained from this might allow you to figure out what the object is. If you need more information, you can always get up and walk over to it or turn on another light. If that fails, you can still touch the object to find out more about it!

What the Audience Sees

When you compose a television picture, remember that your viewers have lost all those subtle controls that enhance perception. Moving the head a little won't give them additional information because they are looking at a flat piece of glass with flickering colored lights projected onto it. Squinting won't help. Getting up and getting closer only reveals that the picture is red, green, and blue pixels. Turning on an extra light won't help, and touch will only reveal a cold, smooth surface.

The appearance of depth and texture in a television picture is entirely artificial. The only perception of depth that the viewer has in your picture is controlled by lighting and camera motion. The only way the viewer can perceive the texture of an object is through the subtle pattern of reflections, highlights, and shadows on the object's surface. Poorly lit objects could be overlooked altogether or become indecipherable blobs, even if they are clearly perceptible in reality. Richly textured surfaces recede into bland obscurity unless lit in a manner that makes the texture visible to the viewer. In creating pictures, you must be aware of how much control the viewer has lost and you, the image creator, have gained.

Additionally, people are much more forgiving of reality than they are of a two-dimensional image of the same thing. If you have the opportunity to videotape in a church or synagogue, you'll often find a perfect example of this. Most of these buildings are very poorly lit for video, and it's not uncommon to have lights shining down on the clergy from a very high angle. The eyes are cast into shadow, glasses cast odd shapes on the cheeks, the nose casts a horrific shadow that extends over mouth and chin. Week after week, the congregation will watch people teach or read in this horrible lighting and won't mind it a bit. They overlook the odd shadows; they don't notice them, even if their attention is called to them. Now take a videotape of the same situation and show it on a television. Right away, the same people will complain about the ugly shadows.

In fact, part of this phenomenon is that the camera does exaggerate the contrast between shadow and highlight—more on that in a minute—but the part of this phenomenon I want to emphasize here is that the viewer is more demanding and critical of the two-dimensional, flickering picture. The loss of extra perceptual cues and personal control means that the brain cannot do the hoop-jumping tricks it often does to "see" through perceptual problems. What you see is what you've got. So here's a rule to engrave on your forehead: Realistic lighting is often not good enough for video and television!

Realistic lighting is often not good enough for video and television!

Aside from the contrast issues that you now have to tackle, remember that you have to supply the viewers' brains with all the visual cues needed to figure out depth and texture as well as color and placement, and you have to do it in a somewhat blunt and unequivocal way. Add to this the very real problem that the camera doesn't see as wide a range of brightness as the eye, and the problem gets more complex. What you see with your eye isn't exactly what you are going to get. The contrast range that the camera can handle is likely to be less than a quarter of the range that the eye can perceive. The range of brightness that a camera (or film stock) can expose is known as *latitude*.

To understand this problem of latitude, let me go back to my earlier assertion that the eye can perceive a range of a billion to one. Actually, that isn't quite true because it cannot perceive the dark-

est object and the lightest object in that range at the same time, and it cannot perceive all light levels equally well. The eye has a number of adaptations that allow it to perceive a contrast range of between 2000:1 and 1000:1 at any given time. Changes in pupil diameter work just like the iris in a camera to physically restrict the amount of light that is admitted to the retina, and neural adaptations change the activity of the neurons in the optic nerve. Also, there is a fundamental photochemical shift that actually gives the eye two discrete ranges of light perception.

You are familiar with this photochemical shift. When you leave a brightly lit area and enter a darkened room, you can't see very well at first. Then gradually, your eyes adjust to the lower light level, and you can begin to perceive detail in what moments earlier seemed like Stygian darkness. After a while, you can see pretty well. What has happened is much more than the change of iris size or neuron activity. In darkness, the retina regenerates a chemical called rhodopsin, which is bleached out by bright light. This chemical allows the rods in the retina to perform at much lower light levels. The entire chemical shift typically takes about seven to eight minutes, with low-light sensitivity increasing during the entire period. Of course, once the rhodopsin has reached full level, your eyes are very light sensitive, and going back out into the sunshine will be a blinding experience—until the rhodopsin is bleached out and your retina chemically adjusts to the high light–level mode. So the eye really can't perceive a huge range all at once, but it has an amazing ability to adjust to a wide range of lighting levels.

What the Camera Sees

I can hear the griping now: "That's more than I ever wanted to know about eyes. What's all this got to do with cameras and lighting and taping the evening news or a dramatic love scene?" Quite a lot, actually, because the most common basic mistake that is made in television and video lighting is to *assume that the camera is going to react to a scene the same as the eye*. It just ain't so, and if you don't grasp the huge difference between your camera and your eye, your lighting will never look right.

> **Note**
>
> Contrast range isn't the only thing the eye does vastly better than video or film. By most estimates, the average human eye is the equivalent of an 11,000- ×11,000-pixel CCD, with pixels only two microns in size. That's an equivalent of about 120 megapixels—talk about high definition! The best 35mm film frame is reputed to be 3000×3000 pixels on the best day. A standard-definition ITUR-B 601 video frame is 720×486 pixels, or 0.35 megapixel.
>
> This means that one of your eyes registers a picture that is about 350 times as detailed as a standard definition television picture and a contrast range that is eight times larger.

The eye is so adaptive to different light levels that you almost don't notice subtle changes in light. In fact, it's generally accepted that the light level must halve or double before it will represent a noticeable change to the human eye. That's quite a change! In fact, it is that halving that is behind the designation of F-stops on a lens. Each progressively higher stop number halves the amount of light passing through the lens and hitting the objective.

Even after you understand the subtle complexities of how human vision differs from the picture on a screen, it's essential to understand the dramatic differences in dynamic range as well. "Dynamic range" is the zone in which an instrument can operate effectively. In audio, it's the softest sound the microphone can register (above the noise floor) up to the loudest sound it can register without distortion. In video, it's the lowest reflected light that can register detail up to the highest level of reflected light that can register detail before turning to solid, blown-out white. The ratio between these two light levels is known as the "contrast ratio."

Even if you assume conservatively that the eye can perceive a contrast ratio of 1000:1, this is still way beyond the limits of either film or video. Most film stocks can achieve contrast ratios of 250:1, and some manufacturers today are claiming 500:1 on their latest, best film stock. But remember that this is an ideal on

F-stops

Exposure in video cameras is measured by the F-stop. This is a measure of the exposure factor (hence the "f") of the lens and iris opening. F-stops are calibrated from the aperture of the iris: f/1.4 on most lenses is wide open, f/2 is one-half the area of f/1.4, f/2.8 is one-half the area of f/2, and so on.

Some lenses (usually for film) are also marked in T-stops. T-stops are marked in red (F-stops are marked in white) and are calibrated to the measured amount of light falling on the film or CCD, rather than calculated from the area of the open iris.

It is generally accepted that the super-flexible human eye does not notice a significant change in light levels much less than halving or doubling; that's why the system is set up the way it is.

F Stop	Ratio
F 1.4	1:1
F 2.0	2:1
F 2.8	4:1
F 4.0	8:1
F 5.6	16:1
F 8.0	32:1
F 11.0	64:1
F 16.0	128:1

2.1 A comparison of how the eye, film, and video handle contrast relative to one another.

the camera original; you'll never get a distribution print with that range. Video cameras haven't reached that far yet. A good prosumer camera like the Sony VX2000 or the popular Canon XL1s might expose well through six stops, or 64:1. Pro camcorders like the Sony DSR-500 can consistently hit seven stops, or 128:1.

Video cameras are now performing at a contrast range similar to many film stocks. Much of the popular idea that film is always better than video is simply outdated, received wisdom from an earlier era when even broadcast TV cameras only achieved contrast ratios of 30:1. Much of that assumed gap in performance has eroded and now is nearly gone. George Spiro Dibie, six-time Emmy Award–winning Hollywood director of photography (DP), says that today, he can light for his video cameras exactly the way he lights for film cameras.

By the time you read this book, the latest great thing might be doing much better—but I seriously doubt that the best film stock or state-of-the-art HD camcorder custom-made for George Lucas will be up to the amazing performance of the eye!

I hope you didn't just skim over those last paragraphs! Look at those figures again, comparing the human eye to the Canon XL1. The likelihood is that your camcorder has a usable contrast range that is less than one-tenth that of your eye! Look at the chart in Figure 2.1 that approximates a comparison. Bear in mind that

changing the iris doesn't expand this range, it just moves it up and down the scale.

This issue is incredibly important if you are to do really fine lighting. It is essential that you understand how limited the contrast range of your camera is and learn to judge the effect of your lighting by watching the monitor. Experience will enable you to "eyeball" lighting better, but even the most experienced DP will always check the effect on the monitor because it is there that you will be "seeing" through the camera rather than your baby blues.

The Legal Video Signal

Okay, here come the video police! If you intend your video for broadcast, "legal" refers to video that adheres to the accepted standards for the NTSC (or PAL) signal. In other words, voltages do not rise above a certain limit. Black levels fall in a certain range (0 IRE for DV, 7.5 IRE for analog), and white does not exceed 100 IRE. Chrominance does not exceed specs. The "video police" are the engineers at the network or station that will look at your video on a waveform monitor and assess it for technical quality. You don't want to get busted by these guys, or your video might be rejected. But there's good reason to observe the legal standards even if you're not aiming for broadcast. All video equipment is designed for these limits. Ignoring the standards will inevitably result in a lower quality picture on playback.

NTSC video is something of a Frankenstein's monster, cobbled together at different times by different committees trying to do different things. PAL (the video standard many other countries use) is better at handling color but still suffers from some compromises. But face it, until DTV is universal (don't hold your breath) NTSC and PAL rules apply, and you really ought to have a rudimentary understanding of those rules. I don't have to get into the details of frame rate, interlace, and color encoding for lighting, but you do need to understand a bit about the upper and lower limits of the signal and how lighting and exposure can affect them.

The video signal is measured on two devices: a waveform monitor and a vectorscope. Both are specialized, calibrated versions of the oscilloscope. Very often, the two functions are combined in a single unit.

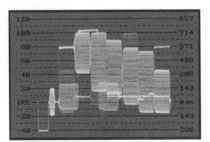

2.2 A waveform monitor displaying SMPTE color bars.

2.3 A waveform monitor
displaying well-exposed video.

The waveform monitor basically measures the varying voltage of the signal across each scan line. This accurately equates to the signal luminance, or monochrome brightness. Figure 2.2 shows the trace of a waveform monitor showing SMPTE color bars; Figure 2.3 shows a waveform monitor (WFM) displaying a sample of well-exposed video. On the waveform monitor, the visual portion of the signal is measured from 0 to 100 units. This scale (traditionally known as IRE, after the Institute of Radio Engineers, now the Institute of Electronic Engineers) measures the range from black to full white. Whoops, there's one little exception—a detail called "setup" or "pedestal." In the United States, Canada, and most other NTSC countries except Japan, black is not 0, but 7.5 units. This "setup" was added at the same time as color to prevent less-than-perfect picture elements from overshooting into the sync area of the signal.

However, digital video—and particularly DV—uses 0 IRE, the Japanese standard for black level. Although this seems odd, it isn't. Digital formats generally use 0 IRE internally, with pro machines adding setup through a processing amplifier (proc amp) setting at the analog outputs. The oddity is that most prosumer DV camcorders and decks, such as the popular Canon XL1 or Sony VX2000, do not add setup at the analog outputs and display 0 IRE black.

At the top of the range, 100 IRE should represent pure white. However, there is considerable headroom in the signal. Analog video formats often display up to 120 IRE; however, digital formats will clip at 110 IRE, the maximum level defined in the digital formats. This is important for lighting design, because it is

essential to create a range of lighting (remember the limited contrast range of the camera?) that fits completely inside that compressed range. In other words, the hottest highlights ought to just kiss the 100 IRE mark, whereas the deepest shadows should just descend to 7.5 IRE, with most values falling somewhere in between. Figure 2.4 shows what you don't want: A scene with too broad a contrast range will produce clipped whites and crushed blacks. You don't want any of these "flat line" areas at top or bottom!

The vectorscope works quite differently from the waveform monitor. Color in composite analog video is defined by the *phase relationship* of the portions of the signal, and that is what the vectorscope displays. You don't have to understand this, but it's a good idea to know what the display means. The phase of the signal is displayed by tracing *vectors* (hence the name "vectorscope") in different directions on the round display. Figure 2.5 shows SMPTE color bars on a vectorscope display. The 75% saturation color chips draw peaks that fall within boxes known as "targets." These are labeled (clockwise from top) Red, Magenta, Blue, Cyan, Green, and Yellow. The smaller target boxes labeled with lowercase letters are for the PAL system, which displays peaks in both boxes. You can tell that a video transmission is properly adjusted when these peaks fall in the targets of the vec-

2.4 A waveform monitor indicating clipped whites and crushed blacks.

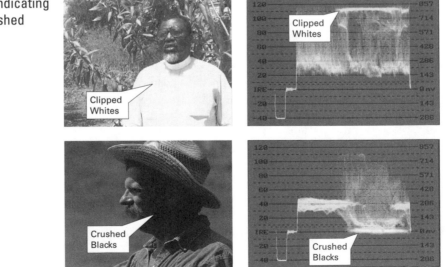

torscope and the white and black levels display properly on the waveform monitor.

Reading a vectorscope is really pretty simple, although for some folks, it takes a bit of getting used to. Remember that it displays color content only, not brightness. The more saturated (stronger) the color, the farther from the center the vector trace. Washed-out, desaturated colors will be closer to the center. Any traces that go outside of the outer circle are overlimit and illegal. The one to watch most carefully is red, which will bleed terribly in analog displays. It's best to stay close to the 75% target with red and not get too close to the outer perimeter.

It's pretty rare for lighting to cause a problem with illegal colors. The two situations where you might need to watch the color content are when lighting a set with strong, saturated colors—the set of a children's show, for instance—or when using strong "party color" gels. Again, watch out for reds! Yellow can also be a problem. On the other hand, it's hard to get a blue so strong that it even approaches the limit. If you're in such a borderline situation and see that you've created an illegal color, the fix is fairly easy: either reduce the lighting level a bit (on a reflective surface) or toss in a little white light (with a strong colored light) to desaturate the color until the chroma reads legal.

For lighting, you don't need to know much more than that! Leave the color burst and back porch measurements to the engineer.

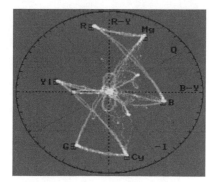

2.5 Vectorscope display of the SMPTE color bars; compare to waveform display in Figure 2.2.

Proper Exposure

Before I get into the niceties of controlling contrast, you must first know how to expose the image properly in the camera, no matter what lighting level is out there. Film folks are used to exposing entirely with a light meter. Although you can do this for video, it is not the recommended method. If you're a film DP who feels naked without a light meter on your belt, you can of course use the same techniques for video with some minor modifications (see *Appendix A*, "Using a Light Meter with Video"). A light meter and knowledge of how to use it can be quite helpful, but a meter is not a necessity for video work because the camera itself is a

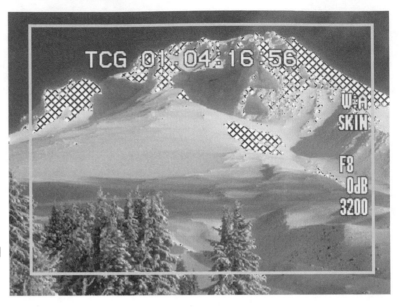

2.6 The 100 IRE zebra display shows a striped or crosshatched pattern on areas of the picture that exceed 100 IRE.

sophisticated light meter; after all, the video signal is a precise conversion of the level of light.

The video signal can be measured quite precisely using the zebra display (an exposure reading that displays in the camera viewfinder) and the waveform monitor I've already discussed. The zebra display is a feature on professional cameras, and some prosumer cameras, that displays either black and white stripes or a crosshatch pattern in the viewfinder on portions of the image that exceed a certain level. There are two types of zebra display: 100 IRE and 70–90 IRE. They work differently and are used for different applications. Some prosumer cameras have a 100 IRE but not a 70–90 IRE display. On pro cameras, the type of zebra display is selectable in the menus; for many cameras, the precise bracketing of the 70–90 IRE is adjustable.

The 100 IRE zebra display is sort of an all-purpose "idiot light" that indicates areas of the picture that exceed 100 IRE, or full white. Remember that although the camera has the headroom to create signal above 100 IRE, that signal is technically illegal for broadcast—100 IRE is white, period. Exposure using the 100 IRE zebra display is quite simple: open up the iris until the highlights display zebra, then back off just a bit until the zebra vanishes. Your highlights are now properly exposed and legal. Of course, this does not necessarily mean that the rest of your picture is well

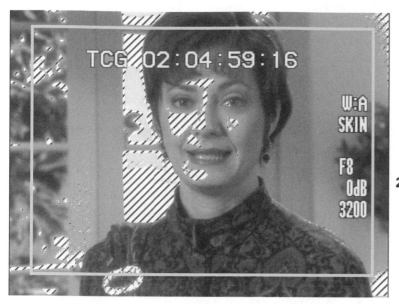

2.7 The 70–90 IRE zebra display is useful for exposing human faces. This display shows a striped pattern on areas that register between 70 and 90 IRE—usually facial highlights such as cheekbones, forehead, and nose.

exposed. It just means that the highlights are not overlimit. You'll still need to decide whether there is enough fill to produce proper exposure in the other areas of the picture. This is where a production monitor (rather that just the monochrome viewfinder) is essential. After you've set the exposure for highlights, you might need to add fill to achieve detail in darker portions of the image. In some situations (outdoors, or in an event setting where you can't control the lighting) you might need to make a judgment call to open up the iris and allow the highlights to go overlimit in order to expose sufficient detail in other areas. *Just keep in mind that if you overexpose too much with a digital format, you'll hit the "digital ceiling" and the highlights will clip.* Severe instances of such clipping might prevent a broadcaster from using your video.

The 70–90 IRE zebra exposes facial highlights and is mainly useful for talking head shots and other shots where the primary focus is on a human face. The tool is based on the premise that properly exposed caucasian skin will display highlights at around 80 IRE. When using this mode of zebra, the display comes on at 70 IRE and goes off at 90 IRE, allowing the camera operator to bracket exposure of the highlighted areas of the subject's face. A properly exposed face will typically display zebra patterns on nose, forehead, and cheekbones, but not elsewhere. Highlights that are over

90 IRE (such as the hair highlight from a backlight) will not display a zebra pattern.

Obviously, there is some latitude here. Darker skin tones display a more restricted pattern of zebra highlights. Extremely light skin might display a much broader zebra pattern on cheeks and forehead. Some people find the 70–90 IRE zebra display difficult to use, but once you get used to it, you can expose faces quite accurately.

The ultimate exposure tool for video is not the light meter, but the waveform monitor. After all, this device displays the precise voltage level of every part of the signal. Some DPs carry a small portable waveform monitor in the field, but it is more common to find them in the studio. With most waveform monitors, you can zoom in to see the value of very small areas of a specific line, which is more precise than the best spot light meter.

The best way to use a waveform monitor for monitoring exposure is with the *low-pass* filter on. This control eliminates the color component from the signal and allows you to see the luminance only. The color component, or chroma, is best monitored on a vectorscope, anyway. This scheme simplifies the display and allows you to clearly see the range of exposure.

Film DPs and still film photographers are familiar with the zone system of exposure originated by Ansel Adams. The zone system breaks the gray scale into 10 zones ranging from 0 (solid black) to 9 (fully exposed white, no detail). In a properly exposed picture, values need to be distributed from zones 1 through 8. This method creates a picture with full contrast, but detail in both dark areas and highlight areas. It's helpful to think of the waveform monitor display in a similar way; the 7.5 IRE setup is solid black with no detail, and 100 IRE should be regarded as fully exposed white. The picture elements should distribute throughout the scale, with most of them falling between 15 and 95 IRE. The hottest highlights should just reach up to kiss the 100 IRE line, while the darkest shadows should dip to near 7.5 IRE but never below. A very contrasty picture displays lots of values near black and near white, with few in the middle; a more normal exposure shows values distributed through the middle, as well.

It takes some practice to become adept at reading a waveform monitor, but after a little while, it becomes second nature.

Controlling Contrast

Although your most basic job is to provide enough light for the camera to properly expose the picture, to get a high-quality picture, you must also compress the range of lighting to make it fit inside the capabilities of the camera. That means that you must lower the level of the highlights and raise the light level in dark areas when compared to what your eyes would perceive as normal lighting (Figure 2.8). The effect in person is a "flatter" look than you would want for live performance, but it is the look on the screen that you are concerned with.

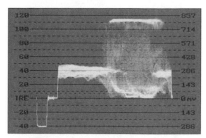

2.8 Controlling contrast involves adding light to dark areas and reducing light to bright areas. The WFM display above shows a very contrasty picture with clipped whites and blacks.
A well-exposed picture has values distributed throughout the range, without exceeding the upper or lower limits.

How do you compress the contrast range? Obviously, by adding light to areas that are too dark and removing it from overly bright areas. However, that explanation is too simplistic because the range of lighting must also relate to the sensitivity and exposure setting of the camera. The two are integrally intertwined. Film DPs, who do not have the "what you see is what you get" advantage of video, must work this blind. They'll set up the lights with a light meter and determine the camera F-stop and shutter speed from formulas. Although film folks can continue this habit with video with some important modifications (I'll get to this later), it is not the typical procedure.

You must work simultaneously with the following interrelated factors:

- the level of light on the subject;
- filters on the camera lens, all of which reduce the lens' light transmission ability somewhat;
- whether the camera is single-chip or triple-chip;
- the sensitivity of the camera chips;
- the speed of the lens;
- the F-stop setting on the lens; and
- the desired depth of field (DOF).[1]

1. Depth of field, often confused with depth of focus, is a measure of the scene that is visually sharp. Depth of focus, on the other hand, is a technical measurement inside the camera of the depth, wherein the image projected on the objective (in this case the CCD) is sharply focused. That is, it is the distance behind the lens where the circles of confusion are reduced to the minimal possible size.

Why White is the Enemy

In controlling contrast, there are two great enemies to watch out for: a light source (such as a window or lamp) in-frame and pure white objects. Either one of these will immediately cause the contrast ratio to exceed the capabilities of even the best video camera. White walls, white shirts, and white paper are the most common culprits. Ever notice that politicians all know to wear blue shirts for television interviews? This is why!

The usual rule of thumb is: "no white on a TV set!" On television, newscasters wear gray or light blue shirts, their notes are typed on special light gray paper, and the walls are never, never, NEVER white. Whenever possible, keep white objects out of the shot or protect them from key light.

Remember, these factors are completely interrelated, so a minor change on any one will have a ripple effect on every other factor in the list. In most cases, however, most of the factors remain fixed, and you will vary only two: the level of light on the subject and the F-stop on the camera lens.

A typical procedure for video is to begin with the *key* light, which is usually the brightest light in the scene. This should be bright enough to allow the camera proper exposure. Set the F-stop on the camera using the zebra display (see the sidebar *Quick-n-Dirty Exposure*) to prevent overexposure.

Many DPs prefer always to use enough light to expose toward the middle of the lens range, perhaps f/4 or f/5.6, because most lenses perform more accurately in this range (sometimes called the "sweet spot") than they do at the extremes, wide open or closed down. Color contrast is better, and the depth of field is greater. However, with the high sensitivity and low noise of modern digital cameras, it is possible to run lower light levels using a lower F-stop, such as f/2.8 or even f/1.4. Sometimes this is effective for achieving a limited depth of focus to throw the picture background out of focus. Conversely, if you want a large depth of field, you will want to use more light and expose at a higher F-stop.

Once you have set the key and the camera exposure, bring in other lights or reflectors to work with that exposure. This is the *fill* light, the light that casts illumination into shadowed areas. A typical setup uses a fill light that is about one-half the intensity of the key. This is just a starting point, of course, because you might want a higher or lower fill level. At a minimum, you usually want enough fill to create a little detail in dark, shadowed areas, rather than a flat line of solid black on the waveform monitor. You don't even have to have a waveform monitor. Just bring in some light until you begin to see some detail in the shadows on the production monitor.

In many situations, you then will add some variation of the *backlight*: a light from high above and to the rear that picks out highlights that visually separate the subject from the background. The intensity of this light can vary tremendously, from about the level of the key down to that of the fill. It all depends on the type of effect you want to create. The one thing you don't want to do is

load on so much light that the highlights become overexposed and clip; pay attention to the look on the production monitor and the zebra display in the camera.

This basic procedure, with variations, generally allows you to create a lighting situation that works with the contrast range of the camera. I'll get into the many pitfalls, problems, and variations later on in the book.

One topic that I should touch on here is the *inverse square rule*, which describes the relationship of distance to light levels. It shows up throughout later chapters as I discuss actual setups and how minor adjustments can affect exposure. Simply put, the law states that the farther a light source is from the subject, the less light actually falls on the subject. Although this might seem self-evident, what is not is the amount of light drop-off as distance increases. If you double the distance from the subject, it seems common sense that the light level would be halved. Not so; the level is *quartered*. Conversely, bringing a light closer to the subject has the opposite and dramatic effect: halving the distance increases the light level on the subject by a factor of four.

Bear in mind that a light source is really emitting photons, which spread out radially from the source. The farther the subject is from the source, the fewer photons fall on that subject. A grue-

Quick-n-Dirty Exposure

Pro video camera lenses have an auto iris function. Simply using this function will often get the exposure close but will be inconsistent because of the varying components of the picture. A *practical* (a light source that appears on-screen) or a dark costume will cause the auto iris to under- or overexpose some shots.

To use the auto iris for a consistent, "quick" setting of exposure, use a photographic gray card. These cards, available at any photo supply store, reflect 18% of the light that falls on them and are the standard for "average" exposure.

Position the card so that the key light falls on it, and zoom in until the card fills the viewfinder. Activate the auto iris; usually, this has a momentary switch and a slide switch. Use the momentary switch and then revert to manual control so the auto function doesn't "hunt" when you move off the gray card.

Now set up your shot and take careful note of the zebra display to see if there are any hot spots that need to be eliminated.

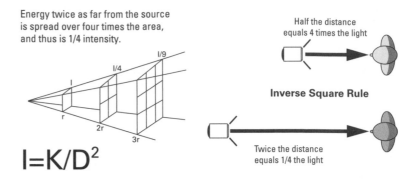

$$I=K/D^2$$

I = Intensity
K = Constant (Light output)
D= Distance

2.9 The inverse square rule indicates light level reduces by one-quarter when distance is doubled.

some but accurate parallel example is the shotgun. The shell has a set number of pellets; when fired, they begin to spread apart. If fired at close range, the effect is devastating because the subject receives the full impact of the entire load. As the distance to the target increases, the load spreads in a "shot pattern." Because the target does not increase in size, the farther away it is, the fewer pellets hit it because the pellets have spread apart.

Understanding this effect is very important in the placement of lights for proper exposure control

Controlling Color

Once you've managed the contrast range of the lighting and exposure issues, you still might have to wrestle with color issues. This is another problem overlooked by the amazingly adaptive eye, for although we think of light as being white, in fact light always has some color or tint in it, referred to as color "temperature." Another limitation of both film and video is that, unlike the eye, the camera can only perceive one color frequency as "white" at any given time. If your camera is set to the wrong color temperature, the scene might look blue or yellow or have a green cast to it.

Retrieve colorperception.pdf from the CMP Books ftp site (ftp://ftp.cmpbooks.com/pub/colorperception.pdf). The color renderings are fake, but they pretty well illustrate how the eye, as opposed to the camera, perceives mixed colors.

The Kelvin Scale

Color temperature is a concept that was first defined by William Thomson, Lord Kelvin (1824–1907). Thomson, an Irish-born physicist, wrote over 600 papers on the laws of motion and the dissipation of energy. He was knighted by Queen Victoria for his work on the electric motor and supervised the laying of the first transatlantic cable in 1866.

Lord Kelvin's name today is most associated with the Kelvin scale, a measure of molecular activity and energy emission. The Kelvin scale begins at absolute zero (i.e., 0 K = –273.16°C), the temperature at which all molecular motion has theoretically ceased. It then describes a variety of natural phenomena as temperatures on this scale. Boiling water, for instance, is 373 K. The color emission temperatures are based on the apparent color of a black body (a material that absorbs all emissions) heated to various temperatures on the scale. A theoretical black body begins to radiate light as its temperature increases; it glows red at 3000 K, white at 5000 K, blue-white at 8000 K, and intense blue at 60,000 K.

True black bodies exist only in theory, so to be practical, think of a piece of iron in the hands of a blacksmith. As the iron is heated, it first begins to glow a dull red, then orange, then yellow, and finally a bluish-white. Each of these radiated colors is an accurate measure of the metal's physical temperature—the activity of its molecules. These color temperatures also refer to different wavelengths of light.

Interestingly, although you often hear it, it is incorrect to say "degrees Kelvin" or "3200 degrees" when referring to the Kelvin scale. Scientists use the term "degree" as a division of an artificially devised scale. Because the Kelvin scale is based entirely on natural phenomena, it is regarded as an "absolute" scale, and temperatures on it are simply identified as "Kelvin" or "K." The proper way to refer to the temperature of a quartz light is simply "3200 K."

Although it seems very complicated, color temperatures can be boiled down to a few shorthand notes. In film and television production, there are a few benchmark color temperatures and stan-

dard methods for converting between them. The principal two are photographic daylight (usually thought of as 5600 K) and tungsten, or quartz incandescent (3200 K). Right away, this is a fib because real daylight can vary from 2000 K at sunrise to 7000 K on an overcast day. But don't worry about that now.

If you've taken still pictures, you probably know that you have to pick the right type of film for indoor or outdoor use. Indoor film is referred to as "tungsten" balanced, and is designed to register white at around 3000 K. Outdoor film is referred to as "daylight" balanced and registers white at 5600 K. If you take a picture indoors with daylight film, everything looks yellowish-orange. Conversely, if you take a picture outdoors with tungsten film, everything has a bluish cast.

The same is true with a video camera. Although the human eye can see mixed color temperatures and register them all as white, the cameras can only pick one or the other. That's why the camera must have the proper *white balance* for the lighting situation. In other words, you have to "tell" the camera what temperature to use as white. Once you've told it that temperature by setting the white balance, you have to make sure that all the lights you use are in that same temperature range, or you have to do something to correct "off-temp" light sources.

In most cases, this is simple: you just use one type of lighting instrument—for instance, all quartz fresnels. In other cases, if it is necessary to mix different types of sources, you need to correct one or more of them using correction gels—more on this in Chapter 5, "Lighting Controls and Uses."

Although this sounds easy, and often is, you'll be astounded at the times that it proves complicated. It's easiest in a studio where you have full control, but when you're shooting in a factory or in an office where other activities must continue, you could be truly challenged. Sometimes in a real-world situation, you simply must live with a less-than-ideal situation and make the best of it. That's when you choose the compromise that will look the best.

Another issue related to color that you might run into is the CRI, or color rendering index. This is a calculated measurement of how accurately a given lamp "renders" colors. A theoretically perfect score is 100. A lamp with a high CRI (in the 90s) makes

colors look rich and deep, whereas a lamp with a much lower CRI makes the same colors in a set or costume seem washed-out and sickly. The index rating is a measure of the average appearance of eight standardized colors of intermediate saturation spread throughout the range of hues. Put another way, it measures what wavelengths are missing from a lamp when compared to a theoretically perfect light source.

CRI is an especially important rating for fluorescent tubes because they are often missing significant portions of the spectrum. Fluorescent tubes are a discontinuous light source that could be missing a chunk of red and have a huge spike in the green range. Because the Kelvin scale is based on the balanced radiation of a theoretical black body, it's technically incorrect to classify fluorescents on the Kelvin scale. Kelvin ratings for tubes with a low CRI are less meaningful. Tubes with a high CRI emit a more even spectrum, and the Kelvin rating is more meaningful.

The CRI of fluorescent tubes can range from the sublime to the ridiculous. The most common standard fluorescent tube found in offices and factories, the "cool white" bulb, has a CRI of about 62, which is very poor for video purposes. Colors will never look quite right under this light, no matter how many times you white balance. In contrast, a 3200 K tungsten halogen bulb has a CRI of 95. If you've ever videotaped in a parking lot lit by sodium vapor lights, you won't be surprised to find out that they have a CRI of about 25.

The CRI rating of fluorescent tubes is very important to how well they will work with a video camera. Some "warm white" tubes are actually worse than cool white, with a CRI of 55. Broad-spectrum "daylight" fluorescent tubes (manufactured for plant growth) are better, with a CRI of anywhere from 75 to 90, depending on the manufacturer. However, the tubes now made specifically for video and film by Kino Flo, Sylvania, and others have a CRI of 85 to 95, giving excellent color rendering.

Volts, Amps, and Watts

Before I go any further, I need to cover the basics of electricity, electrical loads, and managing power requirements. Lights are pretty hefty power users, so it's essential at least to understand the rudiments, even if you never intend to take apart a connector or touch a wire end. Basically, you need to have an idea of how many lights you can plug into what outlets without causing a fire or blowing breakers!

Several months ago, I had a conversation with one of the managers of a major lighting manufacturer. He related to me a phone call he had received from a customer who bought a 5000-watt (5K) fresnel and was complaining because he couldn't plug it into a normal household outlet! (If you're new to this, a 5K will pull about 45 amps—more than twice what a normal household circuit can supply.) "Used to be people knew what they were about," he moaned. "Now anybody with a credit card can get in the business, and you have to spoon-feed them."

This is more than a couple of older fellows reminiscing about the good old days. It's a reality. In the "old days" (only a few years back) almost everyone working in film or television had come up through apprenticeship or had attended a film school program. They had power management pounded into them as they came up, and they learned it well, or they didn't get any further. That's no longer the case. Digital video has opened up the world of film-making and democratized video production. And while that's good in one way, it's not so good in another. It means there are a

lot more folks bumbling around with equipment they don't know how to use properly. If you're new to some of this and don't know a volt from an amp, please take some extra time with this chapter. I don't want to make a meter-totin' electrician out of you, but I do want to make sure you can pursue your craft safely!

Calculations

The Electrical Nomenclature Table shows some basic terminology and abbreviations. Wattage is the usual measure of the power of a lighting instrument. Because many of the lights you will deal with are high-power units, a thousand watts is abbreviated to "K," which is the term the industry uses even though the proper abbreviation is "kW." A 300-watt light is referred to as a 300W unit; a 1000-watt fresnel might be called a 1000W unit, but more typically it is called a 1K, short for 1kW, or one kilowatt. Similarly, 2000- and 5000-watt units are referred to as a 2K and 5K units, respectively. Of course, in the convoluted parlance of the trade, they can also be called "Babies" and "Seniors," but I'll get into that later!

When you plug something into an outlet, the electrical power you use is measured two ways: in *voltage* and *amperage*. Voltage is a measurement most folks are familiar with. Normal household voltage in the United States is 110 to 120VAC. That's going to remain pretty much the norm for most lighting, except in those few large studio situations where 240V is laid in for very high powered lights.

Amperage is a measure of how much electricity is being consumed. A 100W household light bulb and a 1000W fresnel will both use 120V. But the first will "pull" less than 1A, and the second will pull 8.5A. Plug too many 1K fresnels into a single branch circuit, and they'll pull zero amps because you will have blown the circuit breaker and plunged the place into darkness.

Think of the flow of electricity as if it were the flow of water in a pipe. Voltage might be though of as the *pressure* that the water is under that pushes it through the pipe; amperage would be the *amount* of water that is flowing through the pipe. With a given water pressure, a tiny little garden hose can deliver a certain

Electrical Nomenclature

Voltage (volts)	V
Amperage (amps)	A
Wattage (watts)	W
Voltage alternating current (volts AC)	VAC

amount of water out of the nozzle in a specified period of time; a huge drainage pipe can deliver a lot more water during the same time period, even when the pressure is exactly the same.

You might have noticed already that the greater the wattage, the higher the amperage an instrument uses. In fact, wattage, amperage, and voltage are interrelated. Wattage is the product of the voltage multiplied by the amperage.

Volts × Amps = Watts

Of course, you can reverse this equation to find how many amps a particular wattage lamp will pull.

Amps = Watts ÷ Volts

This is really the more important formula for you to remember in the real world because you want to know how many 1K lights and 650W lights you can plug into a branch circuit without blowing up the place! DP Arledge Armenaki (*Howling V*, *Blackout*) uses a little mnemonic device to remember the formula: "My Aunt lives in West Virginia," or "My Aunt lives in W/V." Silly, but it works!

So here's a practical application: you have a 1K softbox as a key, a 650W fresnel as a backlight, and a 300W fresnel as fill light. Can you plug them into a single branch outlet that runs from a 20A breaker?

1000 + 650 + 300 = 1950W

1950W ÷ 120V = 16.25A

The answer is, "Yes, you can," provided nothing else is plugged in to the circuit. If you need a slash of light on the wall behind the subject, could you add another 650W to the circuit?

1000 + 650 + 300 + 650 = 2600W

2600W ÷ 120V = 21.7A

Blown breaker, darkness. The answer is, "No."

Of course, you probably don't want to haul out a calculator every time you plug a light in. So the quick-n-dirty approach is to use 100V instead of 110, 115, or 120V. This isn't right, but it makes the math easier (just move the decimal point).

$$2600W \div 100V = 26A$$

This is sometimes known as "paper amps" and is useful because of the safety margin it provides.

Determine the Load

As a quick rule of thumb, you can usually run a little over 2000W on a single 20A circuit. But how do you *know* if it's a 20A circuit or how many (and which!) outlets are on a given circuit?

The answer is not easy because it will vary from building to building. If you're shooting in an older home, you can easily run into already overloaded 15A circuits with an old fuse box. Even in public buildings, the power supply can be woefully outdated and overtaxed before you show up with your hot lights.

Most buildings constructed in the past 30 to 40 years have circuit breakers, typically supplying each branch of outlets with 20A. Older homes might still have limited service, meaning that the entire electrical supply to the house is rated for under 100A. Although that might sound like a lot, it's not if you start to include a couple of window air conditioners, an electric stove, and electric water heater in that 100A. If you like higher light levels for taping, it's not difficult to distribute your power load around various circuits and still have the main breaker blow when the water heater kicks in!

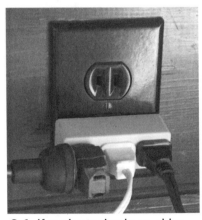

3.1 If you're taping in an older house and you see ungrounded and overloaded outlets like this one, be extra careful to distribute your power usage widely!

Ask to see the breaker box. You're in luck if the main breaker is rated at 200A or if there are two 100A breakers. See if the breakers are labeled. Odds are, they're not, or they are labeled in a code decipherable only to the strange fellow that owned the house 20 years ago. If they are labeled in plain, easy-to-understand English, you're in luck! Just keep your eyes open, because Murphy's Law (the only constant in video production) will bite you somewhere else down the line!

In a public building, you'll find much higher service and you are more likely to find well-labeled breakers. Typically, outlets in a circuit are grouped together along a wall (in a larger room with several circuits) or by the room. Jot down the appropriate breaker labels to help jog your memory while setting up lights. Bring enough stingers (extension cords) to allow you to run power from adjacent rooms easily.

It's not unusual to run two lights from the outlets in the room you're shooting in, two lights from the next room, and a light from two doors down the hall.

Take a look at a real-world example. You're called on to video-tape a lecture at a local civic center. You scout the location and find the breaker box. Hallelujah, the breakers are labeled—and in English, yet! You jot down the labels of the pertinent breakers, which are labeled MtgRm N Wall, MtgRm W Wall, and MtgRm S Wall. This is a wonderful situation because you will have 60A available in the same room, and an easy way to tell which outlets are on what circuit. You can easily distribute your lights around the room

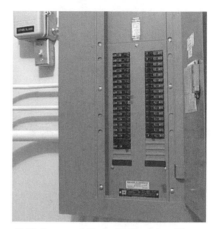

3.2 In a public building, you'll find much higher service, and you are more likely to find well-labeled breakers.

No, that's not Emeril cranking it up a notch. That's the breaker blowing because some electrician's assistant 15 years ago thought it would be easy to run the outlet for the refrigerator in the meeting hall kitchenette off that south wall circuit. Sorry.

OK, so you pull a couple of lights off the south wall and run them over to the north wall, where you are now running a 1K Tota Light (bounced off the ceiling for fill on the audience), a 650W fresnel for fill on the speaker, and a 500W Omni to illuminate the conference banner behind the speaker. That's 2150W, or about 18A. You run the lights for a while to test. Everything seems fine, until halfway through the lecture when the speaker turns on an overhead projector

A 1000W overhead projector was plugged into the east wall, a wall with a couple of outlets that are actually on the north wall circuit. Not only did you ruin the video, you ruined the celebrity guest's lecture. Your name is mud, and they'll never hire you again.

I'm trying to make the point that you must never get overconfident in a building you're not completely familiar with. You'll run into amazing surprises, curious fudges, and even illegal workarounds. Don't ever put full faith in breaker labels. Distribute power needs conservatively. Bear in mind anything else electrical that might come on while you're shooting: projectors, refrigerators, prototypes of miniature hand-held weather control devices the speaker is demonstrating—hey, you never know! Ask! Ask again! Because (trust me on this one) if you blow a breaker at a critical moment, *you* will be the one blamed.

It's a good idea to turn on all your lights early and let them run for a while. That way, if any circuit is overtaxed, the breaker will blow before the actual shoot, and you'll have a chance to redistribute the stingers. Bear in mind that the strongest instrument you can typically use in a normal household 15A Edison plug is a 1200W. In a 20A outlet, you can use a 2K HMI.

If you're shooting in a private home, distribute the load to different rooms. Just as public buildings typically use one circuit per wall, homes often use a single circuit per room, so run a stinger to the bathroom and another one to the kitchen. Run one out back to the garage, if necessary!

Fortunately, as cameras have gotten more and more sensitive, lighting requirements have dropped dramatically. Where once 1K and 2K fresnels were basic requirements, today I typically use an Arri kit with two 650W fresnels and a 300W fresnel for location interviews. Many shooters are using even lower wattages. The innovation of fluorescent lights has changed the power load picture as well because they typically draw less than half the power as an incandescent light for the same light output. Innovations with LED arrays are down the road that could spell even lower power demands for location taping.

Life is not quite so tough in the studio, where I hope you have laid on adequate power and, perhaps, even have a lighting grid and control panel.

Standard Service

Before I get into the complexities of connectors, I'll spend a moment on how electrical service is typically fed into a building, especially the relationship between 240V service and how it is used as 120V at most outlets.

The service to a house or building is typically from a pole-mounted transformer that steps the transmission line voltage (perhaps 34,000V) down to 240V (Figure 3.3). This is fed into the service panel via three wires: two black and one white. The two black wires are the extreme poles of the transformer and measure 240V on a voltmeter. These are the "hot" wires. The third white wire is known as the "common" or "neutral." This is the center tap of the transformer, where the voltage is zero. If you connect a voltmeter between either of the two black wires and the white wire, it will read 120V. A fourth wire, the ground, is a bare copper wire that is generally connected to a long, heavy spike driven into the ground or a metal water supply pipe—hence the term "ground," since it literally connects to the ground around the building. In Britain, this is called the "earth" for the same obvious reason. The ground is a safety valve that provides an easy drain for power if something shorts in an appliance. The outer body (case) of the appliance is connected to the ground; if something inside shorts to the case, the voltage will run to the ground more easily than running through *you*.

The standard household outlet uses one "side" of the 240VAC supply by connecting one of the black wires to the hot terminal and the white wire to the neutral terminal. This supplies 120VAC to that outlet. Every household outlet is required by law to have a ground connection as well. High-power appliances such as electric clothes dryers or electric stoves use 240V by using both black wires.

Remember the formula for wattage, voltage, and amperage? If you use a 240V supply (doubling the voltage) you will halve the required amperage to produce the same wattage. A 1000W light for the European market only pulls a little over 4A at 240V, whereas a 1000W light designed for 120V will pull about 8.5A.

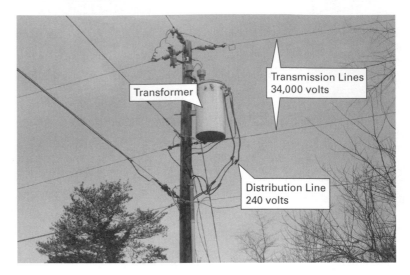

3.3 The line transformer steps down voltage from the transmission lines to 240V.

While I'm on the subject, lamps (or globes) are designed for specific voltages and won't perform right on the wrong voltage. Using a 240V globe on 120V will produce a dim orange glow. Using a 120V globe on 240V will produce another

of a pretty spectacular—and dangerous—variety.

Standard Connectors

All your 120V appliances, computers, and (of course) video lights use the standard three-prong connector. This connector is rated for 15A of load, so it is typically found on any light up to about 1500W. But what about more powerful lights that, like electric clothes dryers, require a different connector—one that is rated to bear the heavier load and is configured in such a way that you cannot accidentally plug it into a lower-rated outlet? Also, different voltages have different configurations, and different countries use different connectors. Add to this the specialized connectors developed for stage and industrial use, and you'll just about go nuts!

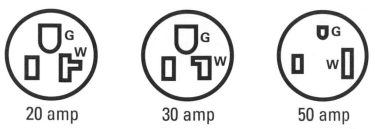

20 amp 30 amp 50 amp

3.4 Heavy-load connectors.

Fortunately, the real world isn't that complex. Only a few connectors are used routinely in the United States, and I'll deal with international connectors and adapters separately.

The basic specifications for electrical connectors are set by NEMA, the National Electrical Manufacturer's Association. The basic, common connector is rated for 125V, 15A. It plugs into the standard household outlet, and has three connectors: hot, neutral, and ground. The hot or "live" connector runs from one of the black wires in the service panel. The neutral (sometimes called "common") connector is run from the white center-tap wire. The ground is connected to that bare copper wire that ties into the earth somewhere, usually through a water pipe or ground spike. The plug can only be inserted in the socket one way because of the orientation of the ground pin, but even ungrounded twin-blade plugs will only insert one way because the socket is *polarized*; that is, one blade is slightly wider than the other. This configuration guarantees that the hot wire is disconnected with an appliance On/Off switch rather than the neutral wire.

Figure 3.4 shows several connectors for heavier loads: a 20A connector, which could be used on a 2K fresnel; a 30A connector, which carries 3000W safely; and a 50A connector, which could power a 5000W Molequartz 14-inch Senior Solarspot.

Please note that not just the connector, but the entire circuit from the service box—breaker, wire, and connector—must be rated for the heavier load.

NEMA-standard straight blade connectors are not the only types you will see in television and video work. Stage lights—and very often studio lighting grids—use a specialized curved-blade plug and socket that locks in place with a twist. These are known as NEMA locking connectors (Figure 3.6). One of the best known

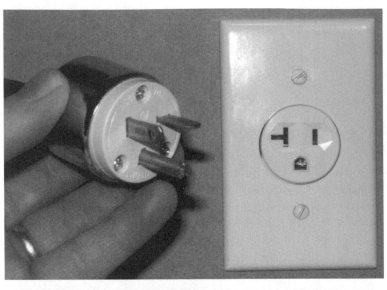

3.5 A 20A socket and connector. Note that although a 15A connector will fit into the 20A socket, the 20A connector's horizontal blade prevents accidentally plugging it into a 15A socket.

3.6 Leviton Black & White NEMA L5-15 locking connector.

brands is the Twist-Lock®, a standard feature of stage lighting systems. Twist-Lock is a trademark of the Hubbell company; other manufacturers have their own line of locking connectors as well, such as Leviton's Black & White connectors. The obvious advantage to these connectors is that they will not accidentally pull out during shooting, as straight-blade connectors have a habit of doing. Locking connectors are available both for wall and chassis mount (as a wall outlet) or male and female in-line connectors (as line cord plugs and extension ends).

On larger sets, especially where higher wattage units are in use, you might also see the Bates connector (Figure 3.7), a flat-pinned in-line connector that is available in 20, 60, and 100A ratings.

3.7 Bates connector available in 20, 60, and 100A ratings. Courtesy Mole–Richardson Corp.

In video and television work, it's common to use stingers to run power to lights, rather than plugging the light directly into the wall outlet. Just as the wiring, the breaker, and the connector in an installed wall outlet must be the proper rating, so too the stinger must be heavy enough to bear the current that passes through it. Here, it is not just the amperage but also the distance—the length of the extension cord (or cords)—that is important. Because voltage loss over a long cable translates into an equivalent higher amperage, you can't just look at the rating on the cheapest 25-foot cord at the hardware store, daisy-chain five of them together, and power lights close to the rated capacity.

Electrical wiring is rated by physical diameter, or "gauge." The American Wire Gauge (AWG) chart, also sometimes referred to as the Brown & Sharp or "B&S" gauge chart, is used in the United States and many other countries. For instance, 12AWG is 0.808 inches, or $^5/_{62}$ inch in diameter. The English system, Imperial Standard Wire Gauge (often abbreviated SWG) is used in some European countries, whereas others use a metric scale. Metric gauge is determined by the area (in millimeters) of the cross section of the wire. Of course, the only measurement system that makes any sense here is the metric system, but it won't be used in the United States until long after full implementation of campaign finance reform, the 100% adoption of DTV by the marketplace, and the freezing over of—well, you get the idea!

Extension cords used for video and television typically are 14 or 12 gauge. Stay away from the bargain basement 16-gauge cable for any but the lightest work—practicals or small fills, for instance. For location video work where you use a kit of four or five lights, none of which exceed 1000W, you can probably get away with using 25- or 50-foot 14-gauge cables. For anything

	Amperage		
Cord Length	10A	12 A	15A
25'	16 ga.	14 ga.	14 ga.
50'	14	14	12
100'	12	12	10
150'	12	10	8
200'	10	8	—

Table 3.1 Amperage ratings for different lengths and gauges of extension cords.

more substantial, or where you are likely to have cable runs longer that 50 feet, please get 12-gauge cables. This is even more important if you are shooting outdoors and using a generator. In that case, you will want to use 10-gauge cable. These are often sold as "contractor" cables. For cable runs exceeding 250 to 300 feet, a very heavy 8-gauge cable might be called for. Just bring some really hefty guys to carry them and make sure you have a deep budget because 8-gauge cables cost as much as they weigh!

On a pro video or film set, where long runs and high-wattage instruments are common, it is typical to use only 12-gauge stingers. I know one gaffer who often cuts 14-gauge stingers in half and dumps them in the nearest trash bin when he comes across them on a film set. "I just want to make sure they don't show up again," he says with a smile.

So what happens when there isn't enough power, or worse, there's no power at all? This isn't unusual in location dramatic work. If there is power near the shoot, but insufficient distribution, then you can call an electrician to do a temporary "tie-in." This will provide you with a full 200A supply for your lights. Be sure to have this done by a licensed electrician who knows local rules. In some cases, a special permit is necessary.

But that doesn't solve the no-power scenario. What happens out in the woods, or in a deserted field, where the nearest power line is thousands of feet—or even miles—away? Although smaller shoots can use battery-powered 12V instruments, most circumstances are going to call for a generator. Noisy ones like those contractors use are easily available in nearly any community. You

can use these in situations where sound is not an issue, but they are very difficult to use when recording sync sound. Special sound-attenuated generators are available for film and television use; they're more expensive to rent but worth it.

Lighting Instruments

A variety of lighting instruments are used in film, video, and television. They are the basic tools of the trade and range in complexity and cost from the simple and inexpensive to the complex and pricey.

First, I want to introduce a bit of terminology you will run into. The historical theatre term for any lighting instrument is *luminaire*, from the French term for what we would call a luminary. Many companies still use this term, although it's not common to hear an American lighting gaffer asking for a Mole 1K by saying, "Hand *moi* that *luminaire de bébé, s'il vous plaît*. It's more likely to be "Gimme dat Baby, OK?"

Also, some folks are very averse to calling quartz halogen bulbs "bulbs." In the trade, glass bulbs or tubes with a tungsten filament inside are known as "globes." A theatrical lighting designer once told me, "If it costs less than 10 bucks, it's a bulb. If it costs more than 10 bucks, it's a globe." It's an artificial distinction if ever there was one, but in a jargon-ridden industry that refers to clothespins as "C-47s" and extension cords as "stingers," you need to know what everyone else is talking about!

Lighting instruments fall into a few basic categories: open faced, lensed, fluorescents, HMI and arc lights, softlights, and specialty instruments. I'll look at each of these in turn, and look at examples of each category. *Please don't assume that this is a comprehensive catalog of every available model from a manufacturer or that I cover all manufacturers.*

Open-faced Instruments

The most basic lighting instruments are the open-faced units, being some variation of a simple bulb and reflector. The simplest (and least expensive) of these is the photoflood reflector (Figure 4.1). These are available at any photo supply store, are inexpensive, and create the right temperature of light. A 500W, 3200 K photoflood bulb, for instance, sells for under $5.00, and a clamp-on reflector costs less than $10.00. The downside is that the reflector doesn't provide any method of control and the bulbs don't last very long. That 500W bulb will only last an average of 60 hours, compared to 1500 hours for a regular household bulb and 2000 hours for a quartz tungsten bulb. They are fine until they go "POP" at the most awkward moment of an interview.

The professional television version of the photoflood and reflector is known as a scoop, mainly because that's usually what they look like. Scoops can be either focusing or nonfocusing but are primarily large spun-aluminum reflectors with a large quartz globe. They project a large, soft-edged beam and are excellent for fill light or broad-area lighting.

A step up the scale would be something like the Smith–Victor 700SG or Q60-SGL. These are also simple spun reflectors, but they use the more reliable quartz bulbs and offer mounting for barn doors or other controls. Some offer basic focusing ability, although the light spread will show some unevenness. They are perfectly satisfactory entry-level units, and a set of three could get

4.1 A standard photoflood is inexpensive but has a short bulb life.

you started—and maybe keep you going for a long time for basic work. An open-faced instrument allows focusing through the simple expedient of moving the bulb backward and forward in the reflector (Figure 4.2). When positioned toward the front, the unit throws a wide beam; when positioned more toward the rear, the reflector gathers the beam into a tighter pattern. Most simple reflector units will show variations in the light pattern (especially at wide beam) because the bulb itself disrupts the light pattern at center. This effect can be mitigated through careful engineering of larger reflectors, so higher end open-faced units will have a much more even light pattern than lower priced units. However, even the best unit will have an uneven pattern when compared to a fresnel. Many open-faced units also cast a slight double edge to shadows, so they might not be best for lighting facial close-ups unless you use some diffusion. They are very useful for lighting sets and backgrounds.

4.2 An open-faced instrument depends on a reflector to focus the beam.

Lowel makes a wide variety of very good open-faced instruments. Their basic unit is the Iota Light (Figure 4.3), a simple folding V-shaped reflector with a quartz tube. This type of lighting instrument is known in the trade as a "broad," for reasons that should be self-evident: they blast light all over the place in a very broad pattern. These are the sledgehammer of the lighting industry — not much subtlety but handy for the intended purpose! They do make excellent light sources for use inside softbanks like the Chimera and are wonderful for bounced fill light.

A more refined unit is the Lowel Omni Light (Figure 4.3), a classic focusing reflector. This is lightweight, folds up small, and takes bulbs up to 750W. Twelve-volt bulbs are available, as well, so the Omnis can be used in the field with battery power.

The larger and slightly more flexible Lowel DP Light is very popular because it allows you to use a range of bulbs up to 1000W. The larger reflector lets the unit throw a more even light pattern than the smaller Omni, and it shares the same type of clever fold-out "ears" that create a big, trapezoidal barn door that provides excellent control. Interchangeable reflectors allow for a long-throw spot configuration. The pattern of the standard peened

4.3 The Lowel Tota-Lite *(left)* and the more controllable Omni Light *(right).*

reflector provides a more even distribution of light at full flood than the smaller Omni.

A step up the pricing scale is the Ianero/Strand Redhead 650W and 1000W, which are open-faced units extremely popular in Europe but less common in the United States. I've never been able to figure out why this is, because the Redhead (and the heftier 2000W Blonde) are very nice instruments that have a very even light pattern.

Arri makes a similar and quite excellent open-faced instrument called the Arrilite, which is available in 600, 650, 1000, and 2000W configurations. This is a substantially more expensive

Ross Lowell

Cinematographer Ross Lowell began experimenting with small, simple lights for location photography. He began the Lowel Light company in 1959 out of his home. His lights were designed to be small, lightweight, and inexpensive, especially when compared with the full-blown studio lighting most of his contemporaries were using. Ideas such as collapsible barn doors and other design innovations have resulted in an Academy Award technical certificate, a SMPTE John Grierson Gold Medal, and over 20 U.S. patents.

In his classic book *Matters of Light and Depth* (Broad Street Books, Philadelphia), Ross Lowell wrote, "It is all too easy to confuse effects with effective lighting, startling images with unforgettable ones, quantity of footcandles with quality of light."

instrument than the Lowel DP Light, but it is a durable professional unit with an extremely smooth light pattern.

Other examples of open-faced lights generally fall into the broads and "cyc" (cyclorama) categories. These lights are designed to blast light in a wide, even pattern to evenly light a large area. Nearly every manufacturer makes some version of these in various power categories. Like the smaller Lowel Tota Light, they are mostly simple V-shaped or curved reflectors with one or more double-ended quartz tubes. Cycs are specially designed to illuminate cyclorama backgrounds evenly. Examples would be the Strand Iris or the Altman Sky-Cyc. Both units can be ganged up with two, three, or four units in a single assembly.

Lensed Instruments

Lensed instruments have a beam that is focused by a glass lens rather than a reflector. Usually, a reflector of some sort is used as well, but it usually only plays a minor role in focusing the beam (as in the fresnel or followspot) or works significantly with the lens as part of the optical design (as in the ellipsoidal or PAR can).

The primary workhorse of theatre, film, and video lighting is the fresnel (pronounced fruh-nel). This is named after the uniquely efficient stepped lens that it uses, which is very lightweight but has strong focusing power. Fresnels are available from nearly every manufacturer in sizes ranging from tiny units like the 100W, 2-inch LTM Pepper to the gigantic 24-inch Mole Solarspot that

4.4 The Strand Redhead and the Arrilite are examples of higher end open-faced instruments.

Augustin Jean Fresnel

The fresnel lens is named in honor of its inventor, French physicist Augustin Jean Fresnel (1788–1827). He studied the behavior of light refracted through prisms and worked out a number of formulas to describe refraction through multiple prisms. His theories form the basis of modern optics. He finally designed a lens composed of circular graduated prisms that act together to focus light into a narrow beam. The prototype was a masterwork of one of the most advanced glassmakers of the day, Francois Soleil Sr. It was installed in the Cardovan Tower lighthouse on France's Gironde River in 1822. One contemporary engineer commented on the achievement: "I know of no work of art more beautifully creditable to the boldness, ardor, intelligence, and zeal of the artist."

pumps out 10,000W. Fresnels have found huge acceptance because of their control and flexibility.

The most common fresnels in television work used to be 1K and 2K units, often referred to by gaffers as a Baby and a Junior. These designations come from the Mole–Richardson line of lights and refer to the physical size of the unit. Their 5K unit is known as the Senior. The smaller 650W unit is known as a Tweenie. Mole has always been known for these somewhat quirky names, usually freely mixing the Mole brand name in somehow: the Molescent, the Molefay, or the Molegator. You ought to be familiar with these names, since it's pretty common to hear gaffers talk about putting "a Junior here and a Baby over there as kicker."

As cameras have become more sensitive, the light levels necessary have decreased, and with them, the power demands. Today, it's more common to see an entire lighting kit for location work comprise 500, 650, and 1000W units. You'll find the full range of lights on a well-equipped lighting truck, but it's rare to see anyone toting around a Junior or a Senior for location interview work. It's not only size, but power requirements. A Junior 2K can technically run off a single breaker in most buildings, but they exceed the power rating of the branch circuit and typical outlet. A Senior 5K requires a dedicated 50A line, which is very uncommon in most buildings except for special installations. Besides, a 1200W HMI will pump out as much light as a 5K quartz fresnel without making unusual demands for power. And that isn't considering the huge amount of heat generated by the power-guzzling brutes. These larger quartz fresnels are mainly found on sound stages these days.

Arri sells a very popular stock lighting kit that includes two 650W fresnels and a 300W fresnel. This is sufficient as a base kit for lots of location video situations. Many shooters use even less light; the popular LTM Blue Pepper Pak includes two 200W fresnels and one 100W fresnel.

Fresnels are not the only type of lensed instrument, of course. Another category, more commonly used in theatre than in television and video, is the ellipsoidal, or Leko. This light is named for the shape of the carefully designed ellipsoidal reflector, which pre-focuses the light before it reaches the smooth, plano-convex lens.

The result is a sharp, projectorlike beam with a very even light distribution. In fact, the ellipsoidal actually functions like a slide projector. Cutout patterns—or even laser-etched glass slides—can be inserted in the body to project a sharp pattern. In fact, this is the most frequent use for ellipsoidals in video and television production, rather than general subject lighting. In the theatre, ellipsoidals are used often from the ceiling above the audience because of their long throws.

A truly unique lensed instrument that has become hugely popular is the Dedolight. Although on the pricey side, location shooters love Dedolights because of their small size and beautifully even light throw. Invented by German DP Dedo Weigert, the Dedolight uses two lenses: a small meniscus lens to prefocus the light and a plano-convex lens as the main objective. The results are somewhat similar to the ellipsoidal because both use a more sophisticated focus system than do simple single-lens instruments. The difference is that the ellipsoidal does the prefocus stage with a reflector, whereas the Dedolight does it with a second lens. Julio Macat (*Home Alone, Ace Ventura, The Nutty Professor*) is one DP that frequently uses a Dedolight as an eye light.

A very large category of lensed instrument is the PAR (parabolic aluminized reflector). Everyone is familiar with this instrument in some form. Auto headlights are PARs; so are the exterior floodlights you have outside your house, which are technically known

Note

The ellipsoidal fixture was introduced in 1933 by Joseph Levy and Edward Kook, cofounders of Century Lighting. Levy and Kook each gave half of their names to their new Lekolite or Leko. Not to be outdone, Kliegl Brothers introduced their ellipsoidal fixture known as the klieg light. Although all ellipsoidals are frequently called Lekos, this is a brand name owned by Strand Lighting and properly only refers to their ellipsoidal reflector instruments. Hand me a Kleenex®, please—oh, any tissue will do!

4.5 The ellipsoidal uses both a specially designed reflector and a plano-convex lens to project a sharply focused beam of light.

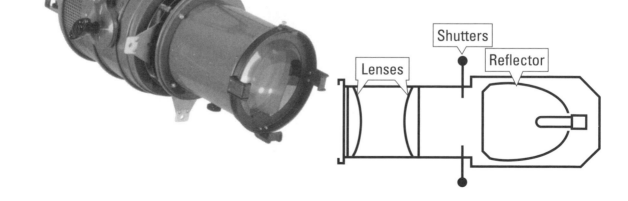

4.6 The Dedolight uses two lenses to project a sharply focused beam of light.

4.7 The ETC Source Four PAR EA throws as much light as a typical 1K PAR but only consumes 575W.

as PAR34s. The standard PAR bulbs for theatrical or video lighting are PAR56 (7-inch) and PAR64 (8-inch). The PAR is an encapsulated unit with lens, reflector, and globe molded into a single piece. PAR bulbs typically look like old round auto headlights and are usually mounted in a simple metal fixture known as a PAR can. They are hugely popular for live concerts and dance shows because they are cheap and durable. They also have a wide variety of characteristics. PARs can be designed as floods, spots, long-throw spots with oval patterns, and just about anything in between. Because the bulbs are fairly inexpensive, it's easy to keep an assortment of throw patterns on hand for different applications.

It should be clearly understood that PAR is a *configuration* rather than a particular type of globe. The basic PAR bulb is a one-piece molded unit with a quartz halogen globe enclosed. However, many HMIs (more on these later) are configured as modular PARs.

Many companies have begun to produce modular PARs that can use either quartz and HMI globes. A modular unit is not molded together but is a system where a set of interchangeable lenses and reflectors snap together with a replaceable globe.

Electronic Theatre Controls (ETC) has recently brought out a very efficient series of modular PAR bulbs that has a lot of gaffers excited. Their Source Four series uses a new modular PAR with a 575W HPL lamp that puts out about the same amount of light as a traditional 1000W PAR64. Maybe this doesn't get you excited, but think back to power management (Chapter 3). If you have to light a large set and you have a limited amount of power available, these units allow you to use half again as many instruments for the same power load. In some cases, this can be a lifesaver, and that's why some gaffers have become almost evangelical about the ETC 575W HPL lamps.

For film productions, especially outdoors, PAR bulbs are ganged together into lighting arrays. These can include anywhere from six to 36 bulbs arranged in an adjustable pattern. This allows the array to be focused for a specific distance. By their very nature (multiple sources spread over an area), arrays create a somewhat soft source. In fact, some early 3D animation programs used digi-

tal light arrays to simulate soft shadows. Arrays behind a large silk diffusion frame creates a gigantic and really, really bright soft source. If you're in a jam and you need a 6-foot by 12-foot light source that puts out 36,000W, use a huge array! Just make sure you have a 300A connection handy.

When daylight balance is necessary, a special PAR globe with a dichroic filter known as the FAY is used.

Fluorescent Instruments

A hugely popular—and relatively new—addition to this list of lighting equipment are fluorescent instruments. Not too long ago fluorescents and television were like oil and water—they didn't mix. The common cool white tubes gave everyone a sickly greenish cast that the cameras couldn't get rid of, and the light often seemed to pulse on tape. The effect was even worse on film. Mention the word "fluorescent" to a DP and you would likely produce a gibbering hysteria or an explosive outburst. That was until the late 80s, when high-frequency ballasts and color balanced tubes were introduced by Kino Flo.

4.8 John Alonzo, ASC, aims the Kino Flo four-lamp Diva-Lite. Photo courtesy of Kino Flo.

Today, just about every lighting manufacturer has a line of fluorescent instruments—some pretty straightforward and others quite innovative. A good example is the Kino Flo four-lamp Diva-Lite, which consists of a bank of color-balanced tubes operated by a dimmable ballast. These are fixed in a case that mounts easily on a C-stand arm.

Fluorescents are the definition of a soft, diffuse light that radiates in all directions. Like all diffused light, they have a relatively short effective throw and thus are best used close to the subject. Since the development of color-balanced tubes, most of the earlier objections to fluorescents for film and video work have melted away. "Flos" have become hugely popular in the lighting trade for a variety of reasons. Foremost are the lower power requirements (fluorescents typically consume a little more than half the power to produce the same light output as incandescent bulbs)

and the cooler operating temperatures (incandescent lights throw off a *lot* of heat).

Although power consumption might not be a major factor for a location videographer, it is huge for television studios, where the power bill makes up a major portion of their operating expense. In addition, the heat buildup from incandescent lights is substantial. Incandescent lamps are typically about 10% efficient, which means that almost 90% of the electrical energy is converted to heat rather than light. This means the studio must install a substantially larger air conditioning system, another energy hog. Installing fluorescent set lighting can result in a major cost savings for a studio. Additionally, fluorescents can now be dimmed through most of their range without an appreciable change in color, unlike tungsten filament bulbs, which shift dramatically toward orange as they are dimmed.

Fluorescents Come to Hollywood

In 1987, while working on the film *Barfly*, DP Robby Mueller was shooting in a cramped interior with a wide lens. He didn't have the space to rig conventional set lighting. Frieder Hochheim (his gaffer) and Gary Swink (his best boy) came up with an answer. They established a base light with incandescent practicals and HMIs through windows. For fill and accent lighting, they constructed high-frequency fluorescent lights with "daylight" tubes. Through the innovation of remote ballasts, Hochheim and Swink were able to tape the tubes in nooks in the walls, behind drapes, and behind the bar. A new class of film lighting was born, and the Kino Flo Company was started. In the early 1990s, Kino Flo began manufacturing their own precisely color-matched tubes that could output 3200 K and 5600 K. Their TrueMatch™ instruments received an Academy Award.

The new, cool, energy-efficient lights were a huge hit. They could be used as key and eye lights, and produced a very soft, diffused light. When moved off-axis, Kino Flos eliminated boom and mic shadows. Unlike standard fluorescents, their ballasts were quiet, and the light was flicker-free without any greenish cast. Tubes could be swapped for different color temperatures.

4.9 The Videssence Baselight B117339BX is a grid hung studio fluorescent instrument.

If fluorescents can save so much money, why is anybody still using quartz fresnels? Fluorescents do have a few disadvantages. First, they can't throw hard light. Most situations still require some hard light for accents and highlights. Even Videssence, a company built on fluorescent instruments, makes a fresnel they call the ShadowCaster specifically for hard point and spot lighting. Second, they are virtually useless from any distance; don't try to light a speaker from 50 feet with flos. Finally, they are big and bulky to transport. If you're flying somewhere, a Lowel Rifa-Lite and stand will fit in the overhead bin a lot better than a Videssence KoldLite.

The portability issue is changing, however, with the introduction of fluorescent instruments designed specifically for easy transport. Lowel recently came out with an instrument called the Case-Lite, a fluorescent instrument built into a flight-ready case with barn doors that serve as the locking cover of the case. Kino Flo has a series called the Diva-Lite, which is also designed for portability and easy setup. The Diva-Lite still requires an external case for transport, however.

4.10 The Gyoury Light System uses light wands that snap into various holders.

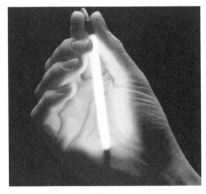

4.11 Kino Flo T2.

The flexibility of fluorescents is also changing. Where early flos were often big, ponderous metal cases designed for permanent mounting on a studio grid, many innovations have been made that make fluorescents useful in a wider variety of situations. The use of remote ballasts started by Kino Flo made innovative set installations possible. Remote dimmable ballast, working either off an analog voltage or DMX (digital multiplexing), have made remote control on sets easier. Smaller ballasts running a single- or dual-tube design have made easy-to-mount and easy-to-move light "wands" possible. Videssence's Modular series is a good example of a wand that can be used singly or snapped together into a bank.

DP Chris Gyoury came up with his own version of the light wand for Alton Brown's *Good Eats* series on The Food Network. The Gyoury System is a separate dimmable ballast with remote wands that can be clamped to stands, furniture, or set pieces or mounted in a more traditional reflector. Each wand uses a 55W Osram Sylvania high-output single-ended tube.

The tiny 4-inch, 2W Kino Flo KF32 T2 bulb is also an innovation that has opened up many possibilities. These are used in car dashboards and other situations where a tiny, easily hidden soft light source is needed. It's my understanding that a certain aging national news anchor has these concealed in the front edge of his news desk, the soft light from below massaging out his wrinkles!

Although fluorescent systems have proliferated and some have clear functional advantages for certain situations, it's very difficult to pronounce one line of flos as the "best." Variables such as portability, dimming requirements (local, analog, or DMX), and other factors must all be considered for a particular usage. Although high-frequency ballasts are essential for film, they are not for video at stock shutter speeds (shutter Off in most cameras).

One factor of overwhelming importance, however, is the color rendering index (CRI) of the tubes that you are using. Tubes with a low CRI (less than 85) will never look right. Tubes manufactured specifically for use in video and film (with a CRI of 90 to 95) will always render color better than consumer tubes.

HMI Instruments

HMI (hydrargyrum medium-arc iodide) lights are the modern and more portable version of the old carbon arc light and are valued because they throw off a very high light level at the same color temperature as sunlight. HMIs have also grown in popularity over the last few years. Don't try to remember what HMI stands for. I can't even pronounce it the same way twice in a row. HMIs are arc lights contained in a sealed capsule.

In my callow youth, I had the job of running a large open carbon arc to expose industrial screen-printing emulsions. Anyone who has ever had the messy and inconvenient thrill of running a traditional arc light knows how much fun they are. They make a huge noise, they throw a pall of white ash all over the place, and it seems as if you have to replace the electrodes every 15 minutes. Okay, I exaggerate. Today, one of the few places you'll see real carbon arcs in use are those gigantic spotlights that mark supermarket openings. Having personally operated one of the old arc lights, I can't convey to you young whippersnappers exactly how delightfully dandy HMIs are. Plug 'em in—Bang!—beautiful bluish-white light; no white ash, no electrodes to replace, no fiddly adjustments. Perhaps you've had the experience of watching a welder at work or even used an electric welder yourself. This is exactly the same way that an arc light—or an HMI—works. Mole–Richardson still makes a genuine carbon arc unit, the Brute Molearc, that puts out about three times the lumens of their similarly sized 10K (Tener) Solarspot. To put this in perspective, however, the much smaller 6K HMI MolePar puts out about the same amount of light while consuming about one-third the electrical power.

Just like arc lights, HMIs must run off a special power supply known as a ballast. Similar to the ballast of an electric welder or a fluorescent light, the major role of the ballast is to limit the amperage that runs through the arc. Ballasts also output the correct voltage for a particular HMI globe and include special circuitry to "strike" or start the arc. These ballasts have gotten much smaller and lighter of late, too. Some even run off batteries. Just as with fluorescents, there are two types of ballasts: the less expensive magnetic ballasts (which can cause flicker problems for

4.12 The K5600 Joker-Bug 800 HMI kit.

film) and the more expensive and efficient electronic square-wave ballast (known as flicker-free ballasts). Both are acceptable for video when shutter speed is set to $^1/_{60}$.

The advantage of HMIs is that they generate a very pure, intense white light that closely matches the quality of sunlight. They are available in a huge variety of sizes and wattages, ranging from the tiny Joker-Bug 150 to behemoths like the LTM Super 12/18KW HMI with its 24-inch fresnel lens. They are available in open-faced PAR configurations with interchangeable lenses, like the De Sisti Remingtons or, as more traditional fresnels, like the Mole HMI Solarspots. Portable HMI kits usually consist of a single instrument with fitted case, power supply, stand, and accessories.

The Limelight and the Arc Light

You've heard the expression "being in the limelight?" It was an old expression for being center stage in the spotlight and derived from the first effective spotlights in the theater, limelights. The limelight was invented in 1803 by Thomas Drummond (1797–1840), who discovered that when a piece of lime (calcium carbonate) is heated with an oxygen/hydrogen flame, it fluoresces with an incredibly intense greenish-white light. The Drummond Light made the first ordnance survey of Britain possible, acting as an objective that surveyors could see through fog. It was then adapted to lighthouses and theatre uses. The Chestnut Street Theatre in Philadelphia was the first to use limelight in a production in 1816. Unfortunately, the Chestnut Street burned to the ground in 1820, perhaps because of all the gaslights and limelights.

The first arc light was demonstrated by British physicist Humphry Davy (1778–1829) in 1810. By using two sharp points of carbon connected to the poles of a primitive but powerful battery of 2000 cells, he could cause the electrical charge to arc between the points, creating a startling white light. The carbon points burned away quickly, however, and it was difficult to maintain the precise distance needed to create the arc. It wasn't until 1846, when a practical clockwork mechanism was perfected to maintain the arc gap, that the first electric carbon arc was used in a production at the Paris Opera.

The HMI lamp (mercury medium-arc iodides), was developed by Osram GmbH to meet a condition established by the German Federal Television System in 1969. These metal halide lamps are basically small, self-contained arc lights. Originally designed for television lighting, they are now used for location film lighting and as a source for many theatrical followspots. The modern HMI lamp is highly efficient (100 to 110 lumens per watt) and produces a daylight spectrum with a color temperature of 5600 K. Lamp wattages currently range from 200W to more than 12,000W.

The H in HMI stands for mercury (Hg), M indicates presence of metals, and I refers to the addition of halogen components (iodide, bromide). HMI® is the registered trademark of Osram Lighting, now Osram/Sylvania. Pass the Kleenex® again, the term is now used as a generic designation.

Be aware that HMIs take a few minutes to reach full output. Before you measure light levels and set exposures, you need to let HMIs "burn in" to full intensity.

Softlights

Softlights are a broad category of lights designed to throw diffused light that creates soft-edged shadows and highlights. Softlights can be any light source, from quartz fresnels to HMI PARs to open-faced instruments. Fluorescents, of course, are softlights by their very nature. The "hard" light sources (such as a quartz globe in an open-faced instrument) are diffused either through a large piece of diffusion material or by bouncing the light off a special reflector. The Chimera Softbank and the Photoflex Silverdome are examples of diffusion-material softlights. They are basically simple mechanisms for mounting a large sheet of diffusion material in front of a hard light source. Of course, the same effect can be achieved (though less conveniently) by hanging a sheet of diffusion material from a C-stand arm and positioning it a couple of feet in front of a fresnel.

The other class of softlight uses some sort of matte white reflector or, in a few cases, a specially engineered silver reflector to bounce the light from a hard source. The most basic example of this is the photographer's white umbrella. One can achieve the same end — sometimes to greater effect—by simply bouncing a hard light off a piece of white foamcore held in a C-stand or by bouncing off a white wall. Umbrellas and bounce cards provide a very nice diffuse light source but provide zero control over the light.

The De Sisti Wyeth or the Mole Softlite are examples of white reflector instruments that provide higher control. These instruments use a quartz tube hidden inside the base of a large curved reflector that is painted matte white. They can use barn doors, snoots, and deep egg crates to control the light pattern quite effectively.

Most softlights—other than fluorescents—are very inefficient. The diffusion material in a fabric softbank eats up a lot of the light; bouncing off a matte white surface transmits less than half the light. When using incandescent globes, bear in mind that they are already only 10% efficient (90% of the electricity is converted

4.13 A simple Lowel Omni with umbrella creates very nice, diffuse light, but is difficult to control precisely. The Chimera Softbank is a popular softlight that is easier to control.

4.14 The Mole Softlite 750.

4.15 Light rays from a softbank radiate from a large area rather than from a single point.

to heat) and an additional bounce or diffusion eats up the light and reduces efficiency even more.

One issue that is important to understand in the use of softlights is the related effect of size and distance to the subject. Many people think that a smaller source like the relatively small Mole 750W Baby Softlite (Figure 4.14) will provide the same effect as a large Chimera. Nothing could be further from the facts. The physical size of the light source—either the diffusion panel or the reflector—has an important effect on the softness of the light. The larger the size, the softer the light. That's because instead of coming from a single point source, light is coming from the *entire surface* of the diffusion or reflector. In Figure 4.15 you can see an illustration of this effect. A large Chimera with a 52×72-inch diffusion will cast a much softer, more diffuse light than the 8×8-inch aperture of the Baby Softlite. The physical area of the light source is simply larger, so the photons originate from a wider range of angles. The large area has the same effect as an array of many, many point sources. Imagine that instead of a single 1K light source inside a softbank, you have mounted 100 small 10W bulbs on a 54×72-inch piece of plywood. Light coming from the spread of sources softens the edge of shadows and highlights and seems to wrap around the subject.

The other factor that affects the perceived softness of the light is distance from the subject. Remember the inverse square law in Chapter 2. It applies not only to light levels but to the effective perceived size of the light source. In other words, if you move the softlight twice as far away from the subject, the apparent size of the light source is cut to one-quarter the size from the original distance. For this reason, softlights are best used close to the subject. This is also true because the light falloff over distance is much more severe from a diffuse source than it is from a focused point source.

Specialty Instruments

A whole category of instruments have been constructed for specific uses or effects. Because gaffers are an inventive lot, this category is always changing. It includes arrays of tiny bulbs for auto dashboards, skylights to cast uniform illumination over cyclo-

ramas, even a "flying moon," a large diffusion unit that is hung from a crane to provide soft illumination resembling moonlight over a large area. Many of these are instruments you'll only run into on a full-blown theatrical film production. However, I'll mention a few that find common use in television work.

A "chicken coop" is an overhead cluster, usually using six mogul base globes in a metal reflector. These provide even overhead lighting, usually softened with a diffusion screen. GAM makes a large 6000W chicken coop known as the Toplight™. The home-made version, often constructed for specific circumstances, is known as a "coffin light" because of its shape. Chimera now manufactures a huge modular unit, often used for automobile photography, that serves the purpose of the custom-built coffin lights. These range up to 15×30 feet in size, which should be big enough for just about anything you can conceive!

Chinese lanterns are very useful as soft light sources. The traditional white paper ones are somewhat hard to find locally these days but are still available from lighting supply houses. They can be used for soft fill and accents in many situations and are a favorite of many DPs. Several manufacturers make fancy versions of the Chinese lantern using flame-resistant diffusion material and an internal cage to support the globe. They don't throw any nicer light than the cheap paper type, but they are more reliable to work with; the simple paper lantern is easily damaged and can catch fire if the globe inside touches the paper.

One intriguing use of the Chinese lantern in the last few years has been to mount it on a mic "fishpole" as a portable handheld soft light source. In a fast-paced shoot on a complicated set, this allows a general lighting setup to be used with close-ups augmented quickly by the hand-held Chinese lantern. In this way, each close-up doesn't require a major alteration of fixed lights. Just like a boom mic, the lantern-on-a-stick can be brought in close until it is just barely out of frame.

Chris Gyoury designed a fluorescent light ball for just this purpose. It uses two or four light wands enclosed in a wire structure of Rosco $1/4$ grid cloth. The unit is designed to screw onto a standard painter's pole; the remote ballast clips onto the rear of the painter's pole as a counterbalance.

4.16 The type of softbank manufactured by Chimera and others — a wire frame covered with fabric and diffusion material that mounts directly on the front of an instrument — was invented by Jordan Cronenweth (*Altered States, Blade Runner, Peggy Sue Got Married*). Until commercialized, the softbank was known to many in the trade as a Croniecone. Gaffers often refer to these softbanks now as baglights.

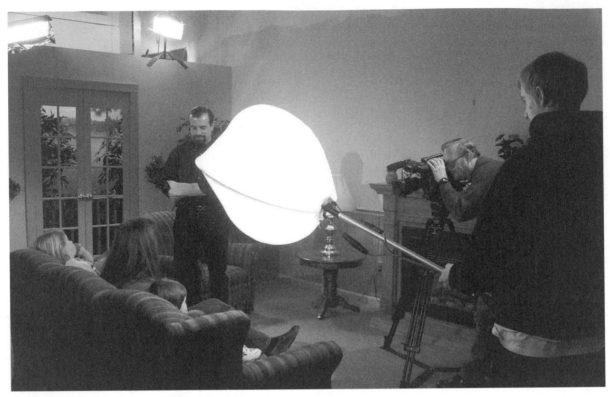

4.17 Chinese Lanterns can be used on a mic fishpole as truly portable soft light.

Many specialty instruments have been cobbled up to mount a light source in a tiny, out-of-the-way, awkward space. One is the GAM Stik-Up™, a tiny 100W open-faced instrument that weighs only four ounces. It can be mounted in a corner with gaffer tape or clipped behind an object with a C-47.

A very important category of specialty instruments is the on-camera light. These are small units that mount on the camera's accessory bracket and can be powered by external batteries or by the camera's battery. Most are simply holders for an MR-16 profile bulb and reflector combination—the type of bulb often used in slide projectors. However in recent years, they've gotten fancier and more versatile. Some (such as the Lowel I- Light) are focusing, whereas others (such as the NRG Varalux) have a self-contained full-range dimmer. On-camera lights are essential in field news shooting and other run-and-gun shooting situations. When used as key light, they create the most unflattering look possible, one you're familiar with from your local news broadcasts. You should use them in this manner only out of dire necessity. I regard

this use as a necessary evil for situations where no other solution is possible. On the other hand, they are quite useful and effective, even aesthetic, as fill lights or as eye lights.

One category of specialty instruments—or perhaps novelty instruments—at the time of this writing are LEDs. Light-emitting diodes have long had lots of uses on television and film sets, but they're in the process of becoming lighting instruments in their own right. Advances in very high brightness LEDs have made them power-saving alternatives for street signals, auto and truck stop and turn signals, and similar uses. A number of companies, such as Color Kinetics, have been producing LED luminaires for the architecture, display, and concert market. These digitally controlled LED array instruments can display any color in the rainbow. Currently, the best of these puts out less light than a standard 60W household bulb, so they are really still for display rather than projected illumination. They are best at providing changing color washes on walls in darkened areas. There is little doubt that the technology is advancing quickly. It won't be long when LED technology will make possible a whole new class of instruments—units that use less power than fluorescents and can be set to any color temperature with the flip of a switch—but these aren't here yet. The best current LEDs are only a bit more efficient than incandescent lights, and it takes about 1000, 5-mm LEDs to match the light output of a standard 100W bulb. However, advances in research promise significant leaps in efficiency and lower costs in the not-too-distant future.

4.18 The NRG Versalight is an example of a camera-mounted light. Some units, such as the NRG Varalux, have a built-in dimmer, a feature that is very helpful when using the camera-mounted light as accent or eye light. Photo courtesy of NRG Research, Inc.

Cookies and Snack Boxes Aren't for Lunch

Gaffers use a whole array of specialized equipment for their craft, but more often, they adapt ordinary objects for special use, and they invariably give them funny names: snack box, cookie, C-47, trombone, meat axe. Almost more than any other field, the theatre, film, and television world loves jargon. Nearly everything has a nickname, and curiously enough, it often has something to do with food. Many of these will be explained in more detail later in the book.

4.19 The Lowel I-Light is a small focusing instrument that can be camera mounted . Photo courtesy of Lowel Lighting, Inc.

Lighting Controls and Uses

A key requirement of effective lighting is the ability to precisely manage the distribution and characteristics of the light that falls on the set. The implements that do this are known as *lighting controls*. The most common basic lighting control is the set of barn doors that mount on the front of an instrument. This simple mechanism allows you to cut or restrict the light beam to keep it off certain areas of the subject or the set. You might need to cut the light to keep it off a white wall, for instance, or you might want to cast a thin slash of light across a backdrop. For location interview work, barn doors will probably supply all the control you need.

However, for full production or set work, there are a whole variety of other controls that provide greater flexibility and precision. These controls include diffusion materials to soften the light, scrims and silks to reduce the light level to specific areas, and flags, cookies, fingers, and dots to throw creatively placed shadows just where they are needed. Reflectors and bounce cards help to redistribute existing light and provide fill. All of these have to do with controlling the distribution, intensity, and softness of the light.

Gels

Gels, on the other hand, control the color of the light. Gels (or color filters) are thin sheets of transparent colored plastic, usually made of dyed polyester. The three major gel manufacturers are Rosco in Connecticut, GAM in Hollywood, and Lee Filters in the

United Kingdom. For film and video, gels break down into two categories: *color conversion* or *correction* gels and *color effect* gels.

One point is very important: Not all gels are equal in tolerance of heat. Cheap theatrical gels literally shrivel under the heat of larger instruments, for which it's important to use gels, known as "tough" gels, with high temperature tolerance.

Color *conversion* gels are precisely calibrated to change one light color temperature to another, say to change a 3200 K quartz fresnel to 5500 K to match sunlight coming in a window. These are intended to force the color temperature of the light to match the white balance setting of the camera. Light created with color conversion gels typically appear white on-camera, although they are also used to create color effects in certain situations. Color conversion gels change light along the yellow to blue range.

Color *correction* gels add or subtract a green component. This is necessary when dealing with typical fluorescent lights, which usually have a strong green spike in their spectrum emission. If you have to shoot in an office or factory that is lit with hundreds of cool white fluorescents that cannot be turned off, and you also need to use a quartz key on the subject, you might need to add some green to the quartz light to match. The picture will be consistent, but it will have a bit of a greenish cast because the camera white balance really cannot remove the excessive green component of these lamps. This greenish cast can then be removed in post.

You can cover the fluorescents with a magenta-toned gel known as a "minus green." The simplest method is to lay large sheets of gel in the tray or grille under the tubes. Of course, covering a large number of big fluorescent fixtures with lots of minus green gel is not always practical. In that case, you can also use a camera lens filter (such as the Tiffen FL-B®) of the same magenta tone to subtract green from the entire scene; however, these often subtract so much light from the scene that they create an exposure problem in video. Another solution is just to gel the lights over the people you are focusing on and let the background and other areas run a bit green.

Color *effect* gels are intended to change the on-camera appearance of the light. These are used when a strong color tint is

needed. Tints like bastard amber are known as *colorizing* gels, whereas strong primary colors are known as *party colors*. To simulate the effect of sunlight coming through a canopy of leaves, for instance, you might use a green gel such as Roscolux #86 (pea green) on the base key light and then Roscolux #07 (pale yellow) on an accent light with a cookie over it to create a dappled pattern. However, the camera white balance would be calibrated to 3200 K, so these colors would appear as a *color effect* on the video (if you white balance with color effect gels on the lights, the color effect will vanish or diminish). In many cases, you will use a blue filter to suggest moonlight. In other cases, you might want to tint a scene or part of a scene with a strong color for dramatic reasons.

Using color conversion gels is an essential science for video and television production. Depending on the type of video you produce, you might never (or rarely) use a party color, but you will certainly have to use color conversion on a regular basis. If you're doing straightforward video work and just want a basic set of color conversion/correction gels, Rosco has a package called the Cinegel Sampler that contains what you need.

Color conversion and correction gels primarily break down into four types.

- *Blue* to convert tungsten to daylight—known as color temperature blue, or CTB.

- *Orange* to convert daylight to tungsten — known as color temperature orange, or CTO.

- *Green* to correct tungsten to fluorescent—known as plus green.

- *Magenta* to correct fluorescents—known as minus green.

Each type has a range of tints for different purposes. These are generally referred to by quarters—for instance, full CTB, $3/4$ CTB, $1/2$ CTB, or $1/4$ CTB. Each tint changes color temperature a specific amount.

The amount you need to shift color temperature is measured in *mireds*, which is an acronym for microreciprocal degrees. Gels are rated in positive or negative mireds. Each light color temperature

Using Party Colors

On the original *Star Trek* series, the set budget was very limited. Cinematographer Gerald Perry Finnerman, ASC, stretched the sets by having all the walls painted eggshell white and bathing them with party colors that reflected the mood of the scene. "I would cut the white light off the walls and paint my colours with the lamps," he said. "I lit the walls with the coloured lights, creating a mood for each segment (warm look for love, cold for evil, etc.). I did the same for exterior planet sets—mixing different colors for a variety of looks."

— Reprinted with permission of The ASC and *American Cinematographer.* © 2002.

has an equivalent mired, which is figured by dividing 1 million by the Kelvin temperature. For instance, the following equation finds the mired rating of a typical tungsten instrument.

$$1,000,000 \div 3200 = 313 \text{ mireds}$$

The mired rating of a daylight source, such as an HMI instrument, would be

$$1,000,000 \div 5500 = 181 \text{ mireds.}$$

The gel you need to correct from one to the other will be rated as approximately the difference between the two. In this example, the difference is 132 mireds. If you need to correct tungsten light to daylight, you need a rating of about –132 mireds. Surprise! That's exactly what full CTB is. Rosco's full CTB, Cinegel #3202, is rated at –131 mireds, whereas Lee's #201 is rated at –137 and GAM's #1523 is rated at –141.

On the other hand, if you need to shift the other direction and correct an HMI to match tungsten bulbs, you need a rating of +132 mireds, which would turn out to be a $^3/_4$ CTO because full CTO converts 5500 K to 2900 K, or the rating for a household tungsten lamp.

Is this a little confusing? Yes, it is. As you might have noticed, the rules aren't consistent through the ranges. Rosco's full CTB converts from 3200 K to 5500 K, whereas their full CTO converts 5500 K to 2900 K. To add to the confusion, Lee and GAM use slightly different temperatures and thus different mired ratings. Sorry, you just have to get used to it. It isn't as confusing as women's sizes in department stores! Of course, that's not saying much, is it?

See the Rosco Web site at (http://www.rosco.com) for color charts and mired values.

Typically, you fall into using a few specific gels depending on what lights you use most, so it's not long until conversions become second nature. For most videographers who have a quartz light kit, the most common use will be to match sunlight coming in a window. This presents the largest variation because the color temperature of sunlight varies dramatically through the year, through the day, and depending on weather conditions. To

Table 5.1 Standard color conversion and correction gels. You can download this chart from ftp://ftp.cmpbooks.com/pub/dvlightinggelchart.pdf. Print this table, laminate it, and keep it in your light kit with your gels.

Color Conversion Gel Chart

| Color Range | Shift | | Mired | | | |
	From	To	Shift	Rosco #	Lee #	GAM #
Blue—Color To Blue (CTB) (Conversion)						
Full CTB	3200 K	5500 K	−131	3202	201	1523
$^3/_4$ CTB	3200 K	4700 K	−100	3203	281	1526
$^1/_2$ CTB	3200 K	4100 K	− 68	3204	202	1529
$^1/_3$ CTB	3200 K	3500 K	− 49	3206	203	n/a
$^1/_4$ CTB	3200 K	3300 K	− 30	3208	218	1532
Orange—Color To Orange (CTO) (Conversion)						
Full CTO	5500 K	2900 K	+167	3407	204	1543
$^3/_4$ CTO	5500 K	3300 K	+124	n/a	285	1546
$^1/_2$ CTO	5500 K	3800 K	+ 81	3408	205	1549
$^1/_4$ CTO	5500 K	4500 K	+ 42	3409	206	1552
Green—Plus Green (Correction)						
Full plus green				3304	244	1585
$^1/_2$ plus green				3315	245	1587
$^1/_4$ plus green				3316	246	1588
$^1/_8$ plus green				3317	278	1589
Magenta—Minus Green (Correction)						
Full minus green				3308	247	1580
$^3/_4$ minus green				n/a	n/a	1581
$^1/_2$ minus green				3313	248	1582
$^1/_4$ minus green				3314	249	1583
$^1/_8$ minus green				3318	279	1584

do this properly with a pro camera, you perform a manual white balance on a white card illuminated only by the sunlight. The camera will display the color temperature it is balanced to in the viewfinder. For instance, on a clear day near noon, it might read 4800 K. Your quartz lights will be somewhere near 3200 K, although to be sure, you might perform the same operation with the white card illuminated only by the quartz lights. This situation calls for a $^3/_4$ CTB.

Large sheets of conversion gel material are available to use over windows to convert sunlight to 3200 K. GAM makes a product called WindowGrip that has a low-tack adhesive already applied for this use. Special material to correct the daylight temperature of computer monitors and television screens is also available.

Gels are light transmission filters. They do not add color to light, they subtract it. In other words, a green gel works by absorbing the opposite color (red) but freely transmitting green. The gel

Light Planning Software

LightShop is a personal computer lighting design software system for film production. The following collection of tools assist the DP, gaffer, grip, best boy, and others on the production team with the technical planning process.

- Create lighting plots using the extensive 1000-item inventory of lighting instruments, grip equipment, electrical distribution equipment, and set pieces.

- Plan power distribution in advance; the program recommends proper cable sizing and distribution boxes.

- Print a Rental Equipment Order form from the equipment included on the lighting plot.

- Order gels, filters, bulbs, and other expendables with the Equipment Order form.

- Calculate line voltage loss effects with the Line Loss Calculator.

- Calculate the minimum required light level at specified ASA/ISO film and the T-stop using the Key Light Calculator.

- Pick color correction from a list of all major manufacturers' filters using the Mired Calculator.

- Perform basic beam distance and diameter calculations using the Photometrics Calculator.

Demonstration versions of LightShop (PC) and MacLux (Mac) can be downloaded from Crescit Software, Inc. at http://www.crescit.com.

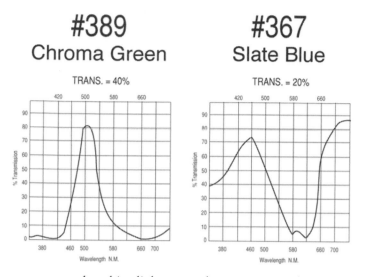

5.1 Spectral energy distribution (SED) curves graphically represent the color transmission and absorption of a gel. Courtesy Rosco Laboratories, Inc.

turns apparently white light green by removing other nongreen components. The precise manner in which a particular gel does this is plotted on a spectral energy distribution (SED) curve, which displays the entire rainbow of discrete colors and plots the filter's ability to pass or block each color.

Figure 5.1 shows the SED curves for two Rosco gels. The first, #389 chroma green, passes 80% of the energy at 500 nanometers (nm, marked N.M. on graphs), but nearly eliminates all other frequencies. Its overall transmission rating is 40%. The second, #367 slate blue, has a more complex signature. It passes 460nm (medium blue) and above 700nm (red), but sharply curtails 600nm (yellow) and reduces 400nm (UV blue) to 40%. The overall light transmission is 20%. Neutral-density (ND) gels have a neutral tint and pass all frequencies equally; they reduce the light level from an instrument or through a window, without changing its color or quality.

Diffusion Materials

A diffusion material acts to soften and diffuse the light without changing its color. Diffusion changes the "quality" of the light, as opposed to its color. A whole range of diffusion materials are available, each of which has a more or less dramatic effect on

5.2 Westcott Scrim Jim butterfly in use. Note the use of reflectors for fill and kicker. No electrical power is needed for these light sources! Courtesy F. J. Westcott Company.

the light. Typically, diffusion materials break down into three main categories.

Grid cloth—a waterproof woven textile that can be sewn or grommeted for attachment to large frames

Tough spun—a nonwoven polyester fabric

Frost—a sheet polyester material that is frosted to various degrees

Rosco and Lee manufacture all three materials; GAM manufactures a graduated range of polyester frost sheets. Please note that some materials are rated as flameproof and some are not. If you will be using the material close to an instrument (as in a gel holder right in front of a fresnel lens), it is important to use flameproof material.

Don't get stuck using only commercial solutions, however. Except when a flameproof solution is needed, just about any fabric can provide diffusion. An old white bedsheet can diffuse sunlight coming in a window, for instance.

Nets and Silks

Nets, scrims, and silks act to subtly reduce the light level to specific areas. They also usually provide some diffusion. These tools are usually thin, translucent fabrics stretched over a frame. Very large net frames, known as butterflies, knock down and diffuse strong sunlight. Smaller frames are used in front of instruments. Square U-shaped frames with one side open are called open ends and are used when the net must be brought in invisibly during a shot. The open side allows you to introduce the net seamlessly, without the visible moving shadow that a full frame causes. An open end also reduces light on part of the subject (a white shirt) but not another (the face) without creating a shadow line.

Different grades of fabric are available. Real silk, of course, is quite costly and can burn, so often synthetic substitutes are used. The fabric can be white (known as "silk") or black (known as "net"). Nets absorb light, whereas white fabrics provide diffusion. These lighting controls are usually graded $1/4$, $1/2$, and $3/4$ stop.

Large butterflies, 12×12 or 20×20 feet square, can be very difficult to use if there is wind. Remember, they are basically similar to sails and large kites. Make sure that stands are anchored securely with sandbags or guy wires. On very windy days, they produce a whipping sound, similar to ships' sails, that will intrude on audio recording.

Light Patterns

Gels affect the color of the light, diffusion and silks affect the softness of the light by making it more diffuse, and scrims affect the intensity of the light. These tools control light quality, but you also need to control the precise light pattern or the shape of the beam by controlling precisely where the light falls on the scene. You control this effect with an assortment of opaque black objects.

The most basic and common of these controls are *barn doors* mounted to the front of an instrument, which provide quick and easy (if somewhat basic) control of the light pattern. They can cut the light off a white wall or keep spill out of the camera lens to avoid flares. They can usually be rotated to cut off the light pattern at any angle, but because they are very close to the lens, they often cast a somewhat soft edge and sometimes have too little effect on a spot pattern.

When you need to cast a sharper, more precisely defined shadow, you can mount a *flag* or *gobo* on a separate stand a little distance from the instrument. These can be black fabric over a wire frame, cardboard, plywood, or foamcore. Flags are wire frames covered with a black, light-absorbing fabric called Duvetyne or Commando Cloth. Black foamcore ($1/4"$ of a styrofoam sheet with paper facing on both sides) is increasingly popular for smaller applications because it is disposable and easily cut into special shapes. The boom arm of the ubiquitous C-stand is usually called a gobo arm because that's what it is most often used for. The very flexible C-stand head can mount a $5/8$- or $3/8$-inch rod, or it can grip a piece of foamcore between its halves and rotate to nearly any position.

Flags and gobos are also referred to as "cutters" and are differentiated by position: sider, bottomer, or topper (also called a teaser

5.3 A cookie, or cucaloris, is a random cutout pattern, usually of thin plywood, used to create a dappled lighting effect. Courtesy Mole–Richardson Co.

after theatre parlance). Flags and cutters should not be placed too close to the instrument; a bit of distance is needed to create the sharp edge on the shadow. Usually, the flag should be placed about one-third of the distance from the light to the subject.

These controls allow the DP or gaffer to throw large controlled shadows on parts of the scene. However, sometimes a pattern of light and shadow or more precise control of the light on a specific hot spot is necessary. That's when cookies, fingers, and dots, or the thin aluminum cutouts Ross Lowell calls "blips," come into play.

A *cookie*, or cucaloris, is a random cutout pattern that throws a dappled pattern of light and shadow. They are incredibly useful for breaking up large boring walls or simulating the dappled light under trees, and they are frequently used in night or evening scenes. Of course, cookies aren't the only devices used to cast light patterns. Real venetian blinds can cast slatted patterns, or cutouts shaped like window panes can be used. Chimera makes a line of large transparency patterns of windows, foliage, ferns, and so on, to cast shadow patterns on backgrounds from their softbanks.

Fingers and *dots* are small shapes mounted on wire much like tiny flags and nets. They are positioned carefully to throw a small shadow on a specific area—either a hot spot that needs to be knocked down or an area that the DP wants to de-emphasize. Fingers and dots can be opaque or use the same range of silks found in scrims. The proper grade is selected depending on how

5.4 Fingers and dots are small shapes that cast a small shadow on a specific area—often to kill hot spots in the picture. Courtesy of Matthews Studio Equipment, Inc.

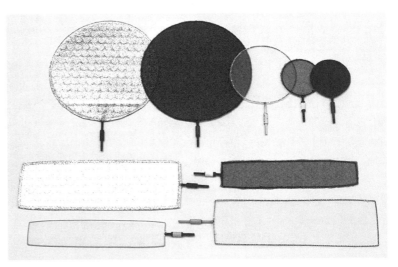

5.5 Blackwrap is used on a light to provide precise, custom-formed light control.

much the light needs to be reduced. These are typically most useful in close-up work or when shooting tabletops.

This category of light controls has to include the gaffer's favorite pal—no, not the tape, I'll get to that later. It's a roll of stuff called blackwrap. It's heavy aluminum foil that has been anodized matte black. Boy, is it great stuff! It's inexpensive and disposable, can be molded into any shape, and can be cut into shapes. A roll of blackwrap is often all the light control you'll need. It can replace barn doors, snoots, and a host of other accessories. You can mold a snoot out of it to produce a precisely shaped beam of light, or you can cut patterns in it. You can extend barn doors when they're just not quite large enough; the most basic and common use it to cover the open juncture between barn doors and the instrument body to eliminate light scatter. Blackwrap is one of the must-have items for your Gaffer's Survival Kit!

Reflected Light

An important tool that also belongs in this chapter (because it has to do with controlling the light pattern) is the reflector. Many times when a little extra light is needed, especially for close-ups, you don't need to set up an extra light. There's plenty of light on

5.6 A reflector provides fill in an exterior shoot. From the author's video *Basic Lighting for DV.*

the set, it just needs a little rearranging. Enter the humble reflector or bounce card, which can range from a piece of cardboard covered with aluminum foil to a snap-open treated fabric circle to a huge polished aluminum sheet. It can even be a simple sheet of white foamcore or posterboard. It is simply a sheet of some material that will bounce light into the area it's needed.

Basic Lighting Techniques

Before I start with the textbook diagrams, I really need to cover some basic theory of what good lighting is all about.

Obviously, lighting is necessary to provide enough excitation for the camera CCD to produce an image. As I discussed in detail in Chapter 2, the contrast range needs to be compressed enough to provide some detail (engineers would say signal) in dark areas but not overexpose the highlight areas. I suppose if you did no more than that, you'd be doing better than many; however, this purely technical definition is lacking in soul, and if that's all you do with your lighting, your pictures will lack soul, too. They'll be well exposed and the engineers will think they're great, but it would be nice to accomplish a little more than that.

Back in Chapter 2, I talked about how lighting provides subtle cues to the brain about texture and depth. These are incredibly important because there's no third dimension to television or film, only height and width. The illusion of depth and dimensionality is just that: an *illusion* created by artistic lighting. It's up to you to create that illusion, and trust me, it doesn't happen by accident. Laypeople and beginners are often baffled by the amount of time it takes to light a scene properly because they don't understand the subtlety of what's going on. The compromises between the technical necessities (controlling hot spots) and the artistic potential (creating a convincing look) can take a bit of juggling to accomplish. That said, good lighting isn't always that hard or time consuming to achieve. It's the combination of a trained eye

and the experience to know what works that allows pros to set up effective lighting quickly.

A Sense of Depth

First, you need to create a sense of depth. In the real world, of course, this is simply an automatic part of the depth perception created by binocular vision. Lighting might dramatize your awareness of depth, but it isn't necessary. On television, the only tools you have to convey depth are the *shadows and highlights* created by lighting, *depth of field*, and *camera motion*. I'll leave depth of field and camera motion to the camera operators and put my attention on creating shadows and highlights. The combination of highlight and shadow creates a sense of *modeling*—the illusion of depth and dimension.

Early television—just like early films —had to work at creating this sense of depth because it was monochromatic. Black and white television *couldn't* be entirely flat lit, or faces would be undifferentiated blobs. Shades of gray that were too close in value would blend together without definition. When color was added to the signal, all that changed. When television studios discovered that the color provided additional visual definition, flat lighting was born—lots of light all over the place. It was easy, it worked, it was practical. It was easy to use in a studio setting where many people might be moving around and where multiple cameras required the lighting to work from any angle. Creative lighting was left pretty much to "the film guys," and this is part of where the film world's negative attitude about video comes from. Video just looks cheap when lit this way.

Flat lighting (also known as *high key* lighting because there's a high ratio of key to fill) provides very little modeling. Look at Figure 6.1. A ball that is lit from the front, as when the light is mounted on the camera, looks flat. In fact, it looks like a disk rather than a ball. This sort of lighting is generally only used in location news, and then out of necessity.

Studio flat lighting, or high key lighting, is an attempt to light every bit of the studio equally. Lights on a subject will be of equal intensity from all sides. There is usually some shadow under nose

Flat lighting:
Camera-mounted light.

Flat lighting:
High key and fill nearly equal.

6.1 *(Left)* When the light source is mounted on the camera, there is little or no modeling; the subject appears to be flat and dimensionless. *(Right)* Studio flat lighting has some dimension but seeks to illuminate all sides equally.

and chin, but even those can be eliminated with fill lights from below the face. One program that does this is Whoopie Goldberg's current incarnation of *Hollywood Squares*. The stars in the squares have fluorescents surrounding them—above, beside, and below—creating a completely shadowless, and very artificial, environment. More typical studio flat lighting looks a bit like the ball on the right in Figure 6.1. There is limited modeling, but not much.

I'll bypass flat lighting for the moment (I cover it in Chapter 8, "Studio Lighting"). It's a necessary evil to be tolerated when necessary, but not an artistic ideal. Forget that flat lighting is used on big shows like *The Tonight Show* and *Meet the Press*. That doesn't make it good lighting! Okay, I'm opinionated and intolerant and have been known to make snide remarks about the "local news look." I've been reamed out by local news folks who felt insulted by comments I've made during lectures and workshops. But look, friend, it just isn't a value to aspire to unless your sights are set really low. If you want your lighting to rise above the totally plebeian, you need to know how to do it, but please don't mistake it for great stuff.

Instead, you can build some great lighting by creating a sense of shape and depth, and I'll analyze how your eye and brain interpret the cues you'll give them. Going back to the ball, turn off all the lights except one and move that *off-axis* from the camera. This will be the main light for the scene, known as the key light.

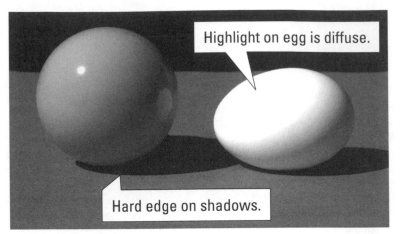

Highlight on egg is diffuse.

Hard edge on shadows.

6.2 Moving the key light off-axis from the camera creates strong modeling that conveys a sense of depth and shape.

Remember, if the light is too close to the camera position, there won't be much modeling. Look at the ball in Figure 6.2. Although much of the picture is in darkness, you can tell right away that the ball is spherical rather than a flat disk. How? By the pattern of light and shadow. The position of the key light in relation to the camera is tremendously important for creating this illusion.

What else can you tell? You can tell that the ball is shiny and that the light source is a hard light. How? By the highlight, which is a reflection of the light source. The tiny, sharp-edged highlight could only come from light falling on a shiny object. The sharp edge of the shadow confirms that the light is a hard source. Look at the egg. The shadow is still fairly sharp edged from the hard light, but the highlight is less defined, more spread out. You can tell from this that the surface of the egg is *not* shiny. See how these subtle cues build up? You didn't have to think consciously about either shape or texture. Your mind pulls these cues together on the fly and interprets the depth and texture.

Now look at the same scene lit with a slightly diffused light source (Figure 6.3). This is similar to a fresnel with a light frost diffusion material or a small Mole Softlite. It's still pretty contrasty and dark, but you can tell the light source is different. How? The shadow edges are softer, and the highlight on the egg is even more diffuse.

Now I'll use a really diffuse light source, like a large Chimera softbank (Figure 6.4). What a difference! Notice how the light seems to wrap around the ball and egg, and how the shadows are

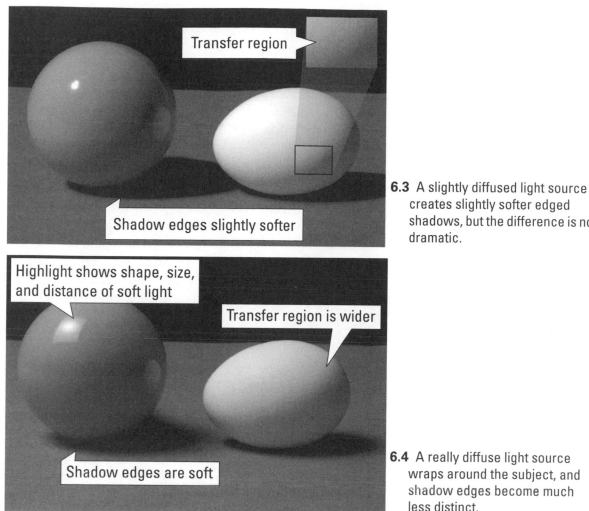

Transfer region

Shadow edges slightly softer

6.3 A slightly diffused light source creates slightly softer edged shadows, but the difference is not dramatic.

Highlight shows shape, size, and distance of soft light

Transfer region is wider

Shadow edges are soft

6.4 A really diffuse light source wraps around the subject, and shadow edges become much less distinct.

quite soft edged. However, you can still tell that one object is hard and shiny and the other has a rough texture. How? Again, by the nature of the highlights. The ball shows a sharp reflection of the light source, whereas the highlight on the egg is so diffuse it's almost nonexistent.

The soft transition from light to shadow is known as the *transfer region* or transfer zone. The softer the light, the larger the transfer region at both the shadow edge and the highlight edge. But note something else; if you look carefully (or look at the signal on a waveform monitor), you will see that the highlight isn't just pure white, although it might look that way in a black and white rendition. When properly exposed, highlights show a bit of the tint

and texture of the underlying color of the object. This is called a *transparent highlight*. If the highlight is a solid pure white, the picture is overexposed.

Now I want to relieve some of the stark darkness of the picture. I'll revert to the slightly diffused light of Figure 6.3 but I'll add some light to the opposite side to illuminate the shadowed areas a bit (Figure 6.5). This is known as fill light. Because I dislike flat lighting so much, I'm not going to use a fill light that is of equal or near-equal intensity to the key. I'll use one that is about half the intensity. This brings out the shadowed side, allowing any details to be seen. Okay, billiard balls don't have much detail, but bear with me—most of your subjects will! By using a lower light level for the fill, you still achieve a strong sense of modeling. The ratio between key and fill is a major factor in determining the feel of a scene. When key and fill are nearly equal, the ratio is 1:1 and the effect is flat. If the ratio is 1:32, the effect is very contrasty and dark.

Now I'll add a backlight to create an accent on the upper section of the egg and ball. This enhances the sense of modeling and also acts to visually separate the subject from the background. The backlight can be quite subtle or quite bold, depending on the effect you want to create. The type of backlight depends on the position in relation to the subject and the camera. A *hair light* shines down from directly above and slightly behind the subject. A *rim light* is more behind and slightly off to the side opposite the key and creates a thin rim on the subject. A *kicker* is like a rim, behind and off to the side opposite the key, except it is more to the side, so it creates specular highlights on the side of the face.

6.5 Fill light brings out detail in the shadows, but doesn't eliminate modeling; the backlight adds an accent that can help to separate the subject from the background.

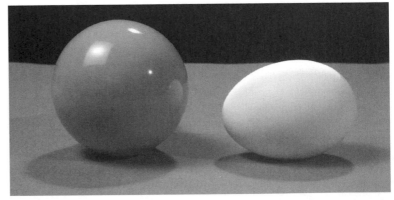

One thing to note about backlight: Any time you have a light pointing toward the camera (backlight, kicker, or rim), the effect is much stronger than a light pointing away from the camera. It is as if the light skips off the object, like a flat stone on water, so a backlight of equal intensity to the key will give a very pronounced and probably artificial effect. A backlight of about half the intensity will give a more subtle accent.

Please note that a backlight does not light the background! It shines on the subject from behind. A separate light is used to illuminate the background.

Basic Lighting Setups

The basic procedure is as follows.

1. Start with the *key*.
2. Set the *fill* light to illuminate shadowed areas.
3. Set a *backlight* to separate the subject from the background.

Guess what? Key light, fill light, backlight—you've created the textbook three-point lighting setup! This formula is a sort of starting point for lots of variations. You see it on TV all the time; often a network news crew will even take the trouble to set up three-point lighting in awkward field situations.

In this situation, the key light is typically on the side near the camera (known as an onside key or camera side key), but off-axis from the camera to provide some modeling. The light is positioned above the subject, but not too high. It must shine *into* the

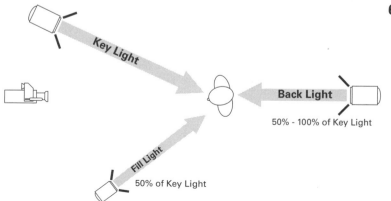

6.6 The three-point lighting setup is the basic formula for television lighting.

Key Light

Back Light

50% - 100% of Key Light

Fill Light

50% of Key Light

Using Distance to Control Intensity

Remember the inverse square rule? If you double the distance between the light source and the subject, the light intensity is quartered, and the reverse — halving the distance increases the intensity by a factor of four. A very effective and simple way to control the precise intensity of the lights is to move them closer to or farther away from the subject. If you add diffusion to a light, you might need to move the light closer to compensate for the reduction in intensity.

This isn't always possible, of course, because of space restrictions. Other methods of controlling intensity are the electronic dimmer and scrims. The problem with using a dimmer on incandescent lights is that the color temperature will shift toward orange as the light is dimmed. Scrims, on the other hand, reduce the intensity without changing the color.

face of the subject; if the angle is too steep, it will just create awkward and ugly shadows. A key light that is too high is the usual problem with most residential lighting when videotaping.

The fill light is usually about the same height on the side away from the camera. The backlight is directly behind and above the subject, pointed at the back of the head and shoulders.

If you learn how to do this one setup well, you can light interviews competently until the cows come home. But it's not the only approach out there, so don't get too stuck on it. Creativity and flexibility are the keys to creating great lighting in real-world situations. One problem you'll encounter right off the bat is that it's tough to have a perfect backlight—directly behind and above the subject—in location situations. In the field, you usually have to rotate the light off-axis until it's more like a kicker (a light from the rear and side).

Each of the lights must be properly focused on the subject. In nearly every case, you want the center of the beam to hit the subject. The easiest way to do this with either focusing open-faced instruments or fresnels is to adjust the beam to a tight spot, aim the spotlight at the subject, and then back off to a flood setting. Now limit the coverage of the beam with barn doors and black-wrap. The flood setting allows better shaping of the beam with these controls.

Don't get stuck on one setup! A common variation on this approach is to reverse the key and fill: position the key light on the side of the subject *away* from the camera. This is known as an *offside key* and adds a different feel to the picture than an onside key. Some DPs refer to this as lighting from the camera side or lighting away from the camera side.

Now experiment more. What effect do you get if the key is higher? Lower? Change the height of the fill. Rotate the setup around the subject, placing the key farther off-axis from the camera. Try adding some diffusion to the key. How does that affect the look? Switch the diffusion to the fill; that looks a little different. Adding diffusion to the light reduces its intensity, so you might need to move the light with diffusion closer to the subject to compensate.

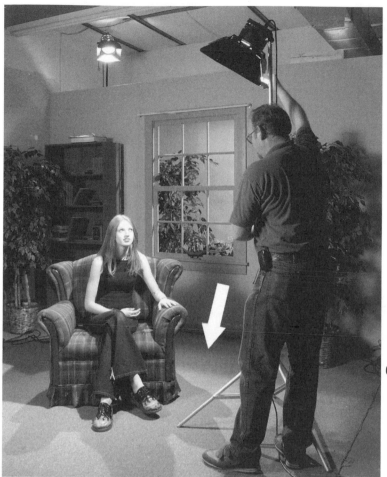

6.7 The walls on this set aren't white, but you still want to keep the key light off of them. Notice how barn doors keep light off the wall; the arrow points out the shadow edge cast by the barn door.

Lighting the background can be an issue with the three-point setup. In order to focus the viewer's attention, it's a generally accepted practice to have the background lit darker than the subject. A rule of thumb is that the background should be lit at least a stop lower, or half the light intensity, than the subject, so you usually want to control the key light so that it only illuminates the subject and doesn't spill onto the background. It's pretty common to open the fill light (which is about half the intensity of the key) wide open and light the background from that. However, it's best to use a fourth light and light the background separately for complete control.

This is especially true when you must shoot in front of a white wall. White walls are the bane of video shooters because they usu-

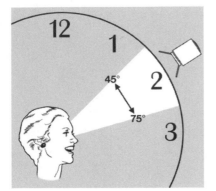

6.8 The key light must shine into the subject's face. Imagining a clock face, the key should shine from about 1:30 to 2:30, or about 45° to 75°.

ally overexpose when the subject is properly exposed. A good rule of thumb is to keep light completely *off* white walls whenever possible and then to use a tiny bit of bounced light to illuminate the wall. Nets or flags also can be used to protect a white wall.

The height of the light source, especially the key, is incredibly important. The principal problem with most architectural room lighting is that it falls from directly above, casting ugly shadows from the brow and nose. Television and film lighting must come from a much lower angle, shining into the face of the subject rather than down on top of the head. This is particularly true for interviews and close-ups. The precise angle to use varies. For example, visualize a clock face with the subject at the center. The key can be positioned anywhere from about 2:30 up to 1:30. Much above that and the shadows become annoying; much below the level of the eyes and the subject looks a bit like a kid at camp holding a flashlight under his face.

Here's a rule of thumb many shooters use to set both height and angle of the key. The shadow cast by the subject's nose is known as a nose caret. In normal lighting, this shadow should not fall too close to the upper lip (vertical angle) and should not extend too far onto the cheek (horizontal angle). As a starting point, position the key so that the nose caret falls into the fold that runs from the side of the nose to the corner of the mouth, without extending onto the cheek. For the anatomically minded among you, this is the juncture between the orbicularis orbis (the upper lip muscle) and the levator labii (the cheek muscle). This line is known as the nasal-labial fold.

6.9 Two instruments and a reflector can light an interview quite effectively.

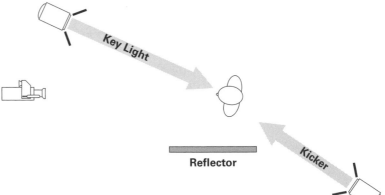

Set Up the Shots First!

Film gaffer Craig LaVenture has a pet peeve: directors that have him light a scene before the camera is set up. Very often, when the actors are on set and the camera shot is finalized, the lighting must be altered to compensate for a subtlety the director didn't foresee, or the gaffers have spent hours creating a lighting effect that never shows up on-camera.

His advice? "Insist that they set up the shots first." Have the actors—or stand-ins—walk through the scene and have the DP rough-in the camera angles and shots. This will ensure that the lighting setup is appropriate and economical.

The best procedure is to

1. block and mark,
2. light with actors or stand-ins,
3. rehearse both camera and lighting,
4. tweak the lights, and
5. shoot.

It's important to have actors or stand-ins at marks when lighting the scene. As Arledge Armenaki always says, "I can't light air!"

Now that you've had an introduction to the basic three-point lighting setup, I'll show you some variations. You can use two lights and a reflector quite effectively for interviews by positioning a key and kicker about 180° apart and off-axis from the camera, using the reflector or bounce card for fill. A different effect is produced if the reflector bounces the light from the kicker instead of the key. Varying the angles of this setup creates different looks as well. Try rotating the arrangement in the diagram to create an offside key, with the strongest illumination on the side of the subject's face away from the camera. The camera is now catching mainly fill on the subject, with rimmed highlights—a very different feel from the original configuration.

Now lose the second instrument and drop down to a one-light setup. Using just a single instrument (preferably a large softlight) and a reflector, you can still produce a very nice environment for an interview. Although this setup might appear limited at first, a number of variations can be contrived. Again, try the softbank as both onside key and offside key. The amount of fill can be varied through the position of the bounce card. This doesn't work nearly

as well with a hard light source; part of the magic for this setup comes from the diffuse light that seems to wrap around the subject. This setup isn't appropriate for every situation, but the advantages here are obvious: It's a simple, quick setup that still provides a very professional look.

Now I'll take this minimalist approach a step further! Lose the bounce card! Nothin' but a small softbank! Try this: Position the subject sideways close to one of those white walls that are always intruding into your shots. Get as much space behind the subject as possible. Position the camera even closer to the wall, shooting a bit away from the wall. Place the softbank to the side of your subject and slightly to the front, using the wall as a huge bounce card. Keep the spill from the light from hitting the wall behind the subject to keep it dark. Bingo! Nice lighting, nice modeling, separation from the background, one light.

Lighting Jujitsu, or the Art of the Reflector

Now that I've experimented with a bounce card, I'll explore beyond brute force artificial lighting by harnessing the existing light and bending its strength to fit my needs. It's a little bit like Jujitsu, the Japanese martial art that uses an opponent's strength to defeat him. It's very efficient and elegant.

In lots of situations you will have plenty of light—just all in the wrong places. Outdoors on a sunny day and indoors near a picture

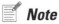 **Note** _____

In the early days of film, outdoor scenes were lit entirely with reflectors. In fact, sometimes reflectors were even used to bounce sunlight into interior settings as the main illumination!

Reflectors of different dimensions and finishes, ranging from large polished mirrors to plywood covered with gold leaf or simply painted white, can provide varying qualities of bounced light. Rigid 4×4-foot reflectors are very useful in lighting exterior settings. A silver reflector is referred to as a "priscilla," whereas a gold foil–covered reflector is often called an "elvis." Large 12×12 or 20×20 foot frame-stretched fabric reflectors are also used. A very popular fabric for this use is "griff" or Griffolyn, a reinforced polyethylene laminate manufactured by Reef Industries.

Today's small fold-up reflectors are much easier to carry and can effective light control in the field.

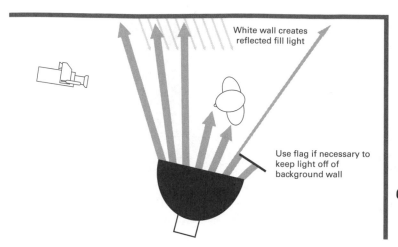

White wall creates
reflected fill light

Use flag if necessary to
keep light off of
background wall

6.10 Used creatively, even a single
instrument can produce
professional results.

window, there's a lot of light. The problem is rearranging the light to conform to the needs of the camera and to create the sort of modeling that makes the picture seem real and three dimensional to the viewer.

Frankly, it's not unusual to see film and TV crews hauling huge HMI banks out into the field and setting up large generators to provide fill on brightly lit days. For film shoots, they might be matching the lighting from another scene shot days earlier. For many applications, this procedure simply is not necessary. There's a lot of light floating around, it just needs rearranging, and the simple, no-power tool to do that is the reflector.

For an indoor interview situation, I've already done a setup with one light and no reflector. Now I'll try one with NO light and a single reflector! In this case, position the subject in a favorite armchair near a window, being careful to keep the window out of the shot. The reflector is positioned on the other side of the subject to created bounced fill. Voila! Nice light, no power draw at all! The only downside to a setup like this is that the quality of light from the window will change over time, sometimes making it difficult to intercut different parts of a lengthy interview.

This type of reflector lighting might not always be practical because of the changing nature of natural light, but it illustrates well the efficient use of reflectors that pros use often. In many cases, a reflector held by a grip can fix a lighting problem quickly without running cables and with nearly zero setup time.

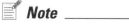 **Note**

The angle of the key can be very important in revealing or concealing problem spots. Some angles can be quite flattering, whereas others can make blemishes or tiny scars stand out like beacons. John Alton, ASC, used to use a simple device — a 60W household bulb mounted on a wand — to find the best angle for the key. With all the other lights off, he would move the wand around the subject's face, observing the effect. When he found the compromise that gave him the effect he wanted and was the most flattering, he would hold the position while a gaffer set up the key to match that angle.

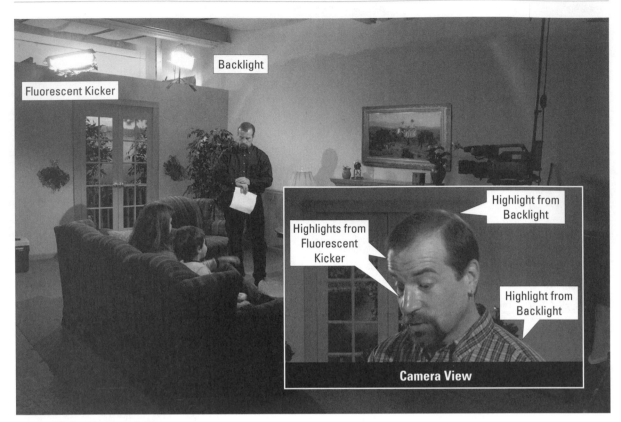

Backlight

Fluorescent Kicker

Highlight from Backlight

Highlights from Fluorescent Kicker

Highlight from Backlight

Camera View

6.11 Kickers, especially softbanks or fluorescent banks, are very effective in creating modeling on a subject. Here you can see the different effects of a fresnel backlight and a fluorescent kicker.

It's especially effective for a quick setup and short scenes where the light will not be changing.

Using a Kicker for Modeling

Although the backlight is quite important, a subtle kicker can be even more useful to create modeling in the subject's face. I have some practical examples of that later. It's not uncommon now in dramatic work to find a lighting designer that uses two kickers instead of a backlight. Recently, Jonathan Frakes invited me to visit the set of *Star Trek X: Nemesis*, and I noticed they were using this technique. DP Jeffery Kimball (*Windtalkers*, *Mission Impossible II*, *Top Gun*) had positioned two angled Kino Flo light banks as dual kickers behind a seated group. This technique is highly effective for situations in which there ought to be a lot of light—the sky, large windows, etc.—behind the subject. The problem is preventing lens flares from the kickers shining toward the camera. Deep egg crates on fluorescents combined with careful positioning can be effective.

Using Softlights

The last two single-light setups really depended on the use of a soft light source to work well. Although they will work with a hard light source, such as an undiffused fresnel, they won't be nearly as effective or seem nearly as natural as when using a large Chimera or Kino Flo or when shining a fresnel through a large silk.

Softlights have become an enormously important part of film and television lighting today. As easy as they are to use, they are often used ineffectively, so I'll look at the effective use of softlights. As I do, bear in mind that these guidelines apply to any type of soft light source: a Chimera light bank, a fluorescent instrument, a Lowel Tota with an umbrella, or a fresnel with a bounce card.

Bear in mind two rules when working with softlights.

1. Softlights are best used close to the subject.

2. Softlights are best used close to the subject!

Do you get the point? Actually, they are two different points. The first rule holds because softlights are very inefficient at any significant distance. Part of the reason you diffuse light is to randomize the light rays. Rather than radiating outward in a simple, predictable, and orderly fashion, the photons are bounced in all kinds of directions—they are randomized (Figure 6.13). It looks nice, but as the distance between the light source and the subject increases, it means that a larger proportion of the photons are just wasted, spilling off somewhere else and lighting the audio guy, the PA, and the camera tripod instead of the subject.

Rule number two (although you might have thought it was the same!) holds for an entirely different reason. The whole point of using a softlight is to get that nice, gradual transfer region from the shadows to the highlights. This effect is drastically reduced as the distance between the light source and the subject increases. Remember the inverse square rule? It applies not only to light intensity, but to perceived size as well. If you take a Photoflex SilverDome softbank and position it 4 feet from your subject, you'll get a very nice soft effect. If you move the same softbank 8 feet away, the effect changes totally. First, the light level on the subject drops by more than three-quarters (remember all the random light you're losing?). Second, the apparent size of the light source

6.12 Shining a hard light source through a large silk creates a very pleasant light source that's a little hard to describe, combining the best of hard and soft light sources. The light retains definition, but without a hard edge, and the light has a lot of "wrap." Here, two 1K Tota lights are ganged together to shine through a silk.

Hard light—onside key

Hard light—offside key

Soft key—hard fill

Soft key—soft fill

6.14 In the photo on the left, the softbank is 4 feet from the ball. On the right, the softbank is 8 feet away—thus cutting the apparent size and softness of the source to one-quarter its previous value.

A 24×18-inch softbank at 4 feet casts large specular highlights and soft shadows.

At twice the distance, a softbank begins to act more like a hard light and casts a harder shadow.

drops to one-quarter that in the first setup. Lighting intensity aside, this is the equivalent of switching from an 18×24-inch light source to one that is merely 4.5×6 inches—not much larger than a typical 650W fresnel lens! That's not very soft at all.

Look at the effect in Figure 6.14. You can see the dramatically reduced size of the highlight and the smaller (read "sharper") transfer region between the fully lit area and the shadowed area.

Hard or Soft?

Earlier I mentioned that a single-light setup worked best with a soft light source. Now I'll take a look at the difference between soft light and hard light and when one is more appropriate to use

6.13 Hard light radiates predictably from the source; diffusion randomizes the direction of the photons.

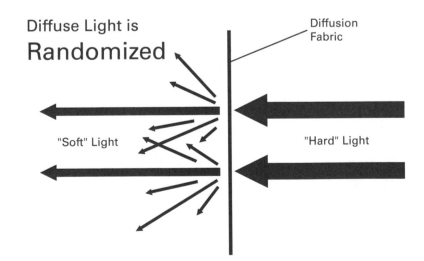

Diffuse Light is
Randomized

Diffusion Fabric

"Soft" Light

"Hard" Light

than the other. Many DPs have shied so far into the super-soft-light camp that they never use hard light. As a result, everything they shoot looks like a portrait studio picture.

The first thing to understand about hard lighting is that you only see it naturally in a few settings: sunlight on a crisp clear day, moonlight on an equally clear night, and when there is some intense and concentrated artificial light source such as a welding torch in the scene. In nearly every other situation, the light will be somewhat diffused. After all, many days are slightly overcast, and the light in our homes bounces around off of white walls and is filtered through lamp shades.

In most situations, the goal you're striving for is to create the impression of realistic lighting and a natural look. In other words, you don't want the scene to look "lit." Later on, when I cover simulating reality in greater depth, I'll delve deeper into this topic, but for now, I'll just take a brief look at the appropriate situations in which to use soft or hard light.

The key is observation. Hard light is imminently necessary and desirable for some situations, especially times when you want to simulate intense sunlight or crisp moonlight. But for most situations, some level of diffusion is called for. Lots of Hollywood films of the forties and fifties were lit entirely with hard lights, and thus often lacked a feeling of natural lighting. Some diffusion (perhaps a light frost or tough spun) on that fresnel will create a little more natural effect.

Softlights really come into their own when lighting interior scenes, where a lot of the illumination in reality would be filtered through lampshades or bounced from white walls.

However, don't abandon hard lighting as a creative tool; it can be used to great effect in certain situations. An example is the ITV-produced *Poirot* series starring David Suchet. Many episodes in this series, especially evening interiors, use hard light very effectively to create a certain feel.

Observation, flexibility, and imagination are the greatest tools that you have when lighting a scene!

Note

Not every great movie is a textbook on great lighting. In Franco Zeffirelli's magnificent film *Romeo and Juliet* (1968), there are certainly scenes of great lighting. The bedroom scene and the death scene in the tomb were very well done. But there are also scenes that are the worst examples of thoughtless studio lighting. In one scene, Juliet comes into a room of the castle to plead with her father. The stone room, a dank enclosed room ostensibly illuminated by a few candles and a tiny castle window, is entirely flat lit with thousands and thousands of watts of hard light. The scene looks about as realistic as a news set. Go figure.

Solving Common Problems

Now that I've covered some basic lighting setups, I'll move on to problem solving. A major ingredient in real-world lighting is catching hot spots, obnoxious reflections, and potential color problems before they ruin your take. Doing this well involves an eye for detail and a real focus of attention on the picture. How well you troubleshoot lighting problems during setup will be a major factor in the quality of the final product because many of these problems are difficult and expensive to fix in post (postproduction).

Hot Spots: Film Folks Be Vigilant!

Hot spots in the picture are one problem you always need to be watching for. These are often reflections on shiny surfaces that must be killed because they generally produce a region of clipped white in the final video. Camera operators and DPs with a film background are already used to watching for hot spots, but because overexposure is more obvious in video, vigilance must be increased. In fact, this is a problem area for many film DPs who go over to the digital format.

Film is more forgiving of overexposed areas. The gentle rolloff in the gamma curve of film means that as an area approaches overexposure, it aquires a soft edge. In digital video, however, the overexposed area rapidly hits the digital ceiling of 255, or 110 IRE. Because no more bits are available, the area is recorded as a solid area of overlimit white with no detail. *Any detail that might have been visible in the clipped area is permanently gone.* This

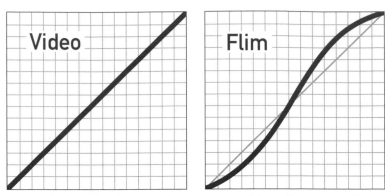

7.1 Film has an S-shaped gamma curve *(right)*, which gradually rolls off response as the film nears full exposure. This is kinder and more forgiving for hot spots than the flat gamma curve of video *(left)*.

📝 ***Note***

Pro cameras often have a "knee" adjustment (parallel to the film "shoulder") that creates a truncated response it the top end of exposure; however, it is usually less gradual than the gentle film gamma curve. Several higher end cameras, such as the JVC Cineline and some HD cameras, now offer adjustable gamma curves that can mimic that of film.

area of clipped white might be noticeable only marginally on straight playback, but it could be dramatically aggravated if the video clip is broadcast and run through automatic proc amp correction. Either the proc amp turns down the overall gain to make the hot spots legal, thus making the rest of the scene too dark, or more commonly, a limiting proc amp simply planes off any values above 100 IRE, resulting in a much larger and noticeable area of clipped white with hard edges.

Obviously, there will be times that you need to shoot with overexposed areas that are corrected in post, but bear in mind that the headroom is only 10%. Most broadcasters allow tiny hot spots, known in video engineering terminology as "limited excursions," but many networks reject video that has too many areas of clipped white. PBS in particular is notorious for this.

Hot spots are caused most often by reflections of lights on glossy surfaces. They are easily spotted when using the 100 IRE zebra display or when monitoring the signal on a waveform monitor. A little experience allows the DP to spot them with the eye; often it's simply a matter of watching details like a hawk.

Offenders can range from eyeglasses and jewelry to tabletops and picture frames. With set pieces or items in a room where an interview is being conducted, the simplest solution often is to remove the offending piece. A minor change of camera or lighting angle often fixes the problem. When the object really can't be moved, a dulling spray will create a temporary matte finish and kill the reflection. Dulling spray is specially formulated to be cleaned off of most surfaces easily; however, I'd be very hesitant to use it on a piece of high value. In other words, when interviewing the Queen

of England, it is not advisable to squirt dulling spray on her 18th century sterling tea set! Find another solution to that particular problem. The most common uses for dulling sprays are chrome fixtures, glass in picture frames, or mirrors. In lots of cases, simply covering the offending object with black tape is sufficient.

Glossy tabletops can also be a problem. Because you are probably using some sort of backlight or kicker on the person sitting at the table, it's very likely some of that light will fall on the table and bounce directly into the camera. A diffused highlight is not a problem; it's a direct reflection of the light source that must be avoided. Minor changes in the camera angle or lighting angle often can solve this problem. Don't be a slave to precise continuity of the angle of the backlight. It's often necessary to "cheat" angles between shots to fix problems like this. As long as you don't alter the general sense of the lighting too much, the audience will never notice.

Jewelry can be a particular issue because it moves with the body. An occasional glint off a ring as the subject gestures is not really something to worry about; but a brooch that causes a repeating flash, flash, flash as the subject moves must be dealt with. On a dramatic set with actors, you simply ask wardrobe to find something better, but in an interview, the subject might not be happy about removing great-grandmother's brooch. A little diplomacy is called for if you want to be invited back! Ask the subject about removing the offending piece (don't refer to it that way; something along the lines of "that stunning brooch" is more appropriate). If she is hesitant, figure out another way around the problem. Flagging the key to keep the key light off the shiny piece will work; if it's a simple piece that would be easy to clean, dulling spray will work.

Eyeglasses

Eyeglasses are another subject altogether. Although they can be sources of problem hot spots, the major problem with eyeglasses is distracting reflections that obscure the eye. In many situations, it is incredibly important for the audience to be able to see the subject's eyes—specifically, the pupil and iris (see the sidebar "Window of the Soul"). With the wrong lighting angle, a large

reflection can appear in the glasses lens right over the pupils, creating the blank stare of "mirrored" shades à la *Easy Rider*.

Unfortunately, it seems that the "wrong" lighting angle for glasses reflections is very close to the "right" angle for overall lighting, so video shooters have had to come up with all sorts of tricks to deal with reflections in glasses.

In dramatic productions, of course, real prescription lenses are seldom used. Flat glass is used in the frames, so that the glasses will produce a single "flash" reflection as the head is turned. This gives a very realistic impression but vastly reduces the angles that will produce a reflection. It's not unusual for a near-sighted actor to wear contact lenses so she can see and fake plate glasses that give the look called for in her character; otherwise, antireflective (AR) coating applied to prescription glasses works.

These relatively new coatings are pretty much the ultimate solution to problems with eyeglasses reflections. These AR coatings really work and eliminate the entire issue. There are several brands of coatings. Two of the most commonly available are Zeiss Gold ET and Super ET or Crizal® from Essilor Vision. AR coatings are microscopically thin layers of metal that scratch easily, but they have huge advantages for on-camera use. If you work

Window of the Soul

William Blake referred to the eye as the "window of the soul," and in some ways that is true. There is much subtlety and unspoken communication in the language of the eyes. It's very important to be able to see the eyes of other people; that's why talking to a person wearing dark sunglasses can seem intimidating. Good editors often pick a particular shot because they can "read" the eyes of the actors.

Allowing your audience to read the eyes of your subject is an important detail. In a drama, it might make a scene when the subtle motion of the eyes can be conveyed. In an interview, tiny cues can alert the viewer: "This man is lying," or "She feels what she's saying deeply."

The key to making the eyes readable in video is the tiny glint in the iris. Often, this appears naturally if the key light is set to a low enough angle. However, it's not uncommon for DPs to use a special eye light specifically to create that glint. This light can range from a stock camera-mounted light to the "inkie" often used for this purpose in films.

Watch for that glint in the eye—if you can't see it, neither can your audience. Move the lights or bring in an eye light to make it happen!

consistently with talent that wears glasses, get their lenses treated with an AR coating. It costs anywhere from $60 to $80 for a pair, but it's worth it for many situations.

This a solution isn't appropriate for interviews, however, because you must deal with the subject's genuine prescription lenses, usually without AR coating. The curved lenses used in prescription glasses cause the problem; the lenses reflect the light through a wide arc, with the reflection simply moving to a different part of the lens without ever going away! The following list enumerates the tricks of the trade that have been devised to deal with reflections in prescription glasses.

1. Ask the subject not to wear them. Some people (especially those that are far-sighted) wear glasses part of the time for reading or working on the computer. They might be amenable to removing them, as long as they don't have to read anything close-up on-camera. This is less of a solution for nearsighted subjects who wear their glasses from morning to night. If your subject is never seen without glasses, he might look strange—or even unrecognizable—without them. In the absence of an antireflective coating you'll need to move on to a more subtle trick.

2. In an interview setting, try seating the interviewer a little lower than the subject. This will cause the subject to look downward a little. Make sure the interviewer is not higher than the subject, which will cause the person to look up and create worse reflections. Raising the camera just a bit can help, too.

3. Raise the key light (usually the main offender) slightly. However, don't raise it so much that you create dark shadows on the eyes or cause the nose caret to fall over the lips.

4. Try adjusting the angle of the glasses themselves. Tipping the temples of the glasses up a tiny bit and sliding the glasses down on the nose $1/8$ inch or so can make a lot of difference. The problem with this approach is that it's not stable; the temples tend to migrate back down or the glasses could slip down the nose. To fix this, I've sometimes used rubber grommets to create little "temple jacks" that raise the temples off the ears.

5. If lighting with softbanks, try lighting more from the sides. I learned this trick from Kelly Jones at Chimera. Moving the key softbank more to one side creates strong modeling and keeps the reflection from appearing in the glasses. There's a position that still creates that magic glint in the eyeball without causing a reflection in the glasses lens because the curvature of the iris is more pronounced than that of the typical eyeglass lens.

6. Here's another tip from Kelly: If you just can't quite get rid of the reflection—for instance, the subject glances around a lot—make it work for you. Use some gaffer's tape to make a cross on the front of the softbox diffusion material; the occasional reflection will now look like a window frame!

7.2 Lighting with two softbanks can give a pleasant effect with no reflection in the glasses. Position both the key and fill lights more to the sides than in a typical three-point setup.

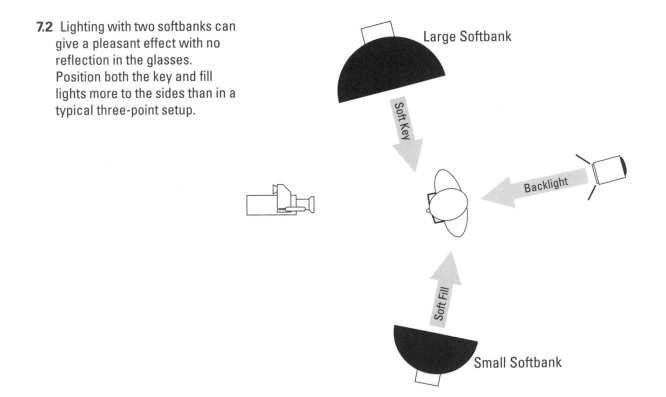

Practicals, or Light Sources In-frame

One of the most common mistakes I see in amateur and event videos is the inclusion of an uncontrolled light source in-frame. I'm sure you've seen videos in which the camera pans around a room on autoexposure and the iris shuts down when a window comes into frame, reducing the subjects to silhouettes. Another typical case has grandma being interviewed next to a table lamp, which cranks the iris shut so far that the room seems dark and grandma is underexposed.

Light sources in-frame are known as *practicals*, and they can be important elements in a scene. They provide visible motivation for the lighting and enhance the natural feeling of a scene. If the lighting plan is designed well, the light will seem to come from practical sources—a table lamp, a window, a wall sconce—rather than from fresnels and scoops that are out of frame.

The difficulty with practicals is that they must be carefully controlled because they create a contrast range that is way outside of what a camera can handle. Even if you've lit an interior carefully, if you show a window on a sunny day, you're going to be faced with a difficult choice: either the window will be vastly overexposed or the subject grossly underexposed.

When doing location interviews for news or documentary work, the most obvious and easiest solution is to pick the shot in a way that keeps the light source out of frame. When doing interviews in a home or office, this is often the best, and simplest, choice. However in drama, you want the practicals to appear, and you need to take the trouble and time to make the contrast range work.

When practicals appear in-frame, they must be carefully controlled to fall within the exposure limits of the rest of the scene. On a set, table lamps are fitted with low-wattage bulbs—perhaps 25 or 40W, depending on the light level of the rest of the scene. One dining room scene I directed had a chandelier with 25W, clear, flame-shaped bulbs. I put the chandelier on a dimmer, and after the scene was exposed, I turned the dimmer down until the lamps were just barely over 100 IRE.

A portable dimmer made from commonly available components can be a real lifesaver. Plug the practical in and turn it down until

7.3 A portable dimmer made from commonly available components can be a lifesaver in the field. Bear in mind that as incandescent lights are dimmed, their color temperature goes down and they become more yellow-orange.

it exposes right with the rest of the lighting. Bear in mind that as the voltage is reduced, incandescent lamps become more yellow-orange. However, this color temperature often looks acceptable with table lamps, the common problem in many settings.

Another quick and dirty fireld solution for table lamps with traditional shades is to place several layers of paper inside the shade to reduce the light that comes through.

Windows are a different matter. You can't put a dimmer on the sun! The classic solution is to use a neutral-density gel to reduce the light coming in. Gel manufacturers make these in large rolls that can knock the light down by one, two, or three stops. Color conversion gels can knock down the intensity of the sunlight and convert it to tungsten temperature. GAM makes a roll of neutral-density filter just for windows that comes with a low-tack, easily removed adhesive. These typically come in 58-inch-wide rolls. This solution is for productions with a budget—a single roll runs over $150. Although the rolls are reusable, they tend to become wrinkled and crumpled after a few uses.

A less expensive solution is Roscoscrim, a perforated black plastic sheet that is durable and reusable. It reduces incoming light by about two stops.

An even cheaper durable solution for the video shooter on a budget is a black fabric scrim material. A very economical solution that's always in my Gaffer's Survival Kit is a 6-foot length of black organza, the stuff widow veils are made of. You can get it at pretty much any fabric store for less than $10 a yard. If the window is near the ground, you can use gaffer's tape to fasten the fabric outside the window. If that's impractical, the fabric can be

7.4 *(Left)* The light coming in the church window makes the subject too dark. *(Right)* Tacking black organza to the interior of the window knocks it down a full stop, which allows you to open up the camera iris and expose the subject properly, yet not overexpose the window. This example is particularly difficult because the subject has dark skin.

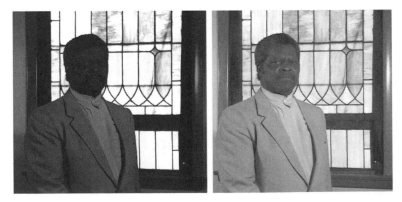

fastened to the inside of the window with tacks or tape. Although the interior fabric is obnoxiously obvious to the eye, it is nearly invisible to the camera.

Lighting Dark Complexions

The next example points out the contrast problem posed by darker complexions. It's sometimes hard to expose Caucasian skin tones properly if there is a pure white or light source in-frame; imagine the difficulty of controlling exposure with a dark-skinned subject! This can become a problem even in a studio setting if you have a very light skinned subject sitting next to someone who is extremely dark. Lighting dark-skinned subjects is an art unto itself. It's not that difficult, but it does involve care and observation.

The first rule of thumb is to eliminate pure white and control light sources in frame. This is always a good idea, but it is even more essential when attempting to capture a dark complexion. Figure 7.5 shows why: this is an example of how *not* to do it! The videographer (not yours truly!) posed the Rev. Leon Matthias in full Caribbean sunlight while he was wearing a white shirt. The result is a grossly overexposed shirt and underexposed face. Simply conducting the interview on a porch, out of direct sunlight,

7.5 How *not* to do it! The videographer (not yours truly!) posed the Rev. Leon Matthias in full Caribbean sunlight while he was wearing a white Guyabera shirt. The result is a grossly overexposed shirt and underexposed face.

would help; having the subject wear a blue or tan shirt would help as well. Shooting under a porch overhang, a reflector can bounce light onto the face, but it would have to be flagged to keep the bounced light off the too-hot shirt. Placing the subject in front of a neutral or darker background is also helpful.

Although one solution to lighting darker subjects is to pile a lot more light on, you can see from this example that lots of light can cause more problems because of contrast issues. You want extra light on the face, but you need to keep it off light clothing or light objects in the picture. Although "more light" can indeed work for medium-dark skin tones, it isn't a solution for extremely dark faces.

Subjects with coal-black or extremely dark brown skin can just soak up light in a manner that will frustrate the best frontal assaults. As you'll see later when discussing product shots, definition and modeling of dark or shiny objects comes not from direct (frontal) lighting but from *reflections*. One approach that works quite well is to use a kicker to the rear and off to one side to bounce light off the contours of the face (Figure 7.6). A warming gel (pink or straw) on the kicker often looks good; so can a $^1/_4$ CTB gel. Look at the underlying tone of the skin. If it is a warm brown, try an orange or straw gel. If it is a cooler black, use the blue gel. Above all, remember that large diffused sources or large

7.6 A kicker light to the rear and a large piece of foamcore help to provide reflections and modeling on extremely dark skin.

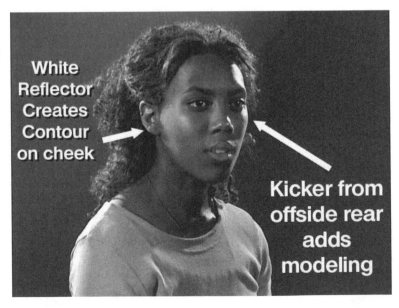

White Reflector Creates Contour on cheek

Kicker from offside rear adds modeling

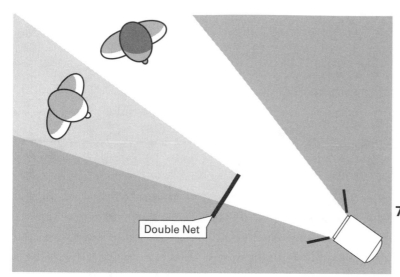

7.7 Use a black net to cut the intensity of the key falling on the pale subject, or use two key lights of different intensities.

reflectors work extremely well. A kicker on one side and a large softbank on the other can create a lot of detail on a very dark face; so can a strongly illuminated large piece of white foamcore just out of shot. In these cases, both the kicker and the foamcore create areas of reflected highlights that bring out the modeling and detail of the face for the camera.

When faced with a high-contrast situation where a very dark skinned person must be lit in the same scene with an unusually light skinned subject, all the same rules apply. Use a kicker, a soft-box, or a large white reflector to help provide definition on the dark-skinned person. But use other light controls—flags, scrims, or barn doors—to limit the amount of light hitting the light-skinned subject. Again, the situation is helped if no one wears white! A single key can be used for both subjects with a black net cutting the intensity of the light on the pale subject (Figure 7.7). Exploit the inverse square rule by seating the darker subject near-est the key and the pale-skinned subject farther away. You also can use two keys of different intensities, both flagged off with barn doors so they illuminate just one or the other subject.

A couple of years ago, a poor fellow e-mailed me and several other lighting folks to ask for advice. He had to videotape the manager of a quarry, and the client insisted that the interview be out in the quarry itself. The problem was that the manager had nearly coal-black skin and the stone they specialized in was white

7.8 Here, a Scrim Jim® silk diffuses the direct sunlight and reflectors provide fill and backlight. Photo courtesy F. J. Westcott, Inc.

marble! The sunny-day test shot was a disaster of aggravated contrast. What was he to do?

"Shoot on a cloudy day," several of us suggested, "use aluminized reflectors for key," and "use a gold reflector as a kicker." Finally, one of the other internet advisors (I don't recall who) came up with the crowning touch: *hose down* the wall of white marble behind the subject to turn it the light gray of wet rough marble rather than the brilliant white of dry rough marble. The combination of ideas worked, and the videographer was a genius with a happy client and a bonus!

This example illustrates a point: It might not take just *one* "big tweak" to fix a problem shot, but a whole collection of little tweaks together!

Too Much Light in All the Wrong Places

In many situations (as in shooting a dark-skinned subject in front of a window), you have *too much* light or light in all the wrong places. This situation is common outdoors on a clear sunny day, especially during the middle of the day when highlights are too hot and shadows too dark and pronounced. There are two basic approaches to fixing this situation. You can either bring in lots of lights to act as fill (the brute force approach) or redistribute the light you have (the more elegant approach). Each situation has an appropriate solution, but by far the most common video situation is the latter. Reflectors that redistribute the light and diffusing

7.9 DP Steve Slocombe sets up a network feed with historian Stephen Ambrose. Note the use of collapsible reflectors on either side of the subject.

silks that take the harsh edge off the sunlight are generally more practical than truckloads of generators and HMIs.

In many cases, simply using a reflector is sufficient to reduce the contrast and bring fill light into the shadowed areas of a subject in strong sunlight. How you orient the subject and the camera to the sun makes a difference, too. I like to use the sunlight as an off-side key (illuminating the side of the subject that is away from the camera) and use the reflected fill on the camera side. Another possibility is to have the subject face away from the sun and use the direct sunlight as a backlight, as in Figure 7.8. In this case, you must watch for lens flares! Probably the worst orientation is to have the subject facing into the sunlight because that always produces an unflattering squint.

The use of a large silk to diffuse the sunlight is a common solution (Figure 7.9). Silks are large frames covered with silk or nylon fabric. The silk is placed between the subject and the sun, and reflectors are then used for fill and back. Silks are quite effective, but are difficult to use if there is any wind. Aerodynamically, they are not too different from a boat sail; in a breeze their most likely reaction is to fall over on the talent!

Generally, on any daylight outdoor shoot, reflectors should be the first line of approach for lighting unless there is a strong reason to use powerful lights. Always look at the situation with an eye

7.10 DP Allen Daviau, ASC, and filmmaker Elyse Couvillion set a shot to take advantage of natural light in the digital short *Sweet*.

toward using existing light—rearranging it if necessary, rather than fighting against the forces of nature!

In the lovely independent digital short *Sweet*, filmmaker Elyse Couvillion and DP Allen Daviau did just this by surveying the apartment, the corporate boardroom, and the school classroom that they used as location sets to find the times of day that the existing light would work in their favor rather than against them (Figure 7.10). At certain times of day, the angle of the sun coming in the windows hit the white walls and reflected throughout the room, so heavy additional light was unnecessary. Careful scheduling allowed them to work with nature.

Obviously, in the film and television business, you can't always do that. Schedules must be kept and the mere progress of nature can't intrude. When you must shoot for hours with the sun apparently in the same place, you need to bring in high-powered solutions like a 24,000W FAY array. If you have to keep shooting into the night in a rented mansion and you need it to be sunny outside, an 18,000W HMI Solarspot squirted in the window will do just the trick. By the same token, these solutions cost money; creativity, imagination, and careful planning might reveal another way to accomplish the same effect.

Different Color Temperatures in the Scene

Mixed color temperatures in a scene shouldn't be an issue in a studio or on a stage, but it is often a problem out in the real world, where you don't control every aspect of the set and lighting. For example, you might need a pan shot of a large office where efficient and happy employees crunch spreadsheets and process words. Unfortunately, the office has sunlight coming in windows and yucky cool white fluorescent lights that can't be turned off. Do you white balance to the sunlight or to the fluorescents? A more common problem in an office setting occurs when you white balance to the warm white fluorescents and the computer monitors all look blue. On the other hand, you might need to videotape a family that is illuminated by incandescent light and watching television, which will result in a washed-out, intense blue.

You have several ways to approach mixed color temperatures, and the solution you choose will have to be custom tailored to the situation, the time frame, and the budget. Of course, this kind of problem always crops up when both budget and time are tight. The variety of situations seems almost infinite. Certainly, event or news shooters will encounter situations when they simply must shrug their shoulders, pick a white balance, and forge ahead!

In most situations, however, you should build in enough time (that can read "budget") to make some effective tweaks to the scene. In the large office, the most expensive solution of replacing all the fluorescents with daylight tubes might add $1000 or more to the budget in material and staff, but if building maintenance is a few weeks away from a routine replacement of tubes anyway, it might represent nothing more than a change in maintenance scheduling and the purchase of a tube with different specifications. Always ask the question! Just be ready to shrug your shoulders philosophically when the answer is "No."

You could also purchase ND sheet gel for all the windows, which would be somewhat cheaper but still add a substantial sum to the budget. The typical video client will look at you like you have a blinking light on your beanie hat and bananas sticking out your ears. "Can't you just *take* the picture? This ain't a work of art, you know!"

Perhaps you should always begin with the cheaper solutions, anyway. This problem is not just one of color temperature, but of *what quantity* of *which* color temperature. A great solution is to wait for a cloudy overcast day to shoot and balance to the fluorescents. If that's not possible, choose a time of day when strong sunlight is not streaming in the windows. If the office windows face east, then shoot in the afternoon; if the windows face west, shoot in the morning. This vastly reduces the quantity of one of the color temperatures you need to deal with without adding to the budget. If you balance to the ugly fluorescents, which are around 4500 K, you might consider using a magenta filter such as Tiffen's FL-D or FL-B to eliminate the greenish spike of the cool white tubes. However, it might cut the light level so low that you'll have to use gain on the camera. The exterior light will seem blue, but not excessively so, because the difference between 4500 K and 5600 K is not as pronounced as the difference

between incandescent light and daylight. The windows will probably still be overexposed; if so, it's advisable to eliminate them from the picture as much as possible.

The problem of conflicting color temperature from computer monitors and television screens is ubiquitous and often overlooked, but there's nothing more unpleasant than getting back to the edit suite tp see an illegible, blown-out blue computer screen with a black bar rolling through it. It doesn't really capture the experience of the human eye, does it?

This problem is not too different from the office with the windows: a combination of different color temperatures and balance between different color sources. You need to regard any monitor or television as a practical. After all, it is a direct radiating light source—not as much as a bare 60W bulb, but a light source nonetheless—and it's generally close to daylight temperature. (Television manufacturers discovered a long time ago that cranking up the color temperature of the cathode ray tube into the blue range made the tube seem brighter to the human eye.) Again, you have two problems to solve: the color difference and the intensity difference introduced by an on-camera practical.

Solving the color balance problem has basically three solutions. The first might not be appropriate for many situations, but it will be eminently workable for some: don't solve it at all! In certain situations, you will want to retain the blue glow of the monitor for effect—a shot of a writer working intensely on a novel late at night, for example. Balance to the incandescent table lamp and capture the blue glow on his face. Just be sure to expose so that the screen is legible and not overlimit and adjust fill light as necessary. On the other hand, you might want to capture someone watching TV alone in a dark room late at night, for which the blue glow is equally effective. However, in most situations, you will want to match the color temperatures closely to simulate the experience of the super-flexible human eye.

The second solution is to white balance to the 5600+ K of the monitor (it could be as high as 6500 K) and gel other lights to match, or use daylight-balanced lights such as daylight fluorescents, HMIs, or FAY globes, which are PAR bulbs with a dichroic coating. Again, expose to the monitor. It's the light source you

Fixing that Annoying Rolling Bar when Shooting Computer Monitors

Yes, this is a lighting book, and this is a camera operator tip. However, the huge number of videos I've seen lately in which no effort was made to deal with the black bar that rolls down computer monitors on-camera calls for the inclusion of this note!

The rolling black bar that appears on a video image of a computer screen is caused by the different *scanning rates* that typically are used for computer monitors. NTSC video scans at 29.97Hz, whereas the typical computer monitors scan at rates of 72 or 85Hz. The black bar, which will vary in size and speed depending on the scan rate of the computer monitor, is the *blanking interval*, during which time the cathode ray beam retraces from the bottom of the screen to the top of the screen before beginning the next trace.

Two methods, which often must be used together, will eliminate this problem.

1. *Reset the scan rate of the monitor*—The first and best method is to reset the scanning rate of the computer monitor to 60Hz. Please note that this is not always possible. Some monitors and SVGA adapters do not support 60Hz; however, most will. On Windows computers, right-click anywhere on the desktop and select Properties. Click on the Settings tab then click on the Advanced Properties button in the lower right. Usually, a drop-down Refresh Rate list appears at the bottom. Select 60Hz, then click OK. Windows NT asks you to test the rate to be sure it works. Often, you must reboot the computer for the new rate to take effect.

 After resetting the scan rate, the rolling black bar usually disappears almost entirely. At most, you have a narrow darker or brighter bar that moves slowly on the screen. Generally, this is acceptable in many situations, and you don't need to do anything else.

 Several years ago, I did special effects for a show in which a number of computer monitors were visible on screen. All of them were set to different scan rates. The DP was frantically trying to adjust the camera clearscan control to get rid of the rolling bar on one monitor, only to find it made another monitor look worse! I went around to all the machines and changed the scan rates to 60Hz, clearing up the problem. The rest of the show, the DP treated me like a genius.

2. *Use camera clearscan*—Most pro cameras have a clearscan feature specifically to deal with the rolling bar problem. Basically, clearscan is an infinitely adjustable shutter speed that allows you to match the scan rate of the computer monitor.

 On Sony cameras, turn on the Shutter switch, press the Menu switch/dial, and highlight the Shutter selection. Turn the Menu dial to cycle through the normal shutter speeds until you reach the CLS (clearscan) mode. Adjust the dial up or down until the rolling bar is minimized. If the bar is black, reduce the frequency. If the bar is white, increase the frequency.

Remember—*Read the manual*!

can't really change much, although you can turn down the brightness of the screen a bit. Adjust the other lights to match the monitor, but don't just slap up lights, expose to them, and expect the monitor to magically match the arbitrary light level! You also should use clearscan to get rid of that annoying rolling bar (see the sidebar "Fixing that Annoying Rolling Bar …"), which is even more annoying than mixed color temperatures and worth the effort to eliminate.

The third solution is to force the monitor or television to match the color of the lights. If you're lighting with incandescent lights, you'll need to place a CTO (color temperature orange) gel over the monitor or TV screen. Cut a large sheet carefully to fit. Usually the static electricity of the screen will hold the gel in place. This solution looks incredibly stupid in person but works like magic on-camera. Like the black organza mentioned earlier, the gel is invisible to the camera. Rosco even makes a Video Monitor Correction kit specifically for this purpose, with 60×48-inch sheets of optically clear film that's just the right shade of orange for the purpose.

In all these approaches, don't adhere slavishly to a perfect match. Your eyes are used to seeing a mix of color temperatures all the time. It's just that the difference is not as pronounced as when seen through a camera, so there are situations when it's quite effective to correct the color difference halfway and still let one source run a little blue or the other run a little yellow. You can also have a situation in which partially correcting the difference (use a $1/_2$ CTO on a computer screen rather than a full CTO, for example, or $1/_2$ CTB on the lights rather than a full CTB) and then white balancing somewhere in the middle will work This allows the incandescent lights to run warm yellow and the computer screen to seem a bit blue, but not to the extent that it looks excessively different from the natural situation.

As I hope you've gathered in this chapter, troubleshooting common lighting and exposure problems involves careful observation and creativity. Often the best solutions are simple and low tech, and frequently you must combine a variety of small fixes for the best effect.

Chapter 8

Studio Lighting

Much of the lighting that is covered in this book is temporary location lighting: instruments mounted on mobile stands with stingers on location or on a temporary set. However, television studios have permanent light grids with heavey-duty control systems and special HVAC units (heating/ventilation/air conditioning) that provide quiet cooling. Lighting principles remain the same in a studio, but the installation is different.

A studio is a more controllable environment than locations are, so they are essential for more permanent situations. The most common local application is the news set. But just like sound stages in the film world, studios are handy for any sort of scene that doesn't have to be outdoors. It's easier to light sets in a studio: adequate power is available, the grid provides mounting options practically anywhere a light is needed, and sophisticated dimmer panels provide precise and easy control. Of course, other factors are more controllable as well—namely, audio.

Studio lighting takes a bad rap sometimes because it is associated with local news, soap operas, and game shows. But this assessment is unfair. Studio lighting can be pretty ordinary, but it also can be done with style and artistry. Many of the best lit episodic television programs are shot on studio sets. One of the best recent examples has been Sidney Lumet's excellent series *100 Centre Street*, which is shot with multiple cameras in 24p[1] digital high-def video.

1. 24 fps progressive scan.

8.1 A&E's excellent series *100 Centre Street*, starring Alan Arkin, is a fine example of the best of studio lighting. Sidney Lumet, a veteran of the days of live TV, used the latest digital technology but resurrected the techniques of multiple cameras and live switching for the program. The show is proof of successful dramatic lighting design for multiple cameras. DP for the show is Ron Fortunato, production design by Christopher Nowak. Photo courtesy of A&E Television.

Local news doesn't *have* to be flat lit, although lots of station managers think so. With today's computer-controlled light control boards, a good lighting designer can set up a studio for every conceivable combination of anchors, walkarounds, and other variables that afflict news sets.

I'll take a look at designing a basic studio lighting installation, and then examine typical applications.

A studio is basically a large empty room that has been sound-proofed and usually has a sophisticated and quiet air-handling system, a large smooth floor (either polished concrete, movable linoleum squares, or poured composite), and a heavy-duty, independent supply of power. A large studio usually needs its own line transformer from the power distribution lines to damp surges and dips in power from heavy machinery starting in another building. I won't get into the many complex details of studio design here—studio acoustic design is a whole book in itself—but if you're building a real studio, rather than converting a warehouse or office on a shoestring budget, I recommended that you hire a studio designer. These folks not only understand all the interrelated complexities and problems that can crop up, they also are up on the latest materials and techniques. They know the mistakes that contractors usually make and how to avoid them. I will touch on the key points that relate to lighting, however.

Safety Note

Safety must not be an afterthought in the studio. Lighting instruments are heavy items, and barn doors have sharp edges. Too often, when rushing to get a shot lit under time pressure, safety is forgotten or compromised. An instrument that has been sloppily hung can suddenly become an instrument of destruction.

A falling light can injure, maim, or even kill!

Drill safety procedures into everyone that works in a studio. Lights must be hung securely, with safety chain or cable hooked to the grid. When rigging temporary light mountings, make sure they are secure and strong enough to bear the weight. Heavy twine can be used when safety cables are not available.

Make sure that fabrics are not too close to instruments. It doesn't take long for drapes to catch fire when touching the front of a 2K fresnel.

The most common safety hazard is not lights on grids, but lights on stands. These are often extended to their extreme length and set up quickly, so they become a top-heavy accident waiting to happen. Use cord or heavy twine to anchor the stand to a set piece or wall. When using boom arms on C-stands, counterbalancing shot bags or sand bags must be used or the entire contraption will tilt over. Even when using shot bags to counterbalance the length of the arm, don't forget that the arrangement is still top heavy and can tip sideways,

The first issue that crops up in studio design is the height of the ceiling. Sometimes it is dictated by issues other than lighting, but when you have a choice, the height probably ought to be several feet higher than anyone has tossed around in discussions. A common mistake of studio design is economizing by using a ceiling that is too low. Although it is typical in smaller studios to locate a lighting grid anywhere from 12 to 18 feet above the floor, the ceiling ought to allow *at least* another 6 to 12 feet of empty space above the grid. This is not wasted space; it is essential to handle the heat thrown off by the lights. Think of each incandescent instrument on the grid as an electric space heater rather than a light. In fact, a 1K throws off about the same amount of heat as a 1000W home space heater. Disposing of this heat is a major issue in studios. It's not uncommon to run far more light wattage than would be specified by a heating contractor to heat the same area electrically. Lights are not thermostatically controlled either. While space heaters turn off when a comfortable room temperature is reached, the lights stay on!

Allowing a large space for heat to collect above the lights will keep the area below the lights more comfortable. It acts as a heat "shock absorber": an area where heat can go while the air conditioner tries to pump it out. Decreasing the space above the grid will require a much higher installation rating, and HVAC tonnage is a *lot* more expensive than adding unfinished height!

Studios can be practically any size, depending on the intended use. They can range from tiny (20 × 30 feet) to behemoth (100 × 140 feet) and everything in between. Because of the characteristics of typical camera zoom lenses, a studio depth of less than 25 feet is generally not practical; even that will seem cramped. Although you shouldn't overbuild, my experience has been that studios are almost always too small. In particular, it's often overlooked that there will always be lots of stuff in a studio that is not being used but can't be in the shot. Dollies, light stands, flats, boxes... *stuff*. A large connected storage area, or just an extra 15 or 20 feet at one end, is essential.

Power System and Grid

The basic ingredient of studio lighting is a sufficient power system. It's always best to be liberal here because your needs in the future might grow. A minimum for a small studio is probably 200A. A larger studio might need 500A or more. Figure out the maximum number of instruments that you will be able to hang on the grid and add a bunch more on floor-mounted stands. I know you usually won't have them all on at once, but just suppose you might need to one day! The power requirements will be lower if you use primarily fluorescent instruments, but more on that later.

Do you need 240V instruments, such as 5K fresnels? How many 240V outlets do you need, and where should they be located?

What sort of lighting control panel will you be using? Where will it be located? Today, these are typically remote controls for the power control modules, which are located either at a common distribution area or at remote locations around the grid.

These questions are essential to designing your studio.

The second component of a studio lighting system is the grid. Although a variety of proprietary grid systems have been devised over the years, the mainstay is simply black iron pipe suspended from hangers. The pipe is usually specified as "Schedule 40 black finish steel pipe"; the size (specified by internal diameter, i.d.) must be either $1^1/_2$- or $1^1/_4$-inch i.d. because standard pipe hangers for instruments will not fit properly on any other sizes. The grid is formed of two layers of pipe, the first suspended at right angles to the ceiling beams and the second layer fastened at right angles below the first with special hardware, creating a gridwork that provides numerous points for mounting instruments.

Special hardware is available to hang the pipes from the steel I-beams, C-channels, or bar joists that support the ceiling (Figure 8.2). These typically clamp onto the bottom of the beam and provide a hanger for $^3/_8$-inch threaded rod. Clamps hang the second layer of pipe at right angles to the first. This approach is much stronger than forming a grid out of cut pieces of pipe with T-connectors.

Right above the grid, power connectors are hung and labeled with position markers. Depending on how the control system is designed, these can be standard electrical boxes mounted on EMT pipe, proprietary load connector strips, or rig-mounted dimmer power packs. Strand has a custom-made connector strip that is essentially an enclosed channel for wires. Short pigtails are used to connect to instruments. Rosco's Entertainment Technologies division makes a product called the Intelligent Raceway that incorporates dimmer packs and connector strip into one package.

How you control the lights depends entirely on your intended use. A small studio might simply wire the standard outlet boxes to circuit breakers, although this is not an optimal situation. The next step up is to have an electrician wire the outlet boxes to banks of standard household switches. However, basic dimmer packages are now quite affordable, so most studios will have some sort of remote control dimmer system.

In days of yore, dimmers were huge autotransformers you controlled directly with large handles. Curious mechanical interlocking systems allowed the operator (or several operators) to manipulate a group of autotransformers in tandem. Those days

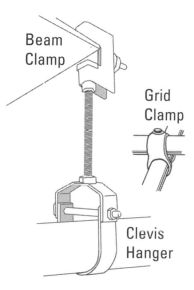

8.2 Special hardware is available to hang black iron pipe as a lighting grid.

are gone. Today, almost all dimming systems comprised separate digital control systems and solid-state dimmer packs or racks. A dimmer rack is often located outside the studio in a separate machine room, wired between the breaker box and the power distribution system above the grid. Each dimming channel (which can typically handle from 1200 to 5000W) is controlled discretely from a remote control board. Smaller systems might use dimmer packs that are mounted directly on the grid, such as the EDI SCRimmer Stik or the Dove Dimmermaster "shoebox" packs. These typically have lower ratings (four 600W channels or two 1200W channels) than rack-mounted dimmers. Smaller dimmer packs can be used in conjunction with a rack system to expand the system or to provide more control.

Each dimmer channel is controlled by a low-voltage signal from a separate control board, which can be mounted anywhere in the studio. These control boards are now a digital ecstasy of flexibility, offering presets galore, storage of multiple programs, control outputs in every flavor (including MIDI and GPI), interfaces with PCs and Macs, you name it. Running the big boards is a tech task of its own: the more flexibility you have, the more complex the system becomes!

8.3 The Strand LX is a straightforward and easy to use two-scene preset lighting panel that can control 12, 18, or 24 channels. The LX uses 10VDC low voltage to control dimmer packs. This is ideal for the studio that primarily needs manual control over each channel.

As time and technology has marched on, more control systems are computer based. A number of software control systems combine with a hardware card or adapter of some sort to turn a standard PC into a full lighting control system (Figure 8.4).

Dove Systems manufactures an interface called the StarCard; others, such as VXCO in Switzerland, manufacture external boxes that interface with the computer via either the printer port or the USB bus. Crescit makes the DMX Dongle. Each offers proprietary control software. Of course, like everything in the computer world, these products will change constantly, so you'll have to do your own research to find the state of the market when you're ready to buy.

Several interface systems allow the control panel or software to communicate to the hardware dimmers. The two major systems in use today are direct current (DC) voltage control and DMX.

DC voltage control uses a low-level voltage, usually 0 to 10VDC to precisely control the dimmer output. Each channel of the board must have a cable directly to the dimmer unit. These are often simply three-conductor XLR mic cables. Small systems (six channels) use an eight-pin DIN connector (sometimes known as a "Bleecon"). Not all systems are the same; Strand consoles can use either +10 or −10VDC for full "On." One or two renegades use

8.4 Rosco Entertainment Technologies offers a PC-based software lighting control system called Horizon. When combined with a hardware interface that generates the DMX signals, the system acts as a full-blown multiple cue list "tracking/last action" control system. A full version of the basic Horizon software can be downloaded from http://www.rosco-ca.com

lower voltages. You must make sure that all the dimmers and instruments in your system match the specs of the controller!

Far more prevalent now is the DMX 512 system, which is an eight-bit digital protocol that can control up to 512 channels independently through a multiplexed signal. DMX equipment typically uses five-pin XLR connectors, although newer equipment might soon be able to use CAT 5 networking cable. Each instrument on the DMX chain is assigned an individual "address" that allows the control panel to tell dimmer pack #12 from fluorescents. DMX

DMX Control Tech Stuff

It is important to make sure all equipment is fully compliant with the DMX 512 standard. Some manufacturers have used nonstandard voltages that can damage other DMX equipment.

Information about the standard is available online at http://www.usitt.org/DMX/DMX512.htm.

Pin assignments as called out in Section 9.02 of the DMX512/1990 standard are as follows.

PIN 1—Signal Common (Shield)

PIN 2—Dimmer Drive Complement (Data 1–)

PIN 3—Dimmer Drive True (Data 1+)

PIN 4—Optional Second Data Link Complement (Data 2–)

PIN 5—Optional Second Data Link True (Data 2+)

Section 4 of the standard requires adherence to EIA-485 with regards to all electrical characteristics, which means a maximum voltage range of –7 to +12VDC. The +18 to +25VDC used by some noncompliant instruments is outside this specification and can damage DMX-compliant gear.

Pins 4 and 5 transmit data to color wheels and motion lights, sometimes known as "intelligent" instruments. In many studios, the second data link is unused, so it is fairly typical to wire DMX with three-wire cable, using only pins 1, 2, and 3 as active.

The DMX chain, or bus, must be terminated, just like a computer SCSI chain. An improperly terminated chain can exhibit bizarre misbehavior and intermittent problems. The terminator is simply a 120W resistor across pins 2 and 3 in the last instrument in the chain. Some instruments terminate automatically, and others have a switch for termination. Some have no termination and a terminator will have to be created. Typically termination issues arise when using a *twofer*, or splitter, in which one leg is properly terminated and the other is not.

signals can run reliably over 1500 feet of cable, which is far more than you would need in the largest studio.

DMX is a standard developed by USITT, the United States Institute for Theatre Technology. Because of the advantages and flexibility of the digital interface, DMX is really the interface of choice today, and I think you'll see the other control interfaces fade away, except for the smallest six-channel systems.

Another interface that you will run into is AMX 192, an earlier multiplex standard that also uses five-pin XLR connectors, but an analog signal. Older equipment might still require AMX 192; most dimmer packs and control panels still support the standard. Because the signal was subject to ground loops and all the other vagaries of analog transmission, it is not nearly as reliable as DMX.

With all this discussion of dimmers, you might be wondering about the color shift I discussed earlier; that is, when incandescent instruments are dimmed, they shift toward orange-yellow. So how do you handle this in a studio?

First, in many cases, the dimmer panel is used as a very fancy On–Off switch and the instruments are used at full power. The option of dimming is always available, but not necessarily used. In addition, a slight yellow shift is not always a problem.

In other situations, dimming is an essential ingredient. On news desks, for instance, where different people with different skin tones are lit with the same lights, dimming presets can be a blessing. Say the morning news crew has an anchor of color with very dark skin, and the evening news crew has a blonde, blue-eyed anchor with very pale skin. You can use carefully designed dimmer presets to vary the light levels of certain instruments to compensate for the different skin tones. But what about the yellow shift?

The usual method to get around this problem is to target the white balance of the cameras on the yellow side—say 2900 K or 3000 K—and run all the lights on half intensity normally. Although this method might seem wasteful, it isn't. The lights run cooler, the globes last longer, and the lighting designer has "headroom" to increase the intensity easily. From that middle range, the lighting designer can generally change the lighting level up or

down a stop without significantly changing the color of the light. It's a fudge, but it works!

Fluorescent Instruments

Incandescent instruments are not the only choice for studio lighting anymore. In fact, they are losing ground to fluorescents all the time, for several good reasons. Yes, lighting designers like the soft light. Yes, talent likes to stay cool. But these aren't the real reasons studios are changing over. The real reason is the thing that always drives decisions in television: money.

Fluorescents are cheaper to run than incandescents by a huge margin. First, they are more efficient to begin with. They put out more lumens per watt than any incandescent instrument, but that's just the beginning. The main savings comes because they don't generate much heat, and as I said before, disposing of excess heat in a studio is a major problem, involving lots and lots of air conditioning. Although it might not seem to be a major factor to the average event videographer or documentarian, it's a *huge* factor if you're a studio manager. For any television studio that is in daily use, air conditioning costs constitute a major slice of the operating budget. Anything that can cut that bill is pure profit for the station or studio.

When KGUN-TV Channel 9 in Tucson, Arizona, switched from a fairly traditional incandescent lighting system (fresnels, softlights,

8.5 KGUN-TV in Tucson, Arizona, realized a huge savings on its power bill after changing from all incandescent instruments to Kino Flo fluorescent lighting.

scoops, and cycs) to Kino Flo Image 80 and Image 40 instruments augmented with Dedolight accents, they estimated an immediate savings of nearly a quarter million kilowatt hours per year. This translated into an annual savings of nearly $10,000 in operating costs. Plus, station manager Gregg Moss says, they received a $2500 rebate from the power company!

Many fluorescent (flo) instruments are now dimmable, and many are now also controllable by DMX. That makes the precise and convenient control of many flo instruments in a studio feasible. Videssence Baselight fluorescent studio instruments, for instance, are each available as nondimmable units, with 0 to 10VDC dimming, with DMX control, or with phase control dimming (a technique more often used for architectural light installations). Nondimming flos can be controlled from a DMX panel through the use of a DMX relay panel, such as the ETC Sensor Dimmer Relay or the Strand CD80 Non-Dim module. Oddly, these are still known as dimmers even though they're only electronic On–Off switches.

Fluorescent lighting does not automatically translate into flat lighting. It can be, but it can also be used to create very effective modeling. The only thing fluorescents cannot do well is generate hard light, so it is still typical to use fresnels as accents. Sometimes studio lighting designers use fluorescents to lay down a base level of illumination but still use fresnels as harder edged key lights. If a combination of instruments must be dimmed without changing color temperature, use the trick mentioned before: populate the flos with 3000 K tubes and set the incandescents up to run at about half power.

Designing light for a studio installation is more complex than simply setting up shot-by-shot lighting. You have to get a good idea of every type of shot that is necessary and take into account all the variables that might crop up. The designer must anticipate problems and plan for them. When planning a new installation, you'll have to ask a lot of questions. Always overdesign because needs will grow and you need to plan for that.

8.6 Fox Studios has an impressive grid, using primarily incandescent instruments.

Flat Lighting

I've griped and moaned all the way through the book about flat lighting, but no matter what style of lighting *I* prefer, *you* need to know how it works. Some situations need flat lighting. If you're trying to emulate a game show or a local news set, you'll want to use flat lighting to get the look everyone *associates* with those types of shows. If you're doing this inside of a drama, where most lighting is done very carefully with an eye toward realism, you might want to use the harshest, most artificial look you can come up with for the fictional game show to make it stand apart from the other scenes.

True flat lighting occurs when light comes equally from every direction; it is fairly difficult to accomplish. Certain types of product photography achieve it with the use of a white diffusion tent, but it is hard to achieve in a studio with real people. The one show that has come the closest is Whoopi Goldberg's incarnation of *Hollywood Squares*, where fluorescent tubes surround the stars in each square. Typical studio flat lighting (technically known as high key lighting because the key and fill are equal or nearly equal) isn't completely flat; thus, it isn't quite as difficult to create. In fact, it's fairly easy and requires little expertise.

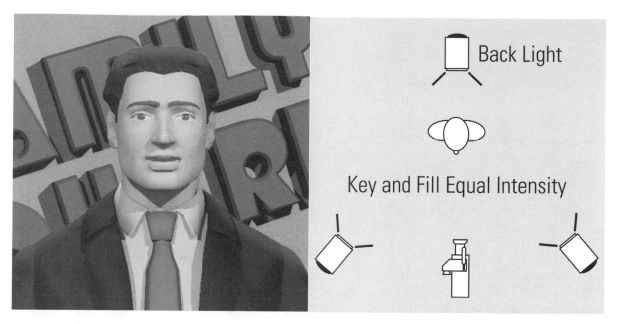

Back Light

Key and Fill Equal Intensity

I'll light my fictional game show, *Family Squares*, by first lighting the host, Bill Bighair. I'll hang two 1K fresnels to shine on either side of Bill's handsome face. From Bill, they are about 45° apart, and positioned equidistantly, so they cast exactly the same amount of light on both sides of him (Figure 8.7). I'll keep the angle low enough so that the nose caret is not too long; in fact, it is minimized into a triangle under his nose, rather than a nose-shaped shadow. I'll hang the ubiquitous backlight directly above and to the rear of the host. This is pretty much the lighting you see on Jay Leno on *The Tonight Show.*

When a 45° key, as described in the previous paragraph, is used with fluorescents, the effect is even flatter because the soft nature of the light makes the shadows less distinct. This particular setup is so easy, the weekend intern could set it up; the flos provide a wide, even light over the entire area. However, when both instruments are of equal wattage, the look is really too flat and boring for words, and it needs something to punch it up.

A slightly improved, and more common, variation of this setup is the frontal key (Figure 8.8). In this setup, a single key is mounted above the camera, pointed directly into Mr. Bighair's good-looking mug. Two fills are used, one on either side at about a 45° angle—much as the two keys in the previous setup. You hope

8.7 Flat lighting on Bill Bighair on the set of "Family Squares." In essence, key and fill are of equal value so there is no difference in illumination on either side of the face. Nose caret and chin shadow become inverted triangles.

they are *not* the same intensity as the frontal key, although I'm afraid in many studios they are. Reducing them to half the value of the key creates some sense of modeling toward the sides of the face. This setup has a number of advantages, the major being a reduction in the harsh triangular shadows under chin and nose.

That illuminates the host at his central mark, but what about the rest of the set? Much like basic stage lighting, I'll just clone the frontal key configuration in overlapping sets until the entire set is bathed in light (Figure 8.9). Anywhere Bill or the contestants walk on the set will be equally lit from both right and left. Overlapping coverage is the hardest part of setting this up with incandescent instruments. Diffusion helps significantly in blending the edges. Fluorescent instruments make this part a breeze and are really the recommended method for creating even lighting over a set.

How do you improve the flat lighting situation? It's actually quite simple. Remembering that modeling is created with highlights and shadows, so you simply need to lower the intensity on one side and raise it a bit on the opposite side. Although it won't create stupendous lighting, the simple expedient of reducing the level of the fill light (pick one side!) to half that of the key is quite effective when using fluorescents.

Another variation is to use a pair of flos in the same way, combined with a small fresnel mounted in a frontal key position

8.8 Frontal key lighting is an improvement, reducing the harsh shadows under the chin and nose. This setup is in very common use on news and interview shows today. A bit of diffusion on each instrument would help the look considerably and is highly recommended.

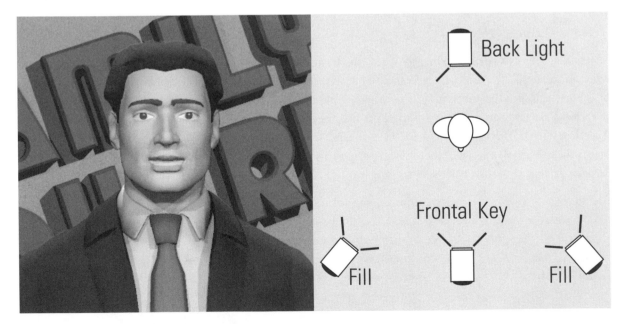

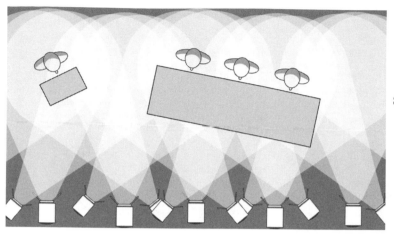

8.9 The frontal key arrangement is replicated across the entire set, resulting in a fairly even distribution of light wherever the contestants walk. Fluorescents are much easier to arrange than incandescents to obtain even coverage.

(Figure 8.10). This key adds the punch that was missing from the overly flat 45° fluorescent situation mentioned before. Many news sets today use fluorescents like this, combined with smaller fresnels to at add punch and accents. When artfully designed, this combination can be quite pleasant and effective.

Next, I'll tackle a studio situation that calls for a bit of "light surgery" (more on this in the next chapter). It's the hot new game show, *Millionaire Tax Audit Survivor*. The problem is that the celebrity host is, well, a bit on the portly side and has developed extra chins in recent years. How can I design dramatic lighting that will make him look great? Well—good? Well, okay—better?

8.10 Fluorescent lighting doesn't have to be flat. Instead of lighting both sides of the face equally, reduce the intensity on one side to produce a better sense of depth.

Back Light

8 Tube Flo
440 watts

4 Tube Flo
220 watts

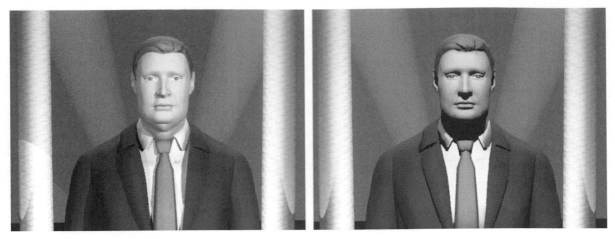

8.11 On the new hit show *Millionaire Tax Audit Survivor,* you need to conceal the host's portly extra chins. The nicely modeled lighting I would use in many situations accentuates the problem. The solution *(right)* is a strong frontal key that hides the worst features in shadow.

The solution was used in another highly successful game show where the host was a bit on the older side and had developed a wattley look under the chin. I will use an extremely low key setup with very little fill and mount a single frontal key (with a little diffusion, thanks) at a height that will cast a strong shadow below his chin, concealing the, well, less appealing feature (Figure 8.11).

There are lots of situations where careful lighting can solve a problem like this and many situations in which you will need to think outside the box to solve the challenges in each situation.

However, not every situation is a news set or game show. Many episodic dramas, ranging from daily soaps to weekly comedies and cop shows, are shot in studios. These shows are more complex because of changing demands and situations and because the action can move around the set in a much more random fashion than on a news or game show set.

Soaps are generally a compromise of flat lighting with a nod toward realism. They are shot on a withering schedule and tight budget. They have to crank out a show a day, with no pauses for great lighting or the whims of artistes. Also, because the shows are shot with multiple cameras at many different angles, the light must "work" from every direction. Flat, even lighting becomes a necessary evil. In recent years, some of the soaps have made an effort to use more accent and shadows to make the lighting more realistic, but the lighting director must always work in the basic tight parameters of the shooting realities.

However, just as with news or game shows, it is not really necessary for the lighting to be completely flat. Simply picking one side of the set for stronger instruments and using lower-powered instruments on the other side will create some of the modeling that increases the sense of depth and reality. It will also help viewers maintain an unconscious but very real sense of placement in the "room." The downside is that a lower key setup like this makes it harder to pull off "cheat" shots, in which the shot is artificially reversed for some reason or another.

Comedies are not known for their artistic lighting, either, although they are usually better lit than soaps simply because they have more time and budget for each show. Big bright lighting is usually the fact of life.

It is in weekly dramatic shows that really fine lighting has come to the fore in recent years. Shows like *NYPD Blue*, *Law and Order*, *West Wing*, and *E.R.* have truly raised the bar for weekly episodic TV lighting. It's worth noting that these shows have some of the highest budgets on television today. However, if you compare the lighting on Steven Bochco's earlier series *Hill Street Blues* (very fine by the standards of the day) with the realistic lighting of

Don't Move the Mark!

Good lighting design, whether high or low key, is best when it can be localized and specific. Pick a mark for the show host, the anchor, or the weather person; light that mark carefully; and then don't move it! Intensities for different skin colorations can be programmed into the control panel, but it's nearly impossible to light every spot in a studio equally well. Do whatever you must to convince the floor director to fight any whims to rearrange the set to "make it look a bit different."

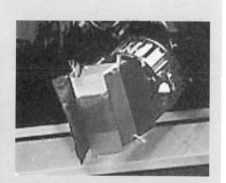

Control is essential when lighting a specific spot. The key should be for that mark, and that mark only. It should not double up as general fill. Use barn doors and semipermanent applications of blackwrap to give the needed effect without casting unusual shadows in the wrong places.

In this detail from Figure 8.6 of the Fox Studios, note how the fresnel is controlled by barn doors—one extended with blackwrap. Diffusion material softens the light somewhat, and a piece of neutral-density gel reduces the light level on the lower portion of the beam. This instrument makes a specific visual contribution to a specific seat in the studio.

today's *NYPD Blue*, it is clear how high the standard has become. These shows are lit better than many Hollywood films, partly because of their huge budgets and careful lighting design.

A quick look at the first season of Dick Wolf's *Law and Order* reveals pretty ordinary lighting. Of course, the show was new and the budget wasn't anything like what it grew to in later seasons. The show quickly established a realistic look, with the majority of light coming from windows in day scenes and practicals in night shots. The shows are a graduate course in great television lighting. They're in reruns many times a week, and they're free, so if you watch them and deconstruct the lighting, and you'll learn a lot.

A very notable example of fine television lighting is Sidney Lumet's series on A&E mentioned at the start of this chapter, *100 Centre Street*. The show is an important example for several reasons. First, it is shot digitally in 24p; second, the show is shot on a set; and third, it is shot with multiple cameras and rough cut through live switching. Lumet has resurrected some of the practices from his early days in live television, and guess what? They work! But most important is that the lighting is designed to work with multiple cameras and with action in all areas of the set. It's a wonderful example of how well it can be done.

Whatever you do in a studio, be inspired by the best examples, rather than just meeting the minimum requirements!

8.12 An early television studio program.

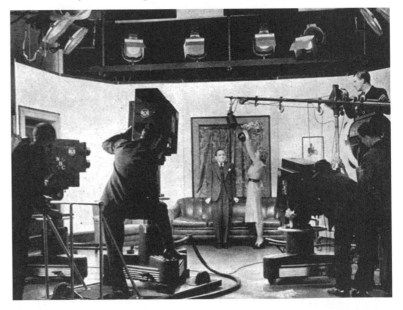

Advanced Lighting Setups

Now that I've covered some basic lighting setups, studio lighting, and procedures for fixing common problems, I'll move on to more complex and subtle lighting. This is the type of lighting that in the past was used only in Hollywood films; thus, it has come to be known as "film-style" lighting.

As television and video production have become more sophisticated and as digital "film" making (there *has* to be a better term!) has emerged as an art, film production values have filtered down into the video world. The gulf between video and film has closed; some television series are shot on video and produced with the same production values as feature films. The standards for episodic television generally have increased dramatically, with major hit shows like *Law and Order* setting a high standard. Programs like *The Education of Max Bickford* are shooting episodes in hi-def 24p with high production values using sophisticated film-style lighting that simply was not seen in a series 20 years ago.

Film-style lighting has two major components: creating a realistic simulation of the eye's experience of the world and creating mood. It is here that lighting graduates from mere illumination to an art form that contributes as much to the experience of the viewer as the music and actors' performances. I'll deal first with the simulation of reality.

In order to light a set—or a real location—in a manner that allows the camera to capture the experience of the eye, the lighting director must spend a lot of time observing natural lighting

with an artist's eye. How do shadows fall? How does the spill from a table lamp change the color of the wall? How does the eye perceive the color variations between sunlight and incandescent light or firelight? You can't capture these impressions without a lot of observation and without mentally cataloging the minutiae of daily affairs in the same manner as a painter.

DPs often describe their art as "painting with light," and indeed it is. But the simile falls a little short because an oil painting is static, whereas film and video involve motion. Great portrait lighting is fine, but it might not work for a set in which many people are moving around. In live production, you also must deal with the motion of the camera, the motion of the actors, and even the passage of time. In some cases, lights will have to move during shots. Lighting for video or film is much more complex than lighting for a still painting or portrait.

As I mentioned in the beginning of the book, some of the methods used to simulate reality in film-style lighting are simply technique: tricks of the trade that are tried and tested. Some are not very realistic but are gimmicky tricks that the audience accepts without question. These practical shortcuts are the visual vernacular of Hollywood that we've all grown up watching. Any experienced film gaffer can toss these basic effects together without much thought; I'll cover some of them in the later sections of this

9.1 Establish a lighting diagram that starts not with the placement of instruments, but a rough plan of the set and a concept of where light comes from—the imaginary sources that you will simulate with real instruments. Even if your plan is very rough, it helps to keep visual continuity.

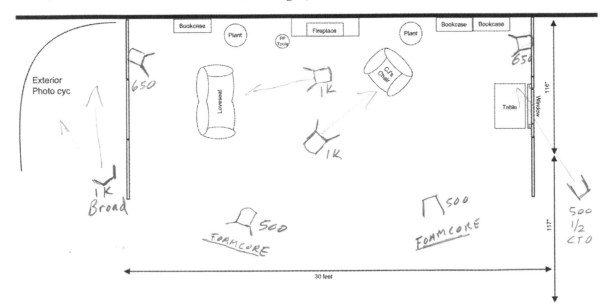

chapter. Really fine creative lighting often starts with the basic technique then advances by refinements that bring it visually closer to a sense of reality.

Lighting Overview

I'll start with an overview of a typical process.

Step 1. Lay Out a Lighting Diagram

The first step toward creating a realistic lighting scenario is to lay out the fictional and real lighting sources on the set. They might or might not be visible in the shot, but you must decide where the lights are that you are going to simulate. What's the primary light source? Where does it come from? Is it late afternoon? Do the windows face west? If so, then you will need golden sunlight streaming in the windows. Are there practicals in scene? If so, are they supposed to supply significant illumination on a subject or are they just decoration? If the main character is seated at a desk in a dark room, the desk lamp practical must seem to provide the illumination, even if the light is coming from an off-camera 500W fresnel. When shooting in the dining room, is the kitchen light on or off? It might seem that a slightly cold, harsh light should stream out into the warm, candlelit atmosphere of the dining room whenever the kitchen door opens.

Where is the main action, and where would the light come from? On a set you have to imagine the light sources. When you're shooting on location, you need to work with the existing light. Use the available light and augment it with reflectors and instruments as needed, but it is important to maintain consistency throughout the scene to preserve visual continuity.

Don't obsess too much about motivated lighting if there isn't an easily apparent light source. Audiences are used to seeing films that have light where the real world would be pitch black, but more on that later in the section on night shots and dark rooms.

Step 2. Establish Action, Close-ups, and Mood

Establish the main action of the scene and frame the initial main shots. What areas of the set need to be well lit and what areas are less important? Where are the key marks on which actors will stop? What close-ups are required? Is the lighting "straight" or does the director want to capture a particular mood? What other shots might be needed? You need to ask a lot of questions before moving lights; otherwise, you'll have to move the lights a second time! Start setting up the key lights with actors (or stand-ins) in place so that you can judge the effects on the production monitor.

Step 3. Establish Exposure

Often, you need to decide on and light to a target exposure. If you want a shallow depth of field, you need to run a very low F-stop (see the sidebar "Achieving a Shallow Depth of Field in Video"). However, many DPs like to pick a stop nearer the middle of the range because it is there that the lens performs best for image accuracy. Set the exposure on the camera and light to that exposure. You might have to make some compromises, but it's best to work toward a target rather than being haphazard about it.

Step 4. Begin Setting Key Lights

Because you have already established the camera shot and the critical areas you're lighting, you can focus on them first. Go back to your mental diagram of the main lighting sources in the "room," and set keys from directions that simulate those light sources. In other words, if the room is lit from a central chandelier, keys to different areas should radiate out from that central area. On the other hand, if the room is dimly lit by a floor lamp and a table lamp, keys should seem to come from them. If the room is lit by sunlight coming in the window, then keys need to come from the direction of the window. This process seems obvious, but I've seen a lot of expensive television shows that had a key coming from the opposite side of a dramatic lighting source.

Achieving a Shallow Depth of Field in Video

DPs who work with 35mm film are often frustrated by the available depth of field (DOF) on video cameras. Having a shallow DOF, in which the subject is in focus and the background is either soft or definitely out of focus, is often a useful effect. However, it is harder to achieve in video than on film.

The basic physics of the DOF relate to the physical size of the image at the focus plane—in other words, the size of the film frame or CCD on which the lens projects an image. The larger the area of the target, the easier it is to achieve a shallow DOF. Current video imaging chips are physically much smaller than film frames, so they offer less natural ability to create a shallow DOF. For example, a $^2/_3$-inch CDD typically has an imaging surface that is about 8.8mm wide by 6.6mm tall (the $^2/_3$-inch designation refers to the outer case, not the active imaging area). This is roughly similar to a 16mm film frame, which is about one-third the size of a 35mm frame. Obviously, $^1/_2$-inch CCDs have less natural ability to create a shallow DOF than $^2/_3$-inch CCDs. With the tiny $^1/_4$-inch CCDs used in consumer DV cameras, it is almost impossible to achieve anything resembling a shallow DOF. In fact, those cameras are in sharp focus over such a deep range that many lens filters do not work on them.

DOF is affected by lens aperture: a smaller aperture creates a deeper DOF and a wider aperture offers a shallower DOF.

DOF is also affected by the length of the lens: at the same F-stop, a wide-angle lens has a deeper focus than a telephoto lens.

Combining these two factors, it is possible to create film-like DOF for particular shots using video. First, shoot with the zoom lens partially zoomed in, at least in the middle of its range. Next, light for a nearly wide-open lens—f/2.8 or f/1.4. Either use less light or put a neutral-density filter on the lens. Together, these steps allow most cameras to create the shot you are looking for.

Because a shallow DOF is most commonly used in medium close-ups and close-ups, this technique will work well. However, it is usually less practical for creating a shallow DOF in wider shots.

The following fixes produce a shallow DOF.

$^2/_3$-inch video (14mm lens) focused at 1.5 meters (5 feet)		$^1/_3$-inch video (7mm lens) focused at 1.5 meters (5 feet)	
f/2.8	1.2–2.1m (3.8–6.9 feet)	f/2.8	0.9–3.6m (3.1–11.8 feet)
f/4.0	1.1–2.6m (3.5–8.4 feet)	f/4.0	0.8m to infinity (2.3 feet to infinity)
f/5.6	0.9–3.6m (3.1–11.7 feet)	f/5.6	0.7m to infinity (2.3 feet to infinity)

Step 5. Watch for Problem Shadows

One of the constant problems with television lighting is handling problem shadows: shadows that draw the viewer's eye in a distracting way or that seem unnatural. The most common of these is the shadow of an actor on a light-colored wall. Other problems can be caused by plants, flowers, or other set pieces that cast oddly shaped shadows. It's best to keep actors as far away from walls as possible unless otherwise required by the script. This will keep shadow problems to a minimum.

Step 6. Create Accent Lighting

Accent lighting can be anything from "sunlight" streaming through a mullioned window and casting a pattern on the floor and wall to splashes of light on set walls from table lamps. In short, lighting accents are anything that breaks up a flat, featureless area and adds realistic lighting texture. Some gaffers call these accents "sprinkles." If there's a fire in the fireplace, obviously you need a simulated flickering accent, but it's also not unusual to have unexplained splashes or slashes of light that are really there just to break up a monotonous wall.

Step 7. Bring in Fill

Now add fill light. Depending on the look you're going for, you might need a lot, so that shadows are only a couple of stops down from highlights, or a little, where you want a dramatic low key look, but want to see details in the shadows. At a bare minimum, you should have some signal above "flatline" 7.5 IRE black in every area of the picture. Don't get trapped in the amateur idea that fill ought to be consistent across a set. In real rooms, the light level varies throughout. You can leave one section darker or more shadowy and have lower contrast in other sections. Just make sure that the variation has some logical relationship to the imaginary lighting plan. In other words, you don't want dark shadowy areas that ought to be fully lit. Don't feel slavishly bound to duplicate reality, either. Just as music and shot direction are the province of the director, shadows and light quality that establish mood belong in the gaffer's bag of tricks. It's not uncommon to

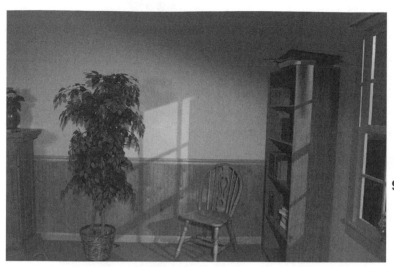

9.2 The simulated sunlight through window panes is an example of accent lighting. The angled shadow near the top of the wall was created with a cutter.

enhance or exaggerate lighting differences to direct the eye: to make dark areas darker than they would be naturally and accentuate dramatic focus with higher lighting levels.

Step 8. Add Shadows

You might want to add shadows with flags and nets or other lighting controls. Shadows direct the eye toward brighter areas of the picture, often the human face. More often, shadows work to *not* draw attention to an area of the picture. They can also enhance the realism of the lighting. One common technique is to use angled cutters to throw a shadow on the upper area of flat walls. Not only does this break up large areas of blank featureless walls, it also simulates the sort of lighting pattern that occurs in many real rooms. These shadows also serve to aid the viewer's sense of depth and enhance the illusion of reality.

Step 9. Control Hot Spots

Now you need to find those pesky hot spots and knock them down. Because actors aren't static on a set, you might find that lighting that works fine for most of the scene becomes a problem as people move about. As an actor moves toward an instrument, the inverse square law comes into effect, and suddenly the light is too hot. You can solve this problem with strategically positioned

9.3 Nets can reduce light levels as a moving subject gets closer to the instrument. Often two are used to provide a gradual reduction in light. Because the net has one open side, there is no hard shadow from the frame to call attention to the transition. The slang expression for the act of floating a net in and out in front of an instrument is "to Hollywood the net."

nets or by backing the light off for the part of the scene in which the actor moves.

When a light shines across a set, the furniture and floor near the instrument could be too hot. You can solve this problem with $1/2$ scrims inserted in the holder behind the barn doors.

You can come up with your own variations on this basic procedure, but the general outline covers the bases. Whether you set the fill first or the key isn't essential, as long as the end result works.

Establishing Mood

I mentioned a moment ago that lighting is part of the director's bag of tricks. It is no less important than music or the emotion of an actor in conveying mood to the viewer, so using light design actively to convey mood is an important part of the lighting craft.

What mood does the director wants to convey? Joyousness? Love? Depression? Ominousness? Together, the DP and the lighting designer can create subtle variations that will help convey that mood. The possibilities here are so complex, I can supply only a few examples.

- Young lovers walking in a wood in springtime might need a base key of warm, slightly amber light with lots of diffusion. Spots of dappled sunlight—harder light through a cookie—accent the scene. In the past, the DP might have used a silk stocking on the rear of the lens to soften the scene, but these days a diffusion filter would be the choice.

- A murderer is stalking our hero in a warehouse. Where is he? Most of the warehouse is dark, with areas of very dim light. Small pools and slashes of light are here and there—from a door, from a tiny window. There's just enough light for the audience to catch a glimpse of the killer behind the hero, but when the hero whirls around, nothing is visible. The addition of sharp-edged music and carefully chosen shots can build high levels of tension.

- The protagonist is introspective, reflecting on the events of the day. Here, a dark set is effective when lit with a table lamp, a reading lamp, or in a period drama, a candlestick. Perhaps

there is a fireplace, with a flicker effect from an orange or amber light to the other side of the key light.

- A woman in turmoil stops in church to pray, to find reassurance. As she enters the church, she relaxes. Lovely colored light streams in the stained glass windows. A bit of fog in the air makes the colored light almost a physical part of the scene. You can see that something has been resolved; a sunbeam breaks through the rose window and falls on the altar. You gotta have some organ music, too.

- The same woman gets up the next morning filled with hope and optimism. Sunlight floods into her bedroom; the room is filled with light. Again, a bit of fog or diffusion spray in the air catches the sunbeams and makes them a physical part of the scene. As she looks out the window, she is close to overexposure, and there is a glowiness to the scene from a diffusion filter on the lens.

- A hostage is tied to a chair in a dark room. A lamp hangs over him, casting a pool of light. A streetlight outside shines through the single window, casting a distorted shadow of the window frame across the door. The door opens, and someone is standing there, backlit, in complete silhouette. The hostage catches his breath, expecting the worse. The figure takes a step forward into the room and into the light from the window, revealing his face. It is the hero: the hostage is safe; everything is great!

These examples, although perhaps not the most subtle, give you an idea of how to create mood. In every case, the lighting manipulates the feeling of the scene. In some cases, light and shadow, and particularly those conveniently placed slashes or pools of light, are used as a staging tool to conceal or reveal the action as it transpires. The light is more than just illumination; it is a player in the scene.

In many cases, the light isn't quite as active a player. Most of the time, you just want to get the scene illuminated realistically. The only thing you want to convey is "real room, real light."

Lighting Darkness

Interiors

Now it's time to take a moment to talk about lighting dark scenes, especially since I just postulated a few of them. The concept of lighting darkness seems to be one of the most difficult for beginners to get their minds around. This topic is my top Frequently Asked Question in the DV.com Craft of Lighting Forum.

Darkness in video and film is simulated, just like everything else. The set can seem quite brightly lit in person because you can't shoot in darkness. If you did, all you'd get is a black picture. If you're going to do that, why bother with sets and location? Just shoot with the lens cap on! The simulation, often referred to as *film dark* or *movie dark*, is not that hard to do. You just have to let go of some preconceptions. It's largely a concept of using shadows and dim lighting as positive elements of the scene, just as you use lighting accents and kickers.

Plan the mood and establish the action. What essential parts of the action do you want visible? Which parts of the action could pass into shadow? Slashes and pools of light and areas of shadow need to work together to make the scene work. Usually, you don't want large areas of flatline black. You need just enough fill to cause most areas of the room to "read." Although you might not want the detail to be distinguishable, you do want the viewer to perceive the sense of the room, just as you would in a dark room

9.4 In a scene similar to Hitchcock's *Rear Window*, the author pauses—his face clearly illuminated by a slash of light. Please note that the author weighs much less than Raymond Burr.

after your eyes adjusted to the darkness. Vague shapes and shadows are fine. In areas where the action can pass into shadow, you might want a spot or slash of light on the wall *behind* the action so that the actor becomes a distinct silhouette.

Which of several techniques for lighting the principal action in a dark room you pick depends on the look and feel you're trying to create.

The first technique is to create "motivated" areas of illumination at key points in the set—light coming in through a door, moonlight through a window, a single practical that leaves most of the room in darkness, even unexplained slashes of light. Key points in the action are tied to these illuminated areas. There's a great example in Hitchcock's classic *Rear Window*. At the beginning of the famous flashbulb scene, the villain (Raymond Burr) enters Jimmy Stewart's darkened apartment. Burr appears as a silhouette in the door, then his movement is silhouetted against a slash of

9.5 In this bedroom scene, the bed is fully illuminated, while the rest of the room is dimly lit with a cucaloris pattern.

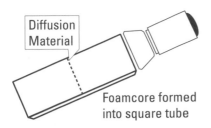

9.6 A square tube snoot formed out of scored foamcore can provide a controllable pool of soft light. Tape a piece of diffusion material partway into the snoot and mount it in front of a fresnel.

light on the wall. He takes a single step forward and pauses. His face is in the slash of light. Stewart can see for certain that it is Burr! If you think for a moment that the move was a happy accident, you don't know much about Hitchcock. Having a principal in a scene move from shadow to light can be very effective, especially when the mood is one of suspense or fear. At one moment the figure is a moving silhouette. In the next, the actor is clearly illuminated for a fleeting moment.

A second method, which works very well when the eyes or features of the principal don't need to be visible, uses a backlight or kicker. A common trick is to use moonlight blue as a kicker for the whole scene—but not too blue, please! It's often used at low level throughout the room with no effort at realism, and it is accepted by the audience. To make it a touch more realistic, you'll want to rig the moonlight streaming in windows with mullion shadows and areas of darkness. A variation is to have blue moonlight as a kicker from one side and warm light as a kicker from the other side. Maybe it's a streetlight that shines in the window, who knows? The audience really doesn't care, they'll accept the fake without questions.

Combining the slashes-of-light approach with the moonlight-kicker approach can be very effective.

The third method, which probably is used far more often that you realize, is to abandon realism and illuminate the principal in the scene fully, while creating a sense of darkness in the surrounding area. In Chapter 1, I mentioned a scene from the Elvis movie *G.I. Blues*. The central area of the room is lit fully. The rest of the room is lit in moonlight blue, cast through cookies to break the light up into a dappled pattern. It's not realistic, but it works. It's just part of the Hollywood vernacular, we're all accustomed to Figure 9.5.

In many cases, you will need to create a "dark room" look in which an on-screen practical illuminates the main subject. The practical can range from a reading lamp (as in Figure 9.7) to a candle or lantern in the subject's hand. If the practical is exposed properly, it will not cast enough light to illuminate the subject well—the subject must be lit separately with a key that simulates light from the practical. This source is often a fresnel placed off-

camera at the approximate angle of light from the practical. You have a lot of fudge room here. Usually, the instrument is cheated forward by aiming the beam in front of the practical to avoid tell-tale shadows. The instrument is often raised a little above the actual level of the practical as well.

Exteriors

The unmotivated full-lighting approach often is used in exterior shots as well. Just start watching movies with an eye to the lighting. Soon, you'll realize how much hokey lighting and how many fake tricks you swallowed without question!

Lighting dark exteriors isn't that different from lighting dark interiors. Much of the concept is the same, but it will require more light power, and it will have to be executed differently because of the larger areas you'll need to fill.

9.7 A softbox simulates the light from a reading lamp. Depending on the level of light you want falling on the surrounding walls, an egg crate might be necessary to control spill. In many cases, a fresnel will provide more precise control but sacrifice the soft quality of the light.

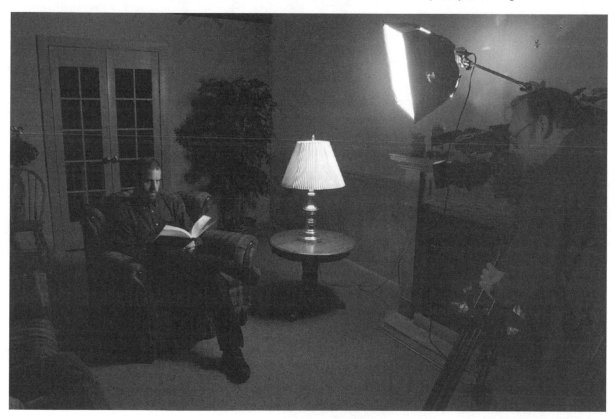

Generally, you want enough fill light to make everything in the background just visible. Then you want to light the main action in a manner that conveys the impression of the situation. I'll provide a couple of common examples.

9.8 This exterior scene *(top)* uses low-level illumination of the background, with the subject lit almost at full levels. Where is the light coming from? Who cares? In person, the scene seems to be very brightly lit *(bottom)*, but the end result on-camera is quite effective.

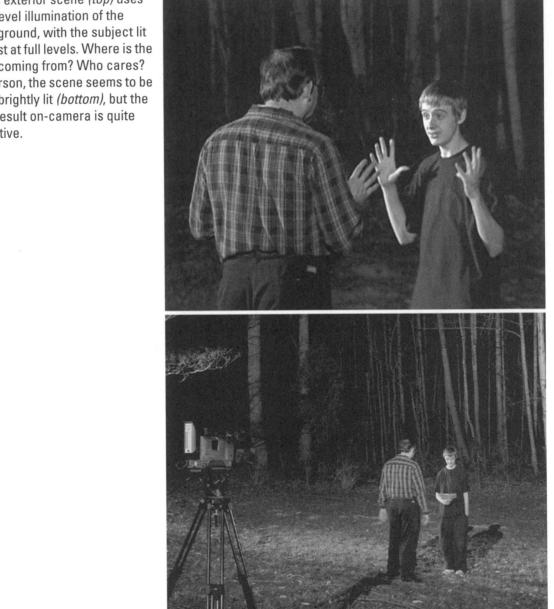

- The main characters are walking down the street at night. They pass through pools of light cast by streetlamps and light streaming out from the windows of the few businesses that are still open. If you expose to the streetlights (they're large practicals) and then put broads inside a window or two gelled with bastard amber, then the rest of the scene will be a flatline black. To add detail to this area and make the characters visible while they are between pools of light, you'll need to add a blue source to simulate moonlight over the entire scene. Usually this is done with an HMI; with the camera white balanced to quartz, the HMI will run blue on tape. You'll probably need to enhance the pools of light from the streetlamps with fresnels, too.

- A car drives slowly on a deserted road. The headlights sweep across the scene as the car rounds a bend, revealing a person

9.9 Walking through the haunted woods! Mist from a glycol fogger catches the light from the off-screen HMI and gives body to the scene. A softbox from the opposite side provides just enough fill to allow the shadowed side of the subject's face to read.

walking by the side of the road. Just as in the previous scene, if you don't light the scene, all the viewer will see is the cones of the headlights. You won't see the car itself or have any perception of the surroundings. Again, an HMI can seem like moonlight, casting just enough illumination to bring out a vague perception of the surroundings, making the car visible. You might be surprised by how much illumination you need to do this! If the car headlights point toward the camera at any time, you can have even more of a problem providing enough light for the scene to read. Often it is helpful, particularly in street scenes, to point the HMI toward the camera. Just as with backlights and kickers, the light "skips" off the pavement and into the camera. A lower powered instrument can light an amazing area this way.

Another common method of maximizing light for a night shoot is the use of smoke or mist. A light fog will render the HMI moonlight as a blue haze, bumping up the general light level while maintaining the sense of nighttime. A heavier fog or smoke will give the light an almost physical presence in the frame and can be very effective. There are several methods of creating smoke (aside from a fire!) or fog. The main methods in use today are glycol-based foggers like the Rosco fogger and oil "cracker" smoke. For

9.10 The author hams it up as Romeo Schwarzkopf in that famed production *Basic Lighting for DV.* Note how every part of the scene is exposed and there are few areas of solid black. Only his friend Cyrano de Burgerbun, who is off-camera feeding him his lines, is not visible.

more limited effects, a canned mist spray is available to give just a hint of body to the air to catch the light.

- In a classic example of a simple night scene, Romeo delivers his famous lines to Juliet in the balcony. A tightly focused fresnel gelled amber or slightly orange ($^1/_4$ CTO) illuminates his face looking up to the balcony. A broad from the rear with a $^1/_2$ CTB gel simulates moonlight on the castle wall and on Romeo's back. As a refinement, you might use two blue-gelled lights: use the first as fill, then shoot the second through a cucaloris to create the dappled effect of moonlight coming through leaves.

You might have noticed that, when rolling tape or film, the moon is always out. Period. Blue light is simply one of those effects from the Hollywood vernacular that we accept as night. It has often been the practice to use very blue light (full CTB gel), but as more realistic lighting has prevailed, many lighting directors have tended toward a more subtle effect. When balancing to a quartz source, a $^1/_4$ or $^1/_2$ CTB is plenty.

One effective fake for moonlight is a daylight source inside a large China ball hoisted on a crane. Many directors have come to use a source inside a white helium balloon that is tethered 40 feet or so in the air. The effect is quite convincing. Several companies, such as Airstar Space Lighting, make balloons for just this purpose.

Daytime Exterior Contrast Management

Taping outdoors involves a number of challenges. You can't control either the weather or the motion of the big main key light 93 million miles away! Clear sunny days are too contrasty; heavily overcast days don't provide enough contrast. For news, documentary, or incidental shots, these are fairly easily solved. For dramatic work, where specific weather is called for and you need lighting consistency for long periods of time, the difficulties are more complex.

Bright sunny days present contrast issues: the nicer the weather, the more of a problem. The sun will act as a hard light source with no diffusion, casting harsh and ugly shadows on faces. The

Email Bag: Lighting on the Cheap

I frequently get e-mail from young producers working on low-budget films. You know the type—they shoot every Saturday and the pay is pizza if everyone is lucky! The scenes they want to create are similar to some of those I've already covered, but the bottom line of their question is always, "We don't have a budget, how can I do this with Home Depot worklights and a flashlight?" Good lighting doesn't have to cost big bucks. It's more in the concept and artistry than in the instruments. That said, here are a few real suggestions to cheaply light exterior dark scenes, right from the DV.com Lighting Forum.

No-Budget Night Shots

B.L. writes: Can anyone give me any suggestions for lighting ideas for a NO-budget project. We are shooting half interior and half exterior at night. We have no budget at all …. Are there any good guerilla tactics to use for lighting? Any help would be appreciated.

Jackman responds: Lighting doesn't have to cost much. The best work comes from the imagination and observation, not expensive instruments. The two main rules are to make sure that the image is properly exposed—not overlimit and with enough light that the camera doesn't have to go into gain-up. This last is especially true if using a Sony VX1000.

Beg or borrow a couple of worklights or those clamp-on reflectors. Eat one less pizza and buy some photoflood bulbs at the photo store. Get some aluminum foil to control the spread of the light.

Night shoots are a favorite topic of mine, and a trick that lots of folks seem to have trouble grasping. You have to *light* the night shoot! Please go watch a few movies with night scenes and deconstruct how they are lit. It's usually from the side or toward the rear, creating a few fully lit areas and lots of dark shadowy areas. Moonlight seems blue, so the convention is to use blue gels on the lights. If you're too poor to buy gels, then point the camera at a pastel yellow card (rather than white) and do a manual white balance to shift the camera image toward blue.

Deserted Road Tricks

E.L. writes: I will be shooting a short film soon and it involves four persons, in a car on a deserted road, in the middle of the night. I will (probably) be shooting on a mini-DV camera (and for sure) in black and white.

1. What is the best way to light the interior of the car? (A small, not so big, European car.)

2. Can I get enough light off of the main headlights of the car—I'm not in the position to transfer heavy lighting equipment to the "set"—this is because they [*the actors*] will be wandering around the car and close to it, terrified of what might be hiding in the dark.

effect will be worse toward midday because of the inherent ugliness of direct overhead lighting. It's actually a lot easier to capture nice video on slightly overcast days, when the sunlight is already diffused; the contrast range is naturally compressed, and often you end up with slightly more vivid colors, especially greens. The problem is that you might not want to shoot with an obviously overcast or cloudy sky as a backdrop. If the glorious blue sky is what you want behind your subject, you'll have to do some work to get the best end result.

There are several solutions to this problem, which often need to be used together. Anytime the problem is too much light in all the wrong places, the solution of choice is bounce cards and reflectors. On a bright day, these can function as active lighting elements just as well as standard instruments, but they have the advantage of requiring no power! Mirror and silver reflectors can act as keys from different angles and can bounce intense light into areas the sun isn't reaching. Gold reflectors can simulate the *golden hour* for longer than the 30 to 40 minutes of perfect shooting time the real golden hour provides. Beadboard and

A Struggle with the "King of Darkness"

New filmmakers aren't the only ones that have a tough time grasping the concept of lighting darkness. Ron Garcia, ASC, has a great story about a shoot in a dark forest.

"During the filming of *Twin Peaks: Fire Walk with Me*, we had to shoot a night scene between Laura and Bobby while they were waiting to do a dope deal in the woods. David Lynch did not want to use any movie lights at all! He wanted the kids to use a flashlight (just one). I explained about photographic darkness, but this was David Lynch, King of Blackness in Spirit and Photography—he was adamant about the scene not looking as though it was lit. He asked, if I used motion picture lights, where the light would come from naturally in the middle of the forest? I said the light would come from the same place the music comes from—he didn't laugh!

"Ultimately I talked him into using a small handheld Xenon light and instructed the actor (Bobby) to always try to light himself and the other actor while they were talking. Then I told David I'd kill myself if I couldn't at least bounce a 1.2K HMI par into the overhead pine trees (he thought the bead board was too bright). He finally agreed and we shot the scene."

—Ron Garcia, ASC
—Reprinted with permission of The ASC and *American Cinematographer.* © 2002.

Good suggestions from other forum members included:

- Try using day-for-night
- Use Kino Flo T5 bulbs to illuminate the car interior
- Use a flashlight bounced off a small white card to illuminate the car interior
- Use a Lowel Omni Light with a 250W 12VDC bulb.

Jackman responds: Okay, these are good ideas, but here's the rub: most folks don't foresee: "… in a car on a deserted road, in the middle of the night."

Is it your intent to have absolute inky blackness around the car? That's what you'll get. The audience won't really perceive "deserted road" at all. The shot could be done in a driveway. In order to expose to headlights and allow the camera to read the surroundings, you need some low-level general fill. Usually, this would be done by bouncing an HMI off a reflector, but that doesn't sound like an option.

Try this: Use a second car off-camera and bounce the headlights off a white bedsheet stretched out and held 45° to the front of the car—just enough fill to barely see detail, to understand the setting. You *don't* typically want inky black, even in scenes that are supposed to be in pitch dark.

And this: Tape $1/2$ CTO (color to orange) gels over the on-camera car headlights and white balance to those. This will reduce the light output somewhat and also force the camera to see the bounced fill from the other car shifted to blue. The colors won't matter if you're ending up in black and white.

As for the car interior: yes, the Kino T2 or T5 is great, but on a low budget, I'd opt for a cheapo 12V map light or trouble light from the auto store. Just gaffer tape it to the instrument cluster shining up into the driver's face.

Now: Have a THIRD car there with jumper cables so you can jump the other two and get home!

Cheap Portable Power

D.F. writes: So, I'm getting ready for my first project. Very short film. Part of it will be in the desert at night, so we'll need to light it. The problem being … where do we plug the lights in? Keep in mind, this is very low budget here.

I've been doing some homework. The first idea that came to mind was we could try an adapter for a car lighter! I found some. But they seem to be $70 or more. For not too much more, I ran across this "portable power" battery that will run 250 watts. But I'm not sure how long the lighting will last on that thing.

white cards can act as kickers, backlights, and fill. Bear in mind that many early films were lit entirely with reflectors.

However, although reflectors can rearrange the light, they cannot change the basic hard quality of direct sunlight. For this reason, a light diffusion fabric is often used over the subject in addition to reflectors. This can range from a 30×36-inch scrim (just enough to diffuse light on a face) to a 6×6-foot or 12×12-foot butterfly.

Exactly the opposite problem crops up on a heavily overcast day. Gray light seems to come from everywhere (in fact it almost does), and the lighting is stale, flat, and unprofitable! Intervention is required to punch up the contrast to create some modeling on the subject's face: add light to one side or take it away from the other.

The first approach is fairly obvious. A silver reflector as a key bounces additional light from one side onto the subject. Live instruments—usually HMIs—provide key light and ambient light the fill.

The second approach, taking light away, might not be as obvious. It's a technique known as *negative light*, but despite the science fiction sound, it's fairly simple. A large, flat, black object—a flag, gobo, or butterfly—is placed on one side of the subject just out of camera range. The black flag seems to magically suck light away from one side of the face, deepening the shadows—hence the mysterious-sounding name.

In reality, negative light isn't all that magical. On a heavily overcast day, light really does come from everywhere because the cloud cover acts as a single huge light source. What the black flag

9.11 A butterfly diffuses the direct sunlight and knocks it down a half stop. A silver reflector acts as a kicker, and a white bounce card provides fill.

Not to mention, I'm still looking into how many and what kind of lights I'll need (feel free to suggest anything for that I'm filming in MiniDV, BTW).

Am I missing any other/better option for power? Thanks for any feedback!

Jackman responds: If you're really tight on $$, why don't you try rigging up some 12V lights and running them right off the car battery? Buy a hi-beam bulb for a four-light older car and mount it on as high a stand as you can; best at least 12 feet or higher. Run wires right to a battery. Or, use one of those "million candlepower" spots you can get pretty cheap at Pep Boys.

Do a manual white balance, pointing the camera at a pastel yellow card (maybe a yellow legal pad) to make the white balance skew blue. Make it look like moonlight.

You could then use the "portable power" battery to jump-start the car so you can get home!

Do not, under any circumstances, shoot with the camera exposure on *auto* or I will come to your house and personally revoke your independent filmmakers license!

does is block the light from one direction, casting a shadow and absorbing (not reflecting) light coming from the other direction.

Dealing with outdoor lighting for drama can be quite a bit more complex. Taping a single scene can take all day, but the component shots must intercut with a cohesive look. The light can't shift from morning to noon, back to morning, then late afternoon! Both careful planning and lighting control are required.

Planning is essential for efficient outdoor shoots. Sunrise and sunset data and careful orientation of shot planning (you did take a compass when scouting, didn't you?) must be combined with up-to-date weather reports. It is easy and cheap to control lighting for close-ups, but wide shots must be planned for optimal lighting conditions. This is especially true if the weather will be changing during the day.

Sometimes the best planning just doesn't do it, however, or the weather doesn't cooperate with your schedule. That's when brute force must be used and 36,000W FAY arrays or 12,000W HMI fresnels substitute for the sun. However, the brute force method is expensive. If your budget doesn't reach to include a full lighting truck, then you'll have to make your schedule fit the weather, rather than the other way around!

Light Surgery

I've mentioned several times now the use of shadow as a technique to direct the attention of the viewer away from the shadowed area and toward the strongly lit area. Light intensity is very powerful when doing this. Shadows, or reduction in light intensity, combined with diffusion can also seem to reshape problem spots, or at least avoid drawing attention to them! Classic problem areas in close-ups include protruding ears, double chins, wattley necks, puffy cheeks, acne scars, and, of course, the facial wrinkles that the ladies are so sensitive about. I'll look at a couple of examples.

A tight head-on close-up of a subject with protruding ears or fat cheeks can look very different from longer shots. The cheeks and ears catch the key light and seem more obtrusive than in longer shots, and the viewer's eye is drawn to them. If the head-on shot is necessary, you can perform light surgery. Two single fingers mounted in a "V" formation can drop the light level hitting the

9.12 A large black flag placed just out of frame can increase contrast on a bleary day. The technique is known as *negative light*.

problem areas, preventing the eye from being drawn to them. The ears are still big, the cheeks still fat, but they are no longer accentuated. They're no longer problems. Neutral-density gels, cut to shape and taped to a wire, also accomplish this effect. Similar techniques can be used to direct attention away from wattley necks or double chins.

Wrinkles and acne scars are more difficult to deal with but can become a critical issue. If shooting techniques mask these subtle flaws for most shots, it can be jarring to the viewer to suddenly have a close-up that reveals age or scars. Here, a combination of techniques is necessary. First, avoid any hard kicker light that will accentuate the flaws. An ounce of prevention is worth a pound of cure! Second, use a heavily diffused key. A softbox is best. Find the most flattering angle for the key. A little experimentation will show that some angles are much better than others.

Legendary DP John Alton used to use a 60W houschold bulb mounted on a threaded wand to find the best angle for a key in tight close-ups. With all other lights out, he would move the wand-mounted bulb around and in front of the subject's face,

9.13 A drizzly day on the set of *Providence*. A 12×18-foot butterfly provides negative light to punch up the contrast a bit. Courtesy Red Herring Motion Picture Lighting.

noting the effects. It allowed him to experiment with a variety of angles quickly and efficiently before moving heavy instruments. After finding the most flattering angle for the soft key, soft fill can help eliminate any remaining problem areas.

A small amount of soft fill from below can work miracles. It's my understanding that this technique is used for the aging Dan Rather, whose news anchor desk incorporates tiny T2 Kino Flo bulbs that shine up into his face, filling in the wrinkles. If you

9.14 The author has always been blessed with large ears—the better to hear you with, my dear! These can be a problem in tight close-ups. Two single (or double) fingers can reduce the light to the problem areas only, preventing the viewer's eye from being drawn to them.

watch carefully, you'll notice that he slides his script pages—picking them up to turn them over would cast a shadow on his face, exposing the gaff!

Some work on the camera side might still be necessary. The classic solution is a stocking on the rear of the lens. Many DPs have found a special relationship with a specific brand of stocking for this purpose—and they can be most particular about it! Diffusion filters on the front of the lens can also minimize remaining imperfections. Popular choices include Tiffen's Soft/FX, Pro-Mist and Black Pro-Mist, or Schneider's Classic Soft and Black Frost filters.

Today's cameras also provide electronic fixes for skin flaws. Most professional cameras provide separate control for skin detail, which allows a softening of detail in areas of the picture that match a user-selectable skin tone. Because this control does not reduce edge sharpness, it doesn't make the picture seem blurry; it just smoothes over those wrinkles and other blemishes. The combination of reduced skin tone with soft light and a mild diffusion filter can have an amazing effect on blemishes in a close-up.

Chapter 10

Specialized Lighting

Although the general principals of lighting won't change, certain setups call for specific techniques. I'll look at a few of these specialized situations in this chapter.

Product Shots

Product shots call for special care and handling for several reasons. First, the client wants you to make their (sometimes unsightly and hard-to-photograph) product look dramatic, attractive, and exciting. Unlike the still photographer, the product or the camera or both could be in motion. You might have a contrast challenge when you put lights on a black product. Another product could look like a white blob from many angles, without distinguishing features to help the viewer understand what it is. Whatever the product is, it's your job to figure out a way to light it and make it attractive.

First, I'll take you through a case study of a new-model home VCR. This product is basically a black box with black buttons and black letters. The only distinguishing features are bright red LED indicators and a green digital display. Right away, I have a dual problem. I need the LED display to read on-camera while giving some shape and texture to the featureless, dull black box.

The first lesson, and one that is very important for many product shots, is that dark objects are given shape and texture by what they reflect. This is true even for objects with a very flat texture.

Remember, black absorbs all light frequencies, so simply dumping lots of light on the black object doesn't work. You have to give it something to reflect.

This is even more true of shiny surfaces of almost any color, and a lot of products out there have shiny surfaces! In many ways, no matter what the object, color, or texture, product photography often boils down to creating and managing reflections.

I want to give the black box something, preferably several things, to reflect. Each surface of the VCR must be treated separately. But before explaining the actual setup, I have to establish an exposure range that accommodates the LED display.

The LEDs are an on-screen practical and represent fixed light values, so I must set the camera aperture to expose the LEDs correctly and then light to that exposure. First, I establish the shot, then I make a decision about the motion. Does the VCR rotate slightly? Does the camera move in relation to the VCR?

I've decided to move the camera in this setup with a boom arm starting at a low dramatic angle and looking up at the control panel and LED display. Then I'll pull out and up until I can see the whole VCR from slightly above.

10.1 Lighting Diagram for VCR product shot.

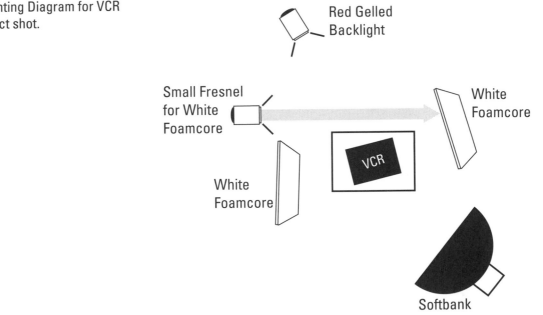

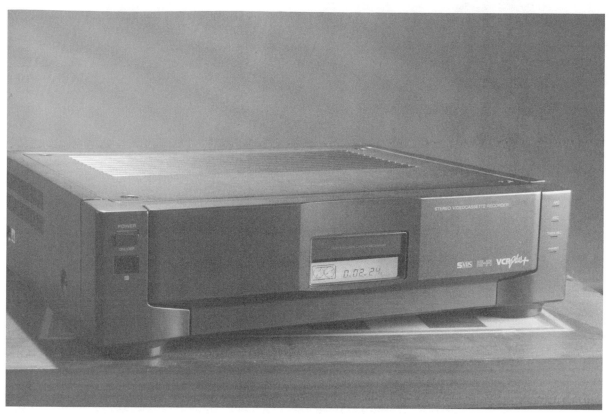

A large softbank on the side opposite the camera will illuminate the front panel, giving a large white light source for the semigloss black plastic to reflect and creating highlights and shadows on the lettering and buttons. Again, the intensity of the softbank must be varied to stay in line with the exposure already set to capture the LEDs. However, I don't want to vary the intensity of the softbank by using distance; I want the softbank as close to the VCR as the shot will allow. I might have to change out the bulb for a different wattage, use a dimmer (remembering to white balance to the dimmed color temperature!), or use black silk or organza on the front of the softbank. When the balance is right, the highlights will glisten and the LEDs will just pop!

That takes care of the opening shot, but now I need to look at the end of the shot, when the entire unit is visible. I need some white cards on the black sides of the unit for reflection. I'll position a white foamcore off the side of the unit; it will catch enough light from the softbank to do the trick. Now I need to make the black expanse of the top interesting.

10.2 White cards and a colored backlight create shape and texture on this featureless black VCR.

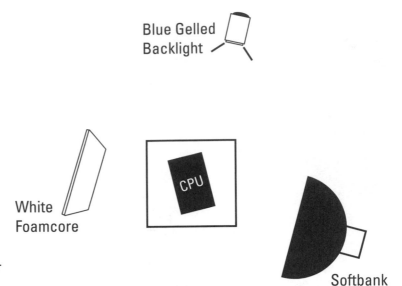

10.3 Lighting diagram for computer product shot.

I'll position a white foamcore on the other side and light it with slash from a small instrument to create a sort of splash of reflection on the flat top. Then I'll add a touch of color from a red-gelled backlight that is positioned to create a color splash highlight on the rear corner of the VCR. Here, the slightly rough texture of the painted metal top catches the colored light and diffuses it. The color is a bit hard to see in the black and white rendition (Figure 10.2), but I hope you can use your imagination! Voila, shape and texture where once there was a featureless black box!

Now I'll jump to the other extreme and shoot a featureless white box—a computer. Many of the same lessons apply. I need to create reflections and highlights on the computer case and create shadows. I will pick a side of the box to be in shadow. In most shots, there isn't much choice. I'll use the side near the camera. I'll position the key light, preferably a large softbank or fluorescent instrument, on the side away from the camera and experiment with the height. I don't want to make it so high that the top of the box is hot, but I'll handle that separately later. I'll make the angle oblique enough to create shadows on the front panel. Fill light from the opposite side probably can be of very low intensity, or even just a bounce card. Remember, I'm dealing with white objects here! They can catch light in ways I don't intend.

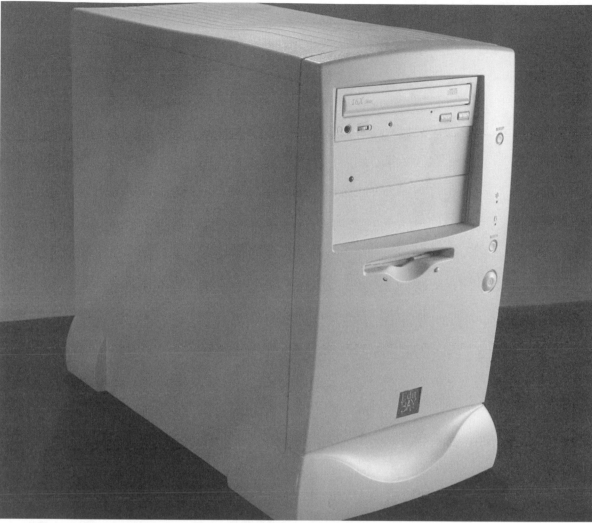

I'll create something slightly interesting on the top panel, just as I did with the black VCR. A colored kicker will help shape the box. I'll use a ¹/₄ CTB gel and focus the kicker on the rear camera side corner. The resulting bounced light from the kicker is again diffused by the texture of the case, but concentrates on the corner, leaving the front off-side corner a darker value. A final refinement might be a little splash or slash of light on the shadowed side toward the camera.

At the other end of the spectrum are clear glass objects. One of my company's clients who received an ISES Award, which is a hand-blown glass sculpture, needs a good shot of it.

10.4 A putty-colored box. Managing the light and reflections on each side separately allows you to create some visual dimension to the featureless box.

Shining direct light on a glass object just doesn't do much. Just like the black VCR, I have to create and control reflections that allow the eye to interpret the shape of the object. The simplest way to do this is to provide two large white surfaces off either side of the camera for reflection. In this case, I'll use a softbank to camera right, providing the main illumination to the scene and a large white surface to reflect. On the opposite side, I'll mount a fresnel that lights the award and a large piece of white foam core. This arrangement creates contour on the other side of the sculpture. Finally, I might experiment with a hard backlight shining through the award. This light will catch the engraving and add a sparkle here and there, although it will do little to light the object overall. The backlight can sometimes be very effective with a touch of color—a shade of blue or magenta, for instance.

When shooting an object like the glass award, try using a star filter on the camera lens; it's a cliché, but a highly effective cliché. Adding a diffusion filter causes the reflected highlights to glow just a bit, and motion allows the audience to perceive the object in different ways. The best motion for this object is rotation under lights so that different angles catch the lights in different ways and cause dynamically moving reflections. A turntable makes this simple.

10.5 Lighting clear glass is mainly a matter of creating reflections that reveal the shape of the object. With a curved or irregular object like this ISES Award, rotation is very effective.

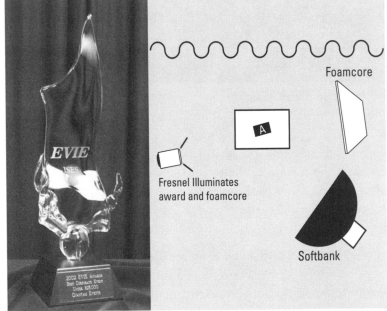

These basic tricks will work for most types of products. You might want to use huge softbanks or large silks for larger objects. For chrome objects, you can fake a bit of the real world for the object to reflect, just as 3D animators do with reflection maps. Try using a large travel poster positioned at just the right angle to reflect in the chrome surface. Abstracts can be nice, too. For shiny objects, rotation or other motion that changes the relationship between the lights, the object, and the camera gives the eye interpretive information and looks cool!

Food Shots

Taking a picture of food and making it look appetizing is just as much an art as making a featureless black box look interesting. The general techniques are not too different from those I outlined for product photography, but there is the added challenge of the time factor. In some cases, you will need to set up the lighting and the shot and then shoot with fresh hot (or cold) food during the limited period it still looks appetizing. In other cases, you'll need to resort to the many fakeries (e.g., mashed potatoes for ice cream) that allow you to work longer. In any case, you'll need the services of a food stylist or you'll need to learn some of their tricks (see the sidebar "Food Styling Tricks" on page 168).

Some folks feel that fakery is the best route. It certainly helps with the time factor. Others feel it is a point of honor to use the real thing. The client might insist on it, in fact. When shooting the real thing, you need to be ready to work with great efficiency. Set the shot and lighting with stand-ins, then plan on substituting a freshly cooked plate just before rolling tape.

Veteran DP Bob Collins once did a shoot for a famous pancake house and had to photograph every item on the menu. He created a jig that would hold each plate in the identical position. A chef set up a kitchen in the studio, and a production line was set up. The chef flipped the griddle cakes and passed the food to the stylist for quick arrangements and decoration, then the hot plate was placed in the jig to be photographed while the chef flipped the next set of flapjacks and warmed up the waffle iron.

How do you light food? As with most products, you have to give the surface of the food something to reflect. If there is a "stock setup" for food that will work in nearly all situations, it would be a large softbox above and to the rear. A huge number of the food shots I have seen lately are done this way. The diffusion on the softbox gives the food something to reflect and creates lovely transparent highlights on tomatoes, apples, and so on. The effect on nonshiny foods such as bread is also appealing.

Soup and other liquids require careful placement of lights. You need to create enough of a highlight on the surface to make it look shiny, but not so much as to obscure the basic color of the liquid.

Clear liquids in clear containers—beer in a glass or soda in a bottle—can be a special challenge at times. If the beverage has an interesting color, such as beer, you can fire a light through the liquid to cast a colored shadow on the tablecloth, on the edge of a plate, or on another piece of food. However, shooting against a dark background can be quite difficult. Try cutting a piece of paper to the shape of the bottle or glass and mount it on the side

Food Styling Tricks

Here are a few of the basics that food stylists use.

- Nonstick cooking spray makes food appear moist.
- Acrylic "ice cubes" don't melt and refract light better than the real thing.
- Table salt in beer or soda precipitates a dandy fizz.
- Nearly all food, especially vegetables and meat, must be undercooked.
- Grill lines are artificially created with a hot skewer.
- Random items such as sesame seeds on a bun often must be "doctored" by gluing extras in spots that seem bare.
- Substitute items often look better than the real thing. Real coffee just looks black, but a dilution of Gravy Master® looks dandy.

A faked plume of steam is essential above hot foods or cups of coffee. This is usually accomplished with a smoker under the table and a tube immediately behind the "hot" item. If the object is large enough, a small incense burner right behind it can do the trick.

The craft of the food stylist often boils down to carefully selecting the perfect bun and the perfect lettuce leaf and arranging the food with an eye for detail.

exactly opposite the camera. Light from the front now reflects back to the camera. If the fake is too obvious, try the same thing with a translucent diffusion material.

Remember, you'll have an easier time exposing and lighting the food the way you want if the tablecloth and plates are not pure white. Off-white or light gray will give you that extra latitude in exposure that you're looking for!

10.6 A basic starting point for most food lighting situations is a large softbox mounted above and behind the food.

Lightning and Fire

Two lighting effects often used in dramatic work are lightning and the flickering glow of a fire. Both can be simulated in several ways, some of which are more convincing than others.

Lightning is easy to simulate poorly but a bit more difficult to do right. The plain vanilla method is to simply flash a blue light, but this doesn't quite work because of the slow rise- and falltime of standard incandescent globes. This means that when the

instrument is powered up, there is a visible (if short) ramping up of the light from zero intensity to full intensity, and a similar (usually slower) ramping back down. Real lightning, on the other hand, has a very sharp risetime, might pulse a bit, and then has a very rapid falloff. Although the audience might accept the flashed instrument as lightning, it would only be out of grace and goodwill. There's some part of the mind that will register "that was a stage light" instead of staying fully immersed in the illusion.

What are the characteristics of real lightning? First, it is blue in color—often more blue than sunlight. Second, it has a very sharp risetime and a rapid decay. It can be a sharp single flash or a pulsing multiple bolt. Often several bolts occur at almost the same time at different places. So-called heat lighting, which can be flashes of light over the horizon or bolts between clouds, is a bit more atmospheric and lower in intensity.

Film productions often use a variation on the old-fashioned arc lamp with a special controller that strikes the arc but does not sustain it. The best of these units is made by Lightning Strikes!. Their units are available in 70 and 250KW models with advanced pulsing controllers. David Pringle and Yan Zhong-Fang won a technical Oscar in 1995 for the invention of these units. However,

10.7 The Oscar award-winning 70,000W Lightning Strikes! unit. Photo courtesy of Lighting Strikes!

they are quite expensive and probably beyond the range of many video and television budgets.

Arledge Armenaki suggests a low-budget version of the arc lamp—the local welder. He's had good results paying a welder to bring his electric arc welder to the set and simply strike an arc or two on cue. The welder is usually thrilled to "be in a movie" and will do it for far less than the cost of a high-end rental. Just be sure to warn cast and crew not to look directly at the intensely bright arc. There's a reason the welder wears a mask or goggles.

The most effective cheap lightning effects used to be photo flash bulbs. The Sylvania Press 25b and 40b bulbs worked really well. It might surprise you to find that stocks of these are still available from suppliers that service old camera enthusiasts. The best known of these is Crest Camera in Wayne, New Jersey. Flash cubes (remember them??) and M2B bulbs are still available from large photo suppliers such as Porter's Camera.

It might surprise you even more to know that flash bulbs are still being manufactured. A company in Ireland, Meggaflash, continues to make specialty high-power flash bulbs. One of their markets is theatrical special effects. The best Meggaflash for lightning is the PF300, which has a slow peak (for a flashbulb) and sustains long enough to produce an effective "lightning strike." For video, you might need to use a $1/4$ or $1/2$ CTB gel because they have a color temperature of around 3800 K. They mount in normal, medium-base screw sockets and can be triggered with anything from a 9V battery to 125V household current. If you like the look of flashbulbs, I'd go with the new units rather than eating up increasingly rare collector bulbs at ever-higher prices.

A more convenient solution is the photographic strobe light. However, many models simply don't provide a long enough flash to be effective in video. Most cheap photo strobes have a very short duration, on the order of $1/1000$ of a second (a millisecond, ms). By contrast, the Meggaflash PF300 flashbulb has a peak at 30ms, with an effective duration of almost 60ms, or $1/60$ of a second—long enough to expose a full frame of NTSC video. Even the lowly flashcubes sustain for nearly 30ms, but a cheap photoflash can discharge so quickly that the effect only appears in a small portion of a single video field. The flash might appear in

the upper half of the picture only, or as a band in the middle. A strange look indeed!

There are strobes designed specifically to offer longer duration times. Some are designed for photographic uses, such as the DLI Varioflash, which has a duration of up to 10ms. Others are designed for the theatrical and music/DJ market. Several of these offer DMX control; thus, they work well with DMX-based lighting controllers. The Botex DMX strobe controller from NCW offers user control of flash duration; other integrated units, such as the Diversitronics 5000-DMX, do not have variable duration but have a 5.5ms duration and high flash rate. These units can be set to the highest flash rate and fired in rapid, brief bursts.

One aspect of lightning that is usually ignored is the multiple strike effect. Often, more than one flash originates from different points at slightly different times. This effect can be simulated with two flashes at different locations, triggered in quick succession. For example, if you use flashbulbs, set up one behind the actors

10.8 The simplest setup for the effect of flickering fire is to have an orange-gelled instrument on the floor run by a manual dimmer.

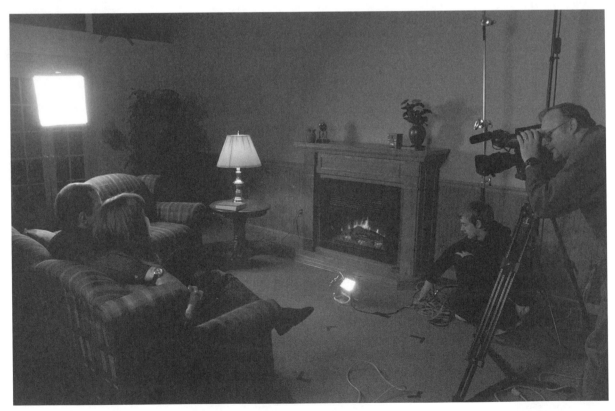

and the other off to camera right, each triggered by different people. If the second person is to trigger the flash effect instantly on seeing the first flash, the delay will be just enough to give a real feel to the effect. When combined with a really fine, properly paced sound effect and an appropriate startle response from the actors, this effect can look quite convincing.

Fire is a completely different effect. Any time you show an actor near a fire, whether outdoors or in front of an interior fireplace, you must create a random flickering glow. There are a number of ways to simulate the flicker of fire, most of which work to one degree or another. The simplest is to use an amber- or orange-gelled instrument on a manual dimmer and have someone with an artistic touch create a random dimming pattern.

A second simple setup combines the same orange-gelled instrument with a darker orange or red instrument. Both are placed at floor level, a little apart, shining up into the face of the actor. Typically the key light will be from the opposite side so that the fire effect lamps illuminate the shadowed side of the face. Just wave a cookie in a random pattern in front of the lighter gelled instrument to create the random flickering effect.

Mechanical wheels that rotate in front of the instrument do the same thing, but because they create a constantly repeated pattern, the fakery will call attention to itself in longer scenes. The human element of control allows some randomness, which helps sell the effect.

In this age of electronics, there are black boxes for everything, and fire flicker is one of them. Magic Gadgets makes several different flicker generators for film and television use. The simplest, the Flicker 2D, creates a random pattern with several levels of intensity; in other words, the light doesn't just flicker on and off in a random pattern, it does so with random changes in the intensity level. The upper and lower limit of the range can be set independently, as can the flicker rate.

The more advanced Flicker 3D adds another dimension by flickering more than one light at slightly different locations. The unit can create the moving shadows that are typical of a real fire. You also can create this effect manually by doubling up any of the simple

☞ *Tip*

Take the CTO gel off the flickering fire instrument, substitute a $1/2$ CTB gel, mount the instrument about 3 feet off the floor, shining directly into the actor's face, and voila! Instantly you have the effect of watching television in a dark room!

10.9 The Magic Gadgets Flicker 2D flicker generator creates a random pattern of flicker at several different light levels. Photo courtesy of McIntire Enterprises/Magic Gadgets.

setups previously described. This effect creates dancing shadows and works well when there is very little other light in the scene.

Automobile Interiors

Automobile, truck, and minivan interiors are an important factor in dramatic work. Just like anything else, they have to be lit. The problem is that very compact instruments must be used, often quite close to the subject's face, so low intensity is key here. Subtlety should win out over lumens. You don't want the actor to look "lit," but you want to bring enough illumination to the face to help the camera read the eyes and to reduce the contrast with the bright sunlight outside the vehicle.

In certain situations, you can use external instruments mounted outside the car. If the car is still or the motion is simulated, it's easy to place instruments around the car, shining into the windows at low angles. However, it's not so easy if the car is moving. If you're using a hood mount kit for the camera, a fresnel key can be fastened to it to shine into the face of the driver or passenger.

Fog and Smoke

Where there's fire, there often needs to be smoke. Fog and smoke are known as *atmospheric effects* and are accomplished in a variety of ways. Several pyrotechnic devices (pellets and powder) produce white, billowing smoke. They are extremely effective but should be handled by someone with a pyrotechnic license.

Fog can be produced by an old-fashioned oil cracker (atomizer) or, more often, a glycol-based fogger of the type that are common in clubs, haunted houses, and theatres. These foggers were invented by Rosco to avoid the health issues related to burning oil and other solutions commonly used. The glycol fogger can create many smoke effects and can be piped through 2-inch flex hose to control the point of emission.

The Curtis Dyna-Fog (designed as a mosquito fogger) can create ground fog effects. High-volume steam generators sometimes are used to create steam effects for saunas and the like.

Although the Rosco glycol fogger received a technical Emmy award for its safety, many folks continue to be concerned about breathing artificial fog. It's best to be safe because breathing any fine aerosol deeply into the lungs for an extended period of time can be a problem, especially for allergic or sensitive people. The crew should wear protective masks and actors can move out of the fog zone or wear masks when not performing.

10.10 The author mounts a Gyoury light wand on the visor in a minivan. The wand is then dimmed until the right light level is found.

More often today, moving cars are lit with small instruments mounted inside the vehicle itself. For daytime shots, this is usually a small fluorescent tube mounted on the visor. The idea is not to call attention to the lighting, but to bring just enough lumens onto the actor's face to make the lighting balance work. Low-power incandescents work as well, but the extra heat creates a fire hazard with the headliner or visor material.

If the scene calls for a car interior at night, the approach is inverted. Rather than mounting the light above the driver on the

10.11 The same Gyoury light wand for night use. It is mounted on the instrument cluster, shining up into the face of the driver. The dimming ballast allows adjustment to an effective light level.

visor or outside the car, the usual practice is to simulate the light coming from the instrument cluster. The instrument, which can range from a tiny T2 flo to a Gyoury wand, as in Figure 10.11, is mounted below the face, shining up. Instrument clusters don't really cast much illumination, so you'll need to be careful about overlighting. Also, most instruments today cast either a red or (more typically) a green glow, so you might want to gel that color.

The most effective auto interior lighting at night is very low intensity—just enough for the camera to read when everything else is dark. Be sure to make liberal use of transitory light sources outside the car. If the car is moving, plan several fresnels gelled with amber to illuminate the interior as the car passes by them. Don't forget the moonlight effect! A general blue fill around the car that also partially illuminates the driver or passenger can be very effective.

Close-ups in which eyes and expressions need to be visible can be effectively lit with a careful combination of moonlight and light from the "instrument panel." Of course, just as with general night shots, many DPs simply abandon realism and light the subjects at a much higher level than could be rationally explained. This is a perfectly honorable part of the Hollywood vernacular tradition, and the audience will accept it. But it's best to pick one look and stick with it. Switching back and forth calls attention to the fakery of the fully lit approach.

Bluescreen and Greenscreen

The second most frequently asked question I get after how to light night shots is how to light green- or bluescreen shots. Greenscreen is pretty fascinating because it opens the way to imaginary imagery and the creation of impossible shots. The typical misconception is that greenscreen shots must be flat lit. This misunderstanding arises from the need to light the background evenly. However, the foreground should be lit very carefully in a manner that will match the composited background. In fact, inconsistency between foreground and background lighting is a major visual cue that will give away a composited greenscreen shot. Consider these examples.

- You've built a set of the deck of a ship and need to composite sky and ocean behind the actors. The actors are lit as if in strong sunlight, with a strong key from a specific location in the "sky." Kickers simulate the highlights of wide-open sky reflected in the skin. Low-contrast lighting would make this scene look as phony as a three dollar bill.

- Spaceman Billy is in his space suit desperately trying to fix the flipperflummy regulator on the underside of the XK-7 space shuttle. Behind him, you will key the whole universe. Here, to simulate the harsh light of the sun in space, you need very hard, high-contrast lighting with hardly any fill because there are no clouds or atmosphere to diffuse the light.

- The hero, Konan the Librarian, has just succeeded in collecting a record number of overdue books. There is one left to retrieve, checked out 17 years ago by a hermit who lives atop an inaccessible rocky crag. In the final scene, Konan holds the book victoriously aloft as he stands on the impossibly high peak, surrounded by precipitous cliffs, as the sun sets behind him. The actor needs to be strongly lit by amber-gelled kickers on either side and above, with a very low frontal fill. Again, even lighting would blow this scene.

Bear in mind that there are two lighting setups for bluescreen: one for the background and one for the subject in the foreground. The best practice is to avoid having these interfere with each other whenever possible. Both setups are critical to the effectiveness of the final product—the background lighting for a successful composite and the foreground lighting to "sell" the integration of the subject with the composited background. Both composited background and foreground need to use the same lighting angles and have the same perspective. If either one is off, no matter how clean the key is, the viewer will feel that something is off in the scene.

Many greenscreen composites are intended to look fake and not simulate reality. Weatherman-style shots, in which informational graphics appear behind the host, really can be lit any way you want. However, for realistic shots, you need to know what the composited background will be and how the lights fall in it. Attention to detail is what will make the shot believable.

👉 Tip

When using proprietary keying hardware or software, always check with the manufacturer for specific guidance on lighting the background. In other words, read the manual!

Lighting the Background

You can take one of two distinct courses when lighting the background. The one you pick will depend on the keying hardware/software you use. Plain chromakey, the technique of identifying a specific range of color and rendering it transparent, is best lit differently from Ultimatte® and other proprietary keying software.

The difference is spill—reflected green or blue light from the background that appears on the foreground subject. This is the great bugbear of simple chromakey, and it must be reduced on the set through lighting techniques. Ultimatte on the other hand, has a proprietary spill removal algorithm that automatically filters out the problem, so Ultimatte greenscreens can be lit almost

10.12 A large studio with a hard cyc is not necessary for basic greenscreen work. Here, the author has converted part of an office with green fabric. Ordinary fluorescent worklights (with electronic ballasts) illuminate the background, and the subject is illuminated with a softbox and Lowel Omni as backlight.

without regard to spill. In fact, the techniques used to kill spill on a chromakey set will cause problems in an Ultimatte composite, so I'll tackle each system in turn.

Chromakey

When an actor stands in front of a large, intensely lit bluescreen or greenscreen, two factors come into play to create spill. One is *radiosity*, the green or blue light that radiates off the screen onto nearby objects or people. The second is reflection on the skin or other surfaces from the screen because it acts as a large reflecting card.

Both of these problems are minimized by the application of the inverse square law—create some distance between the subject and the screen! This is a good idea generally because it is easier to light the foreground subject when there is some distance between subject and background. Radiosity drops off rapidly and is usually completely insignificant on a subject 8 or 10 feet away from the background. Reflections aren't as affected by distance, however,

Chromakey Trick

Technically, the best key with the cleanest and most accurate edges will always happen off the camera signal rather than off a recorded format. The camera signal could have a horizontal resolution of 600 to 800 lines, whereas most digital formats don't go far above 500 lines. The crux of the issue (the key, if you will!) is that nearly all digital formats decimate the color sample to half that of the luminance. That's what 4:2:2 video sampling refers to.

If you are shooting in a studio that has a hardware chromakey (most switchers/special effects generators have them) you should try to pull the key live (create the finished composite) if at all possible, while also recording the raw greenscreen footage as safety in case there's a problem. In many cases, this isn't feasible for any number of reasons, and the final composite must be created in post. Even then, you can use the hardware keyer to spot and correct problems with the lighting of the background.

Try this trick. Switchers can generate color backgrounds. Set up a color background in the keyer that is about the same green or blue as the set background. Now run the camera signal through the keyer; key this perfectly even, flat color behind the subject; and record the keyed composite. Record the live footage as safety, too! Now, when you get to pulling the key in post, the software has a near-perfect clean background to deal with; the only fudge factor will be the tiny latitude needed right at the edges of the subject.

10.13 The Strand Orion is an example of an incandescent cyc light, which is used above and below a cyclorama for even lighting. Courtesy Strand Lighting.

so other methods also must be used. A very simple technique is to light the background at a lower level than the foreground. Remember that the more lumens you put on the background, the more the color will reflect on the subject's face, hair, and clothing. Many folks resist this suggestion because they've always heard that greenscreens must be lit brightly. This is simply not so. The hardware (or software) can typically key out any color and range you specify and can remove dark green as easily as bright green. For classic chromakey usage, I recommend lighting the background to a value of less than 50 IRE when viewed on a waveform monitor. If you're using a light meter, the light on the background should be about half that you use as key on the foreground.

Although intense bright lighting is not necessary, *even* lighting is. The more even the lighting on the background, the less latitude is needed in the software while pulling the matte. The less latitude needed, the less likely you are to encounter problems with blue halos or vanishing ears. The theoretical ideal key would have a perfectly even color in the background, with none of that color appearing in the foreground. The closer you can get to this ideal through careful, even lighting, the better the end result will be. This is where fluorescent instruments really excel and beat incandescents hands down every time.

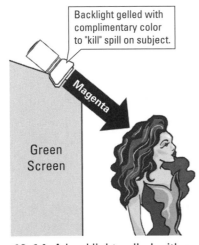

10.14 A backlight gelled with a complementary color can help eliminate or reduce spill. Choose a gel that is opposite the key color on a color wheel.

Typically, you'll still have some spill to deal with, usually on shoulders and hair. The classic approach, and one that works when set up right, is to use a backlight gelled to a color opposite that used for the background. For a blue background, use straw; for green, use magenta. Doing this just right is a bit of an art because, to the eye, the colored light is quite noticeable. However, on-camera, the right setup of intensity and color virtually eliminates the spill without seeming magenta or straw. It's best to watch the effect of the colored backlight on-camera rather than with the eye.

Ultimatte

Lighting for Ultimatte is quite different because of the spill removal. Ultimatte uses a sophisticated process to subtract the selected key color from the foreground. It does an extremely good job in most situations, sometimes at the expense of a slight color shift in clothing. Selecting wardrobe that has no slight green or blue component will prevent this.

Because the spill removal works so well, Ultimatte recommends lighting the background brightly—at the same level as the key for the foreground. It is still advisable to have a good bit of distance between the foreground subject and the background to allow for flexibility in lighting.

☞ *Tip* _____

Check the Ultimatte Web site at www.ultimatte.com for updated tips on lighting for their product.

Lighting the Foreground

A number of problems crop up when lighting a green- or blue-screen shot. Set objects can cause particular problems, especially if they have shiny surfaces. A table with a varnished top can reflect the green background so that the top literally vanishes in the composite, leaving teacups and saucers floating in air. Even many tablecloths have a surface that is shiny enough to cause a problem, although usually to a lesser degree. Shiny objects of any sort can cause this problem. When possible, use very flat finishes for bluescreen shots.

Often, green invisible set pieces are included, especially when using the newer virtual sets. A plywood cube of the proper height painted green lets the actor set objects down on a virtual surface.

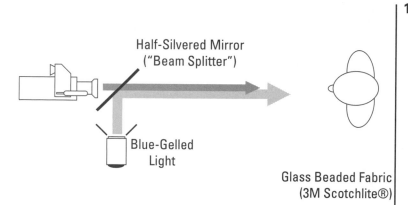

Half-Silvered Mirror
("Beam Splitter")

Blue-Gelled
Light

Glass Beaded Fabric
(3M Scotchlite®)

10.15 A beamsplitter allows a colored light to be shined exactly along the camera's axis. This can place intense, even blue light on reflective material or create special effects, such as red glowing specular highlights in a monster's eyes!

However, these set pieces present peculiar problems because they are difficult to light evenly, and they are in the foreground zone, where you might be using a contrasty lighting scheme. The top will catch more light, and the object will cast shadows that must be eliminated either live or in post. One solution is to use a darker shade of the key color on the top of the set piece than on the sides. Another is to use traditional lighting controls—flags or scrims—to control the amount of light on the top of the set piece.

When the blue floor must be visible (or rather *in*visible in the composite), it must be lit carefully to preserve the even color, while interfering as little as possible with the lighting of the subject. It is especially important that lights not be pointed straight down or angled toward the camera from a rear position because it will create specular highlights on the floor that will appear in the composite as *veiling*—blue- or green-tinted areas. Lights for the floor should be nearer the camera so that light is bounced back to the camera, without the hot specular highlights.

In some cases, backlighting the subject is essential and will create those pesky hot spots on the floor. When this situation is

Green- and Bluescreen Tips

• Personally supervise the selection of wardrobe for the talent. Whether you are using blue or green for your key color, the wardrobe must stay far away from that color. In one virtual set show that used a greenscreen, I warned the director to select only clothing that had no green in it. Halfway through the live shoots, I discovered that one of the principals was wearing an aqua-colored blouse. It looked blue to most folks, but actually contained a lot of green. That minor mistake caused a lot of trouble in post, where I had to hand-paint many mattes to fix digital "holes" in the offending garment.

• Is green or blue better? The real issue is what color do you need to have in the foreground. If the subject needs to wear a blue shirt, use green. If green needs to appear in the foreground, use blue. Many folks feel that blonde hair keys better against blue than against green. When all else fails, use any other color that isn't needed in the foreground. Blue and green are the favorites because they do not appear in human skin tones, a color you can't change very easily. However, virtually any color can be used, including red and yellow. Dick van Dyke tells me that *Mary Poppins* was shot against yellow backgrounds.

• Take more time setting up and reshoot when necessary to avoid using those dreaded words, "We'll fix it in post." Not until you've had to hand-paint a mistake in hundreds of matte frames do you understand how costly those words are!

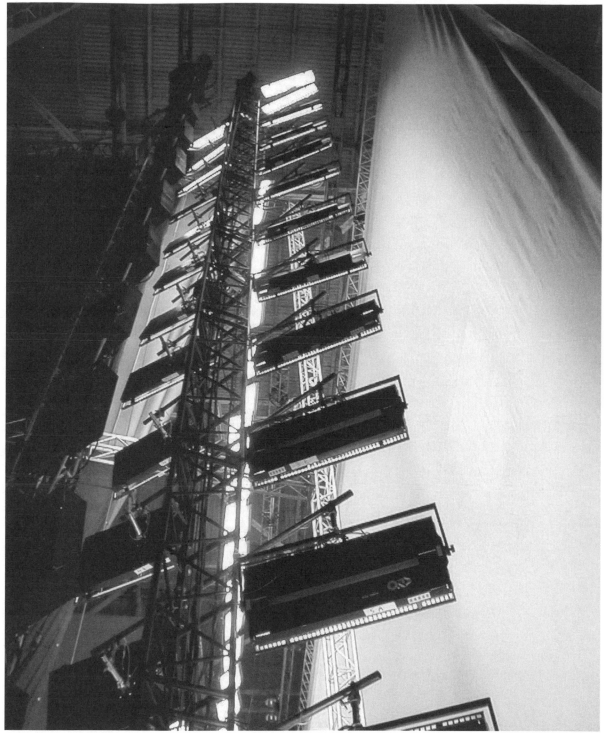

10.16 Banks of Kino Flo Image 80s evenly light a greenscreen in a large studio.

inescapable, a polarizing filter on the camera can eliminate the glare from the floor.

If you're starting to feel like lighting a greenscreen shot is a battle of conflicting problems, you're starting to get the idea!

A similar trick that is used sometimes in film but works just fine in video as well is the use of a beamsplitter and a glass-beaded reflective material, such as 3M Scotchlite® or Reflec Chromatte™. A half-silvered mirror is mounted at a 45° angle in front of the camera lens, and a green or blue light is reflected from it toward the reflective material. The end result is quite good. Reflec sells a special chromakey setup with their fabric that works much the same way by using a ring of high-brightness blue LEDs that fits around the camera lens.

These are just a few of the most common specialty lighting situations you'll run into. In point of fact, every setup is a specialty situation. You should regard each setup as a new and unique challenge. Try different looks and new solutions all the time. Although you'll find basic solutions that work well, you need to avoid falling into the rut of lighting every interview exactly the same way and every product just like the one before.

Imagination and Invention

I hope you have gathered from this book that really fine lighting is a combination of observation, imagination, and inventiveness. Almost any camera-toter can learn a basic lighting setup or two and put together some nice-looking interviews, but to reach beyond that, you need to spend a great deal of time observing the detail of the real world with an artist's eye. After all, you can't create realistic lighting without a solid sense of what "real" looks like.

But reality encompasses a really huge range—day and night, dusk and dawn, cold winter light streaming in through dusty factory windows, the natural glow of a crackling fire, the artificial glow of neon lights at night. Streetlights, spotlights, flashlights, and candles—the "looks" that you find in the real world—are nearly infinite in variation.

Combine this complexity with the unique needs of the television camera and the challenges of simulating a subtle look that really works on the television screen, and you have a real challenge for the creative imagination. That's where invention comes into play. A good lighting director or gaffer needs a streak of experimenter and inventor, a drop of Thomas Edison, to balance out the Rembrandt and Caravaggio. This is true at several levels.

The look of television and video lighting is advancing all the time. Imagining new looks and envisioning the next level is the art of the individual imagination. It usually becomes reality as a team effort, but the payoff is a new look or a distinctive feel that captures exactly what you envisioned.

11.1 The crew of *Law and Order* has turned this building into the Supreme Count for an episode. Note the 12′×12′ butterflies in the foreground. Courtesy of Jessica Burstein.

Television shows with a unique look that stands apart from every other show don't happen accidentally. A show like *Star Trek: Deep Space 9*, with its heavy use of industrial grillework shadows, has an immediate visual identity completely in keeping with the feel and premise of the show. That wasn't happenstance. Some very hard work and thought and classy light design went into that show. The *X-Files* is similarly recognizable by its dark and somber lighting. It is a look that was carefully designed to enhance the premise of the show.

A good lighting director spends time getting the concept and feel of a show before trying to capture it in a new look. Once a concept has been developed, the imagined look has to be translated into reality. Fortunately, gaffers are an inventive bunch! Almost every gaffer I know has a streak of Thomas Edison, and the best ones are always fiddling around with lights, colored glass, tree branches, foamcore, and crumpled aluminum foil. But they don't stop there; they're always envisioning some new gizmo, or a new use for an old one, that will allow them to mount a light in a new or different way. That's how all the weird implements, ranging from meat axes to trombones, came into use in Hollywood. Good gaffers don't just learn to *use* the tools of the trade, they *improve* on them. The innovators are sometimes memorialized in the jargon, but more often, they are forgotten, as their innovation is passed around from gaffer to gaffer through the trade.

In the same manner, gaffers are always inventing new instruments. Sometimes these do something new, like the first Kino Flo lights did. Other times they provide a new and more convenient way to accomplish something everyone was already doing, like the Croniecone, the prototype of the now-common softbox. Gaffers had been shining lights through large pieces of diffusion material for years. Jordan Cronenweth just came up with a method of attaching the diffusion medium to the instrument.

Innovation is sometimes technical, like the development of lower cost electronic ballast for HMIs or more color-accurate fluorescent tubes, but more often it is just an inventive use of components. Small instruments, like the GAM Stik-Up, that can be gaffer-taped in a corner aren't a cure for the common cold or a work of genius, but they sure are handy. Chris Gyoury's new Gyoury Light isn't Nobel Prize material, but the innovation of viewing the tube itself as an independent instrument, rather than as the box it fits in, makes new and clever uses possible.

11.2 The GAM Stik-Up is a tiny incandescent fixture that can be mounted with gaffer tape or a clothespin in out-of-the-way spots on a set.

I've always been impressed by the low-cost inventiveness of Ross Lowell. He often struck out on his own and reinvented the wheel; he just made it a little more affordable. Whether you are a newcomer saving up to buy your first Lowell light kit or a seasoned Hollywood professional used to big-bucks productions and fully equipped light trucks, you *must* have a copy of the Lowell catalog. Take a look at the "blips" and the "Hollywood Strip" for ideas on casting odd-shaped shadows.

Don't be afraid to tinker with your lights or to mess around with unusual materials that modify the light. Washing a featureless wall by shining a fresnel through a piece of textured glass or an interestingly cast vase will create a stunning texture that no purchased professional pattern can create. If the big lighting houses don't make a pattern you need, get out your art knife and black foamcore.

I hope this book has helped you with the basics, but more important, I hope it has focused your eyes and mind in a way that will help you create those new looks and the new instruments that will create the new looks.

Happy lighting!

Using a Light Meter with Video

If you come from a film background, you probably never leave the house without your trusty Polaris or Sekonic light meter strapped to your hip. Then you enter the world of video, and everything is different. Manufacturers don't bother to give you an ASA/ISO-equivalent exposure index for the cameras. How inconsiderate! You can't use a meter without an exposure index (EI, a measure of light sensitivity).

For you folks, I offer two simple procedures to figure out the exposure index of a specific video camera.

The first method uses a photographic gray card. Illuminate the card evenly and zoom in on it so that it fills the entire picture. Make sure the Shutter Speed is Off, which sets the speed to $1/60$ ($1/50$ in PAL). Also make sure the camera is set to no gain. Now press the Auto Iris button on the lens (pro cameras) or switch on the Autoexposure function (prosumer cameras). Now switch back to Manual so that the iris stays at that setting. Take note of the F-stop number the camera has chosen for exposure.

Now take an incident light reading, with your light meter pointed at the gray card and the photosphere pointed toward the camera. If you're using a film-style meter, set the cine speed to 30. The shutter speed is 1/60. As a starting point, set the meter to an EI of 100. Now compare the F-stop reading on the meter with the F-stop the camera auto iris chose. Change the EI setting on the meter until it suggests the same F-stop that the camera chose. Bingo, that's the EI of your camera!

A.1 Sekonic L-608 light meter. Photo courtesy of Sekonic, Inc.

The second method, which is a tiny bit more accurate, uses a chip chart and a waveform monitor. Open the iris on the camera until the white chip measures precisely 100 IRE or the crossover chip measures 55 IRE. Now follow the same trial-and-error procedure outlined above to ascertain the EI of the camera.

Once you have established the EI of the camera, you can use your film-style metering habits for setting exposure. Two caveats, however. First, bear in mind that using any of the gain-up settings on the camera will result in an entirely different EI. If you must use gain up, you need to repeat the procedure in each gain setting to measure the EI in that specific mode.

Second, watch out for those hot spots! Always double-check your exposure with the zebra display set on 100 IRE as an overlimit idiot light. If I didn't hammer on this enough in Chapter 7, I'll hit on it again now. A common mistake that film shooters make on video is to allow hot spots to run too high; then they complain that video can't handle highlights. Remember that video has a flat gamma curve, rather than the gentle rolloff at the top end that most film stocks have. The format is stupid; the camera just does what it's told. It's just a tool. It's up to the tool user, the entity with brains (that's you!), to fit the scene into the latitude of the format.

Basic Primer in Signal Monitoring

Reading a waveform monitor is largely a matter of experience; it's something you get used to as you do it. Video engineers use WFMs to measure a number of aspects of the signal, including frequency response, subcarrier phase, and so on. For now, however, I am mainly concerned with basic monitoring of the signal to make sure that exposure and color values are within legal limits.

You can have two dedicated monitors: one a waveform monitor (WFM) and the other a vectorscope. However, many models incorporate both functions in a single combined unit.

B.1 A studio technician monitors the video signal.

Waveform Monitor

Waveform monitors have several settings that affect the display. Parade mode displays both fields next to each other. The WFM screen shots in this book all display a single frame with the fields combined. Some units refer to this as 1H/2H display. Which you use is a matter of preference. A second setting you need to know about is the Flat/Low Pass. When this control is set on Flat, color information is included in the signal, and you will be able to view the color burst—the calibrating 3.579545MHz frequency that occurs right after the sync pulse and locks the color of the picture. The color component is also present in the picture waveform, which results in a vertical spread to the reading. This is useful for some measurements, but confusing in this case, so I recommend monitoring in Low Pass mode. This strips the color subcarrier out of the signal and allows you to monitor luminance, or brightness. The WFM screen shots in this book all display Low Pass mode. Some units refer to the low-pass filter as the IRE filter.

When viewing a signal on the WFM, properly exposed video will fall between 7.5 and 100 IRE, with good distribution across the range. Facial highlights for Caucasian skin tones should fall between 75 and 80 IRE. Hot spots should not exceed 100 IRE except for very brief excursions, typically from practical light sources, such as a chandelier bulb or candle flame. Hot spots should never exceed 110 IRE, which is the clipping level for digi-

B.2 The waveform monitor displays the amplitude of the video signal, which is directly related to exposure.

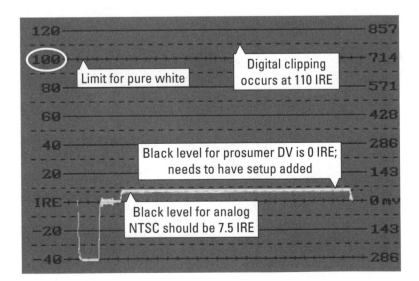

tal formats. Be aware that the live camera signal, which is analog, can contain values above 110 IRE. These will be clipped in the analog-to-digital conversion and compression when the digital signal is recorded to tape, and the data will be lost.

If you are monitoring DV off a prosumer camera/deck (or even a low-end pro deck), you will notice that the black level is at 0 IRE, not 7.5 IRE. This can be very confusing. All digital formats use 0 IRE black internally, but setup (also called pedestal) should properly be added when the signal is output as analog.

Vectorscope

When viewing a vectorscope, you are viewing the phase relationship of the various components of the video signal. This phase relationship is what determines color. The phase, or hue, of the signal is displayed rotationally on the vectorscope. In other words, if you visualize the vectorscope as a clock face, pure red will read at about 11:30, whereas blue will display at about 3:30. The saturation of the color content, or chroma level, is measured radially, or outward from the center. It is important to bear in mind that the vectorscope has nothing to do with exposure, brightness, or luminance value. It only displays hue and color intensity, so pure white and pure black appear identical on the vectorscope—both have zero hue and chroma—whereas they appear very different on the WFM.

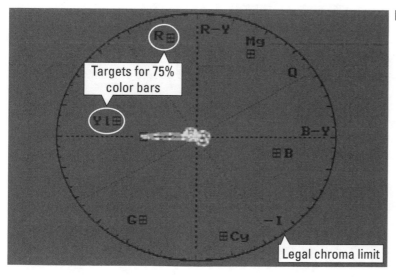

B.3 The vectorscope displays the color content and intensity of the video signal.

Seventy-five percent saturation full-field color bars or the SMPTE standard color bar chart lets you check the hue and chroma of the signal. Properly adjusted, the color peaks all fall inside the designated targets (see Figure 2.5 for a vectorscope display of color bars). If they are rotated either way, the phase of the signal will need to be adjusted with a proc amp. If they are far outside the targets or fall well inside the targets radially, then the chroma level will need to be adjusted with a proc amp. This is how a dub house will calibrate their system to match your video—always assuming that your video matches the standard set by the color bars at the head of your tape.

In production, the vectorscope is less important for lighting issues than the WFM. If you are using strongly saturated colors on the set or party color gels on your lights, the vectorscope will show you when the chroma is too hot. The outer circle on the vectorscope display (known as a graticule) shows the absolute legal limit for chroma. However, it's a good idea to stay well inside this limit! NTSC video, especially when recorded to the lowest common denominator, the VHS format, does not handle strongly saturated colors well. Some colors, such as red and yellow, bleed horribly on VHS, even when they are within legal limits. On the other hand, it's difficult to create a blue that exceeds the limit. So watch out for reds and yellows and other colors that contain red and yellow in strongly saturated form.

Manufacturer Addresses

ARRI, Inc.
(New York Office)
617 Route 303
Blauvelt, NY 10913-1123
Phone: 845-353-1400
Fax: 845-425-1250

(Burbank Office)
600 N. Victory Boulevard
Burbank, CA 91502-1639
Phone: 818-841-7070
Fax: 818-848-4028
www.arri.com

Altman Lighting, Inc.
57 Alexander Street
Yonkers, NY 10701
Phone: 914-476-7987
Fax: 914-963-7304
www.altmanltg.com

Bogen Photo Corp
565E Crescent Avenue
Ramsey, NJ 07446-0506
Phone: 201-818-9500
Fax: 201-818-9177
www.bogenphoto.com

CHIMERA Lighting
1812 Valtec Lane
Boulder, CO 80301
Phone: 303-444-8000
Toll free: 888-444-1812
Fax: 303-444-8303
www.chimeralighting.com

Cool-Lux
412 Calle San Pablo #200
Camarillo, CA 93012
Phone: 805-482-4820
Fax: 805-482-0736
www.cool-lux.com

Crescit Software, Inc.
509 Commissioners Road West, Suite 417
London, ON Canada N6J 1Y5
Phone: 519-539-0531
Fax: 509-756-3919
www.crescit.com

De Sisti Lighting S.p.A.
Via Cancelliera, 10/a
00040 Cecchina
Albano Laziale (Roma) - Italy
Phone: ++39/06/93.49.91
Fax: ++39/06/93.43.489
www.desisti.it

Dove Lighting Systems, Inc.
3563 Sueldo Street, Suite E
San Luis Obispo, CA 93401
Phone: 805-541-8292
Fax: 805-541-8293
www.dovesystems.com

Dedotec USA, Inc.
216 Little Falls Road
Cedar Grove, NJ 07009
Phone: 973-857-8118
Fax: 973-857-3756
www.dedolight.com

Electronic Theatre Controls (ETC)
3030 Laura Lane
PO Box 620979
Middleton, WI 53562-0979
Phone: 800-688-4116
Fax: 608-831-4116
www.etcconnect.com

Great American Manufacturing (GAM)
8236 N. Cole Avenue
Hollywood, CA 90038
Phone: 323-461-0200
Fax: 323-461-4308
www.gamonline.com

Gyoury Light Systems
1255 Canton Street
Roswell, GA 30075
Phone: 770-993-8787
Fax: 770-993-8837
www.meansst.com/gyoury/default.htm

Kino Flo
10848 Cantara Street
Sun Valley, CA 91352
Phone: 818-767-6528
Fax: 818-767-7517
www.kinoflo.com

Lee Filters
Central Way
Walworth Industrial Estate
Andover
Hampshire SP10 5AN
England
Phone: +44-1264-366245
Fax: +44-1264-355058
www.leefilters.com

Lightning Strikes!
www.lightningstrikes.com

Lowel-Light

140 58th Street
Brooklyn, NY 11220
Phone: 718-921-0600
Toll free: 800-334-3426
Fax: 718-921-0303
www.lowel.com

LTM—US

7755 Haskell Avenue
Van Nuys, CA 91406
Phone: 800-762-4291
Fax: 818-780-9828
www.ltmlighting.com

Magic Gadgets

www.magicgadgets.com

Matthews Studio Equipment

2405 Empire Avenue
Burbank, CA 91504
Phone: 818-843-6715
Toll free: 800-CE-Stand (237-8263)
Fax: 323-849-1525
www.msegrip.com

Mole–Richardson

937 N. Sycamore Avenue
Hollywood, CA 90038
Phone: 323-851-0111
Fax: 323-851-5593
www.mole.com/

NRG Research, Inc.

233 Rogue River Highway
Building #1144
Grants Pass, OR 97527
Phone: 800-753-0357
www.nrgresearch.com

Photoflex

97 Hangar Way
Watsonville, CA 95067
Phone: 831-786-1370
Toll free: 800-486-2674
Fax: 831-786-1371
www.photoflex.com

Rosco Laboratories, Inc.

52 Harbor View
Stamford, CT 06902
Phone: 203-708-8900
Toll free: 800-ROSCO-NY (767-2669)
Fax: 203-708-8919
www.rosco.com

Strand Lighting

6603 Darin Way
Cypress, CA 90630
Phone: 800-487-0175
www.strandlighting.com

Pampalite

www.pampalite.com/contacts.htm

Videssence

10768 Lower Azusa Road
El Monte, CA 91731
Phone: 626-579-0943
Fax: 626-579-6803
www.videssence.com

The F.J. Westcott Company

1447 Summit Street
PO Box 1596
Toledo, OH 43603
Phone: 419-243-7311
Fax: 419-243-8401
www.fjwestcott.com

Glossary

AC Alternating current.

accent light An instrument that focuses attention on an area. It can be in any position: key, kicker, or back.

ampere A measure of electrical flow or quantity (amp, A).

AMX Short for *analog multiplexing*, an older lighting control standard. Now superseded by DMX.

aperture The open area of the iris, the variable opening behind the lens that controls the amount of light admitted to the camera.

apple boxes Sturdy pine boxes of graduated heights for a camera operator to stand on. The origin of the name is obvious. You can buy them from a studio supply store for an outrageous price or make them yourself.

arc An instrument that creates light from an electrical arc flowing across the gap between two carbon electrodes.

ASA Rated speed of film, from the defunct American Standards Association, now superseded by ISO (International Organization for Standardization) or EI (exposure index). ASA and ISO technically only apply to film stock; the proper measure of a video camera's response to light is the EI.

ASC American Society of Cinematographers. A DP who has been elected as a member of the ASC has been recognized for his or her contribution to the art.

backlight An instrument positioned directly behind and above the subject, aimed at the subject's back. Care must be taken not to have the backlight shine into the lens of the camera, creating flares.

bail Also known as the yoke, the bail is a U-shaped bracket that holds an instrument, either hanging from a pipe clamp or on a stand connector.

ballast Similar to a transformer, except designed to limit amperage to a specific level. Fluorescent tubes and arc lamps (both simple arcs and HMIs) operate from a ballast. The inexpensive ballasts are magnetic; these can hum and create flicker problems at certain shutter speeds. High-frequency electronic ballasts are preferred for film and television work.

barn doors Hinged black metal flaps that attach to the front of an instrument to control the beam spread.

Bates connector Three-pin, high-amperage connectors.

beadboard A type of housing insulation made of polystyrene beads formed into a flat board. Used to bounce soft, diffuse light.

best boy The gaffer's assistant, a "best boy" can be a woman or an elderly man. It's just what they call it. It's got more to do with "best" than with "boy."

black balance Procedure to set the black level of the camera.

blackwrap Heavy aluminum foil that has been anodized flat black. Next to gaffer tape, it's the gaffer's best friend. It's used to extend barn doors, cut spill, form snoots, and wrap leftover lunch. No, scratch the last, that's the silver type.

blocking A plan for the basic action on the set. Critical points in the action are *marks*.

Blonde An open-faced 2K by Ianaro/Strand, the big sibling of the Redhead. Sometime called a *mighty*.

blue screen 1. A pure blue evenly-lit background. 2. The process where all blue background is rendered transparent, so that a new background can be placed behind the subject.

booster light An HMI or FAY cluster used to augment exterior daylight.

bottomer A large flag used to cut light to the bottom of the frame.

branchaloris A real tree branch used to break up light *à la* the cucaloris. Yes, gaffers have a silly name for everything.

broad A rectangular open-faced light used for wide fill.

brute A 225-amp carbon arc lamp with a 24-inch fresnel lens. It's close to as big and bright as it gets until you get to the truck-mounted arcs used at shopping center openings.

butterflies Large frames that have silk or other scrim material stretched over it. These are used in outdoor shots to cut down the intensity of the sun and provide some diffusion. A *butterfly* can also be an arrangement in which two instruments are hung next to one another but facing opposite directions, often to act as key lights for subjects facing one another.

C-47s Specialized, heat-resistant miniature clamps that hold gels or diffusion material to hot barn doors and serve a variety of other utility holding purposes. Aw, heck, they're just wooden spring clothespins like your grandmother used before they had electric dryers (*see Figure, page 201*). There are two main theories about the origin of the unusual designation. Airplane buffs say the term comes from the Douglas C-47, the WWII-era "Gooneybird" plane that could do just about anything. Others suggest that the designation was the original part number in the old Century Lighting catalog. I personally believe the latter. Witness *C-stand* below! Younger gaffers are now calling these *pegs*. It used to be common practice for gaffers to harass the new kid on the set by seeing how many C-47s they could clip on the back of his (or her) shirt before the newbie would notice. Watch your back!

cable crossing A heavy plastic ramp that covers and protects cable in a traffic area.

Many gaffers disassemble the clothespin and reassemble them backwards to create a new clip that some are calling a B-52. Hmm, that might support the airplane theory. (Top) The plain old wooden spring clothespin, aka C-47 or peg. (Bottom) A new variant, the B-52. The wooden paddles are reversed on the spring, and electrical tape is wrapped around the spring.

cable stretcher A mythological device that gaffers would send the new kid out to look for, with the stern admonition, "And you'd better not come back without one!" *See snipe hunt.* Guess what—they make them now. The TecNec® CableStretcher™ is a multi-conductor line amplifier for camera cable that runs up to 300 feet.

Cam-Lok® A positive locking cable connector for a high-amperage feed.

candela A unit of light intensity, equivalent to one candle. Well, sort of. Actually, it's an international standard set by the 16th General Conference on Weights and Measures in 1979. As a scientific definition, it is based on the luminous intensity of a black body at the temperature that platinum solidifies (2047 K). The formula is mind-numbing; it's easier to just think of it as a scientifically standardized candle. A candela is measured in one direction only, as opposed to a lumen, which measures the entire spread of the light.

celo A semitransparent cookie made with a wire mesh with plastic coating. It gives a more subtle pattern to light than a plywood or foamcore cookie.

chain visegrip A ViseGrip® tool modified with a chain between the jaws. It's useful for clamping odd shapes.

cheater An adapter that converts a standard 15-amp grounded connector to work in an older two-prong ungrounded outlet. Also known as a *ground lifter.*

chicken coop A light box, usually with six silvered globes that bounce a soft, shadowless light directly from above.

Chinese lantern A collapsible wire and paper ball that has a lamp suspended in the middle, providing a soft light source. Also known as a *Japanese lantern.* Many manufacturers now make a Chinese lantern specifically for the film and TV trade with grid cloth diffusion and a spring wire frame. They have a bracket to hold the internal globe away from the diffusion material to prevent fire.

chroma Color content of the video signal.

chromakey The process whereby a particular color (usually green or blue) in the picture is rendered transparent so that a new background element can be placed behind the subject.

circle of confusion The diameter of a point of light when focused on the target inside the camera. The less sharp the focus, the larger the circle of confusion. It could also be a group of baffled executive producers.

clipped white In video, a portion of overlimit signal that exceeds the format's ability to record. The resulting overexposed area has no detail. In digital formats, there is 10% headroom above the legal limit of 100 IRE for pure white. Above that, no bits are available to store information. In DV, that limit is the RGB value of 255, 255, 255.

clothespin Your mom's term for a C-47.

coffin light An overhead box with diffusion and a black fabric skirt to control spread. Provides soft, even, overhead light for a limited area. Or it could be Vladimir's reading lamp.

color conversion gel A gel used to convert a light source from one color temperature to another.

color correction gel A gel that adds or subtracts green to a light source.

colorizing gel A gel that is intended to produce a color effect, such as warming or cooling. This is different from a *color conversion gel*.

color temperature The color of light, measured on the Kelvin scale. Incandescent light is yellow, ranging from 2800 K to 3200 K, whereas sunlight is in the blue range, around 5600 K.

complementary colors Colors at opposite sides of the color wheel (e.g., red and green, yellow and blue).

contrast The ratio between the lightest area of the scene (or picture) and the darkest area of the scene (or picture). Video lighting must fit the contrast of the set into the defined contrast of the picture.

cookie This term has nothing to do with chocolate chips. It's a cutout pattern that breaks light up into a dappled pattern, not to be confused with a *gobo*, although most folks use the terms interchangeably or backwards from their historic definitions. It's useful to simulate dappled light under trees, or it's often used in night scenes. The name is short for *cucaloris*.

CRI Color rendering index. This is a measure of the spectrum content of the light source and, thus, its ability to render colors accurately. Fluorescent tubes and other gas discharge globes are usually *discontinuous spectrum* light sources, meaning there could be gaps and spikes in the spectrum.

Croniecone The original softbox invented by Jordan Cronenweth, ASC. It's a cone of foamcore or other material that holds a large sheet of diffusion material in front of an instrument while preventing spill from the sides.

crowder clamp A clamp designed to hang an instrument from a 2×4-inch or 2×6-inch board.

C-stand A special, highly adaptable lighting stand, short for Century Stand®, and now a registered trademark of the Matthews Studio Equipment Company. Other companies make these stands, notably the Mole–Richardson and Bogen Avenger line. The C-stand has staggered folding legs that provide a horizontal area for sand or shot bags. The special dual-plate head can mount a boom arm or a light mount, or you can clamp flat material on, such as a large piece of cardboard or foamcore. This incredibly flexible stand is an essential on the set. The boom arm is generally called a gobo arm.

A Century Stand®. Courtesy Matthews Studio Equipment, Inc.

CTB Color temperature blue gel, available in several grades to match incandescent light to sunlight.

CTO Color temperature orange gel, available in several grades to match sunlight to incandescent light.

cucaloris A cutout pattern used to break light up into a dappled pattern. It's useful for simulating dappled light under trees, or it's often used in night scenes. Shortened to *cookie*, the term cucaloris has been in use for most of the last century. However, the derivation of that term is a mystery.

Most authoritative theatrical texts comment that it is the ancient Greek word for "breaking or shattering light," which sounds great, except it ain't true. I took ancient Greek in college and have double-checked with several Greek scholars. It isn't a Greek word at all. "Breaking light" would be σπαζωφοσ, (*spadzophos*). I wonder who the pompous ass was (a theatre or film production professor maybe?) who first told his class, "Ahh, yes, that's from the ancient Greek," knowing full well he hadn't a clue!

cue A word or phrase in the script that acts to trigger another action, which could be anything from another actor's line or entrance to changing the lighting, playing music, or initiating a sound effect.

current A measure of the total volume of electricity. Measured in *amperes*.

cutter A long black flag that is used to "cut" light from an area of the set.

cyclorama A smooth, seamless wall, usually with curved corners. It can be fabric or plaster and is used as a featureless background. Also known as a "cyc."

day rate Wages for a days' work, usually based on a 10-hour day.

DC Direct current, where current always flows in the same direction across the circuit. Batteries supply DC.

depth of field The range of distances from the lens in which objects are in focus.

depth of focus The range of distances behind the lens in which the image is in focus. Ideally, it's the precise plane of the target.

dimmer A device for varying the voltage supplied to an instrument.

dingle Another silly name for a *branchaloris*, a tree branch used to break up light. A small branch is a 1K dingle, a larger one is a 2K dingle. Believe it or not. Gaffers have absolutely no sense of embarrassment.

distribution In lighting, the electrical supply system.

DMX Short for *digital multiplexing*, DMX is a digital standard for lighting control set by USITT.

dog collar A safety cable used to attach instruments to a grid.

dolly grip A grip who operates the camera dolly.

doorway dolly A narrow, steerable dolly that will fit through a standard-width doorway.

dots Small round nets or flags used to kill hot spots.

double 1. A scrim that reduces the light by a full stop. 2. A net that reduces the light by a full stop.

Duvetyne (dū-vŭh-teen) Heavy black cloth used for flags and teasers. Usually treated with fire retardant.

Edison plug A standard household electrical plug.

egg crate A deep grate that allows soft light to be controlled into a directional beam rather than spreading all over the place. The deeper the egg crate is, the more control it provides. It looks like partitions to hold eggs.

A soft bank with egg crate to create a tighter beam of soft light. Courtesy Lowel Lighting, Inc.

EI Exposure index. The proper measure of a video camera's response to light.

electronic ballast A solid-state, high-frequency ballast for fluorescent tubes or HMI lights, as opposed to the cheaper magnetic ballast.

ellipsoidal A lensed instrument based on an ellipsoidal reflector. It throws a hard, even beam and can be used as a sort of projector for patterns.

expendables Supplies that are used up in production, such as gaffer tape, gels, blackwraps, and so on.

eye light A small instrument positioned to create a glint in the subject's eye.

FAY Designation for a type of PAR lamp with dichroic coating on the lens. FAY lamps emit blue light in the 5600 K range.

feeder A heavy power supply cable.

fill A light used opposite the key to provide a lower level of illumination in shadowed areas.

finger Small rectangular nets or flags used to control hot spots.

flag An opaque rectangle, usually black cloth stretched over a wire frame, that is used to block light to a certain area. Same as a gobo or cutter. These are sometimes made out of thin plywood painted black, but more and more you'll see black foamcore used as a disposable, easily reshaped flag.

flex arm A jointed arm that can hold a flag or small instrument.

floater A flag, net, or instrument that is moved during the shot. Floating a net in front of an instrument when an actor passes too close is also known as *Hollywooding*. Ah, the verbification of the language!

flood 1. The wide-angle setting of a focusing instrument. 2. Any light that throws a wide pattern, such as a broad or a scoop.

fluorescent A tubular lamp that creates light by exciting mercury vapor gas, which then emits ultraviolet (UV) radiation. The interior of the tube is coated with a special phosphor that emits light outward in the visible spectrum when excited by the internal UV radiation. Special phosphors have been developed to give wide-spectrum light output and specific color temperatures.

foamcore $1/4$-inch polystyrene sheet sandwiched between paper. It's easy to cut, stiff, handy, and available in white, black, and colors. It's used as bounce cards, impromptu flags, and cookies.

focal length The distance between the optical center of the lens and the target when the lens is focused on infinity.

footcandle An older standard measure of illumination; one lumen per square foot.

footlambert A unit of luminance equal to $1/\pi$ candela per square foot.

four by four A flag that is (surprise!) 4×4 feet.

fresnel (fruh-nel) 1. Stepped lens designed by Augustin Fresnel. 2. Focusing lensed instrument based on the fresnel lens. The most common and flexible instrument used in film and television.

frog An arrangement in which light is bounced off a card held at an angle (*see Figure*).

frost Diffusion material made of frosty sheet plastic. Available in several grades.

F-stop A measure of the lens' light transmission. The F-stop calculation is based on the diameter of the aperture. High-end lenses also have a T-stop rating, which is based on the measurement of the lens' performance at different apertures.

fuse A link of metal that melts when too much current passes through it.

gaffer A lighting designer or head lighting technician.

A frog is a bounce card (here, white foamcore) angled above an instrument.

gaffer tape Duct tape on steroids. A two-inch-wide fabric tape with an adhesive that is strong enough to hold well but will not pull paint off walls when used carefully. Available in many colors, including chromakey green and blue.

gamma A measure of the midrange contrast of a picture.

gang box An electrical distribution box that breaks a 60- or 100-amp supply into four 20-amp sockets.

gel A transparent, colored, plastic sheet—usually polyethylene—used to change the color of light. In early theatre, the sheets were made of colored gelatin. Hence the name.

glow light A weak light source that creates a bit of a glow on the actor's face.

gobo A large flag, cutter, or even a full-sized flat used to cast a shadow on part of the set. The best guess as to its origin comes from the early film days, when the director would call, "go black out" a portion of the set. This was abbreviated on the production notes as "GO B.O.," then just "gobo."

golden hour I wish it *was* an hour, but it's the 15 minutes or so right before the sun sets, when the quality of the light takes on a soft glowing golden tone. It's wonderful for shots of buildings, cars, or just about anything. The duration varies depending on the time of year.

gray scale A chart with gray chips ranging from black to white.

greenscreen 1. A pur green, evenly-lit background. 2. The process where all green background is rendered transparent, so that a new background can be placed behind the subject.

grid Pipe system above soundstage where lights are hung.

grid clamp Also known as a pipe clamp, it's the clamp used to suspend a lighting instrument from the grid.

Griffolyn® A polyethylene laminate with a stranded reinforcement. It's popular as a large reflector or flag material for frames 12×12 or 20×20 feet. Originally a reinforced plastic tarp material for the farming industry. Griffolyn® is a registered trademark of Reef Industries, Inc.

grip A person who handles set rigging, camera support, and sometimes flags, nets, and silks.

ground lifter An adapter for an ungrounded Edison plug. *See cheater.*

ground row A row of cyc lights on the floor (ground) shining up on a cyclorama or backdrop.

hair light A backlight positioned above and just slightly behind a subject to create highlights on the hair.

halogen Any of the elements astatine, bromine, chlorine, fluorine, or iodine that are used in many tungsten filament incandescent globes.

hertz A measure of frequency in cycles per second (Hz). Named after the 19th century physicist Heinrich Rudolf Hertz, who proved that energy is transmitted through a vacuum by electromagnetic waves.

high key A lighting scheme in which the ratio of key to fill is nearly 1:1.

HMI A modern arc instrument in which the arc is enclosed in a replaceable globe. Technically, HMI is short for *h*ydrargyrum *m*edium-arc-length *i*odide, a variety of the short-arc metal halide lamp.

Hollywood A housing development outside of Los Angeles that made good by becoming accidentally associated with the filmmaking industry.

Hollywooding Floating a net in front of a light during a shot, usually when a subject must walk closer to the instrument so that the light level needs to be reduced.

honeycomb A crosshatch grid that prevents the spread of a diffuse light source. A shallower version of the egg crate.

hot spot An overexposed reflection or highlight that exceeds the latitude of the camera.

house lights The existing lights in a location.

hue The technical term for color.

incandescent A lamp type perfected by Thomas Edison, that creates light by passing an electric current through a thin filament, which then glows or incandesces.

incident The light falling on a subject, as opposed to the light reflected from the subject. When using a light meter to measure incident light, point it toward the light source rather than toward the subject.

inkie A small fresnel, usually 250 watts or less. Short for inkie-dink.

IRE A colloquial term for measurement of the amplitude of a video signal. The visible luminance of the video signal is divided into 100 units, or *IRE*, with 100 IRE being maximum for legal white. The name is an abbreviation of the former Institute of Radio Engineers, a name long since changed to the Institute of Electrical and Electronic Engineers, or IEEE. However, everyone still refers to the signal units as IRE. At least it has a historical derivation, which makes more sense than a "2K dingle."

iris The adjustable opening behind the lens that controls the amount of light admitted to the camera.

ISO The rated speed of film, formerly known as *ASA*.

Japanese lantern A wire and paper ball with a lamp inside. Also known as a *Chinese lantern*. Useful for soft, diffused light.

Junior A 2K fresnel.

Kelvin An absolute unit of temperature and light color based on the color emission of a theoretical black body at different temperatures, measured from absolute zero. Named after its inventor, 19th century physicist William Thompson, Lord Kelvin. Abbreviated K (e.g., 5000 K). Note that kilowatt is also abbreviated K in the industry but is closed up to its number (e.g., 2K).

key light The main light source for a scene.

kicker A light positioned behind the subject and off to the side opposite the key.

kit rental A fee added to the day rate when using a gaffer's lights.

lamp Can refer to the bulb (globe), an entire lighting instrument, or a kind of practical.

latitude The ability of a camera to handle contrast, defined as the range between overexposure and underexposure.

lavender A specific grade of silk named for its light purple tint. It provides both light diffusion and a reduction of intensity.

layout board Sheets of very heavy cardboard laid down on a location floor to avoid damage from dollies and grip equipment.

Leko The original brand name for ellipsoidal instruments. It's from the names of the inventors, Joseph Levy and Edward Kook, co-owners of Century Lighting.

limbo A seamless backdrop; often roll paper.

louvers Shutters that control the spread and direction of light.

low-contrast (LC) filter A camera lens filter that effectively reduces the contrast of the picture.

low key A lighting scheme in which there is a large difference between the intensity of the key and fill lights. The *film noire* genre uses a very low key lighting scheme, creating a shadowy, contrasty look.

lumen A measure of light intensity over the entire spread of the light beam. *Candela* measures only one direction of emission, whereas lumens are a rating of the candela multiplied by the spread of the beam, taking into account the varying intensities at the middle and edges of the beam.

luminaire A European term for lighting instrument, used more in the theatre than in television or film.

lux Similar to a footcandle, except metric; one lumen over one square meter.

macro Shooting in extreme close-up.

magic hour The 15 minutes or so right after the *golden hour*, immediately after the sun has gone past the horizon. It's only an hour in a DP's wildest dreams.

master shot The wide establishing shot that shows the position of all the characters on the set and in relation to one another.

meat axe An adjustable boom pole or gobo arm, swivel-mounted to a C-clamp that can grip a pipe, such as the handrail of a catwalk. Don't ask, I haven't a clue. It doesn't look like a meat axe at all. Sometimes it also refers to a small flag.

minus green A magenta gel that filters green from a light source. It can be used to remove green from a fluorescent source to match an incandescent light, for instance. Available in various grades.

mired (mī-rĕd) An acronym for *microreciprocal degrees*, which is a method of calculating the compensating differences between Kelvin ratings.

MOS Taping or filming without live sound. The best story I've heard for an origin refers to the accent of the German directors of the early film industry: "mit out sound." Or it could be "missing optical sound" or "motion omit sound." Nobody knows.

motivated lighting Light that seems to come from existing light sources in the scene. They can be on-screen (practicals) or off-screen (sun, moon, window, firelight).

musco light An array of HMIs mounted on a crane.

negative light The placement of a large black flag or flat near a subject on an overcast day to cast a shadow on one side of the face and thus create contrast. It's a nifty term because it sounds like something only a physicist could explain. "Fire up the Heisenberg compensator, Scotty, we need some negative light on this starship set."

net A bobbinet or black net fabric on a frame. It is used to reduce light intensity and is available in single (half-stop) or double (full-stop).

neutral-density (ND) (adj.) A gel or lens filter that reduces light transmission without coloring the light.

nook A small open-faced instrument.

NTSC National Television Standards Committee. It also refers to the television signal standard set by that committee and used in the United States, Canada, Japan, and some other countries in the Western Hemisphere.

obie A camera-mounted eye light named after actress Merle Oberon.

opacity The measure of light transmitted through a gel or filter.

open face 1. An instrument that does not use a lens to focus light. An open-faced light can, in fact, have a glass shield or scrim over the reflector as a safety. 2. The opposite of poker face.

PAL Phase-alternating line. The television standard used in most of Europe and the countries that were formerly under the control of European countries.

pan A horizontal move of the camera on the tripod (*see tilt*).

PAR A lamp that incorporates bulb, reflector, and lens into a single unit. Short for *parabolic aluminized reflector*. Old-fashioned auto headlights are PAR globes; so are the floodlight for your yard. Some newer PARs are not solid units, but systems of interchangeable lenses and reflectors that snap together.

party colors Gels of intense primary colors.

pattern A metal disk with cutout shapes designed to be used in an ellipsoidal light to project a sharp, defined pattern. Often called a gobo.

pedestal Video black level set at 7.5 IRE. It's used in most NTSC countries except Japan, which uses 0 IRE black, and is also known as *setup*. PAL does not use pedestal.

phase 1. In electrical power, one leg of AC power. 2. In a television signal, the relationship between the signal frequencies that control hue.

photoflood A high-output bulb for photographic use. Available in 3200 K and 5600 K color temperatures. They're short lived, so they're better for still photography than for video or film use.

plate A shot or graphic to be used as a background in a composited process shot.

plus green A green gel that adds green to a light source. It can be used to match an incandescent instrument to fluorescent light. Available in several grades.

polarity The direction of DC current, positive to negative. Don't mix up the + and the − please!

poultry bracket A light mount that straps onto a tree or telephone pole. Don't ask me about the origin of this name—unless maybe pigeons like to sit on it?

practical A light source that appears in the shot. It generally must be of lower intensity than it would be in the real world.

process shot A shot that will be composited with another background, as in the subject shot in front of a green- or bluescreen.

punch The ability to throw light. Diffused light has little punch, whereas a fresnel set on spot has a lot of punch. Technically, it's an unscientific assessment of specular collimation—that is, how closely parallel the photons travel.

quality This term refers to the overall effect of the light source. The light can be hard or soft, have a lot of wrap or little wrap.

quartz bulb A tungsten–halogen globe. The term comes from the heat-resistant quartz glass used in these bulbs.

rags See *silks*, *lavenders*, and *scrims*. This term has an obvious origin.

Redhead An open-faced 1K by Ianaro/Strand. It is the little sibling of the Blonde. Sometimes called a *mickey*.

reflector Any shiny surface used to bounce light—often a foil-covered board. Collapsible fabric reflectors are very handy for location shoots.

riser The portion of the light stand or C-stand that is adjustable; also, a platform to raise the lights or camera.

rough-in The first placement of the lights before fine tuning.

scoop An open-faced instrument that uses a large, hemispherical reflector.

SCR dimmer A solid-state dimmer that stands for *s*ilicon-*c*ontrolled *r*ectifier. All modern dimmers are based on the SCR. Older dimmers were variable transformers.

scrim 1. A metal screen that acts to cut down the light intensity without changing its color temperature. Light scrims are circular pieces of metal screen that slip into the gel holder on the front of an instrument. A *single* reduces the light output by half (a full stop), whereas a *double* reduces the light by two stops. A *half-double* (*see Figure, page 211*), however, isn't the same as a single; it's a scrim with an open upper half and a screen across the lower half. 2. A gauzy fabric that is used in set construction.

A half-double scrim.

SECAM A version of the PAL video standard that is used for signal transmission in France and some countries formerly controlled by France. The French must always be different. *Vive la France!*

Senior A 5K fresnel.

senior stand A braced stand that is strong enough to hold a large, heavy instrument.

setup Video black level set at 7.5 IRE. It's used in most NTSC countries (except Japan, which uses 0 IRE black) and also is known as *pedestal*. PAL does not use pedestal.

shiny board A reflector, usually a foil-covered board.

sider A flag that cuts light to one side of the set.

silk A diffusion fabric originally made of silk, but now synthetic. Can be white (providing some light reduction and diffusion) or black (offering a much more dramatic reduction of light). *Silk*, *lavender*, and *scrim* are all terms for different weights and types of diffusion fabric.

single 1. A stinger or extension cord. 2. A scrim that reduces the light by $1/2$ stop. 3. A net that reduces the light by $1/2$ stop. 4. What you wuz before you said "I do."

skypan A flat, open instrument that uses a high-power (10K) bulb to provide flat illumination of a large area, such as a backdrop or cyc.

SMPTE Society of Motion Picture and Television Engineers.

snack box 1. A temporary power breakout box. It usually connects to a 60- or 100-amp supply and provides several 20-amp outlets. 2. A squarish box with a handle on top, if it had a picture of Batman on the side, you could take it to school for lunch.

snoot A tubular attachment that controls the spread of light.

SOC Society of Operating Cameramen. Ladies can join too, but not best boys, unless they know how to work a camera.

softbox A cloth and wire umbrella-like contraption that holds a large sheet of diffusion material in front of an instrument. A more convenient commercial version of the Croniecone.

softlight A type of open-faced light in which the globe (usually a quartz tube) is hidden in the base and bounced outward off a curved white reflector.

solid An opaque Duvetyne flag.

specular 1. A mirror-like reflective object. 2. Hard light.

specular highlight The reflection of a light source on a subject.

speed 1. Shutter duration. 2. The light transmission of a lens. 3. The light sensitivity of film or (I suppose) the calculated exposure index (EI) of a video camera.

spill The light that squirts where you don't want it, often caused by fugitive photons from the sides of the barn door frame.

spot 1. In a focusing instrument, the setting where the beam is narrow and highly collimated. 2. An instrument with a narrow beam and long throw, such as a follow spot.

spun glass A diffusion material made of a mat of glass fibers.

staging area The temporary location to store equipment.

stinger A heavy-duty, usually 12-gauge, extension cord. Safety orange proliferates, but it's a good idea to have several black ones because they're easier to conceal in a set.

storyboard A cartoon drawing of each shot in the script.

target Whether film frame or CCD, the place where the lens focuses the image inside the camera.

teaser A large black cloth hung to block light.

teching down Reducing the reflective value of white fabric in costumes. The term originated during the original Technicolor process, when white shirts were soaked in tea.

Tenner A studio 10K fresnel.

three-phase (adj.) The form of AC power as it comes from the generator. Each of the three "legs" is a single-phase sine wave offset from the next by 120°. The fourth wire in three-phase power is the ground.

tie-in A temporary hookup to the main service that should be done by a licensed electrician. It might be illegal in some areas.

tilt The vertical rotation of a camera on a tripod, as in "tilt up." You would never "pan up."

top chop A cutter that throws a shadow on the top portion of the picture; same as a topper.

top light A light that shines directly down on the subject.

topper A cutter that throws a shadow on the top portion of the picture.

tough gel A gel designed for use in high-heat situations. Basic theatrical gels will burn when used near the front of hot studio lights, so for film and video, only tough gels should be used.

tough spun A fibrous diffusion material designed to withstand the heat of studio lights.

transfer region The transition edge of a cast shadow. Hard light has a sharply defined transfer region, whereas soft light has a more gradual transition from shadow to light. Also called *transfer zone*.

translucent A semitransparent object that transmits light with some diffusion effect.

transparent highlight A specular reflection that allows the color and texture of the underlying surface to be visible. If overexposed, the highlight becomes clipped and no longer transparent.

trombone A telescoping contrivance that hangs from the top of a set wall to provide a support for lights 2 to 4 feet from the top of the wall. Its name presumably derives from the telescoping section, which acts like a slide trombone. It does not play any notes.

A *trombone* is used to hang a light from a set flat. Courtesy Matthews Studio Equipment, Inc.

truss An engineered reinforced beam used for hanging lights. Its usually tubular construction is welded into a triangular form.

tungsten 1. A lamp that uses a tungsten filament. 2. A material used in the filament of most incandescent bulbs.

turnaround 1. A double-ended connector. 2. The amount of time between wrap one day and call the next, generally 10 hours. 3. The reverse angle of basic shots of a scene.

turtle A floor mount for an instrument.

ultraviolet Just beyond the top end of the visible spectrum, ultraviolet (UV) light can make certain pigments fluoresce; thus, it is used for certain types of special effects. If you were around in the '60s and early '70s, you know all about UV, or "black," lights and psychedelic posters.

USITT United States Institute for Theatre Technology.

VAC Volts of alternating current.

variac A variable transformer.

VDC Volts of direct current.

vectorscope An oscilloscope that is calibrated to measure the chroma and hue of the video signal.

volt A measure of electrical energy (V). Whereas amperage measures the quantity of flow, voltage describes the electrical potential, or difference between positive and negative. Its name derives from Alessandro Volta, the inventor of the battery.

watt A measure of power (W).

waveform monitor An oscilloscope that is calibrated to measure the luminance of the video signal, as well as display the sync and color burst.

western dolly A wooden dolly with pneumatic rubber tires.

white balance A procedure for adjusting a video camera to recognize a specific color temperature as "white." This is done by electronically adjusting the gain of the red, green, and blue CCDs while the camera is aimed at a white card illuminated by the main light source in a scene.

xenon A high-intensity gas discharge lamp usually used in strobes.

zebra display A special indicator that appears in a camera viewfinder to indicate the exposure levels in a picture.

zip cord A two-connector molded wire, also called a lamp cord.

zip light A compact 1K or 2K softlight.

Index

The Authority on Digital Video Technology

DV MEDIA GROUP

PRINT

EVENTS

ONLINE

w w w . **DV** . c o m

CMP
United Business Media

DV
Media Group

▶ , ■ , ◀◀ , ▶ , ‖...

You Control the Speed of the Class
with the DV Video Workshop

Learn the techniques, tricks, and jargon of the pros with lighting expert John Jackman in *"Basic Lighting for DV."* This full 72-minute review of lighting equipment, techniques, and gaffer tricks will enhance even the most problematic picture.

To order your copy of the *"Basic Lighting for DV"* video

☎ 1-800-444-4881

🖱 order online from the **DV.com** store.

✉ *Basic Lighting for DV Video*
1601 West 23rd Street, Suite 200
Lawrence, KS 66046-9905 USA

$49.99 + Tax and Shipping